MAKING
WAVES

DC-138 Sunset on the Overseas Highway
Florida Keys

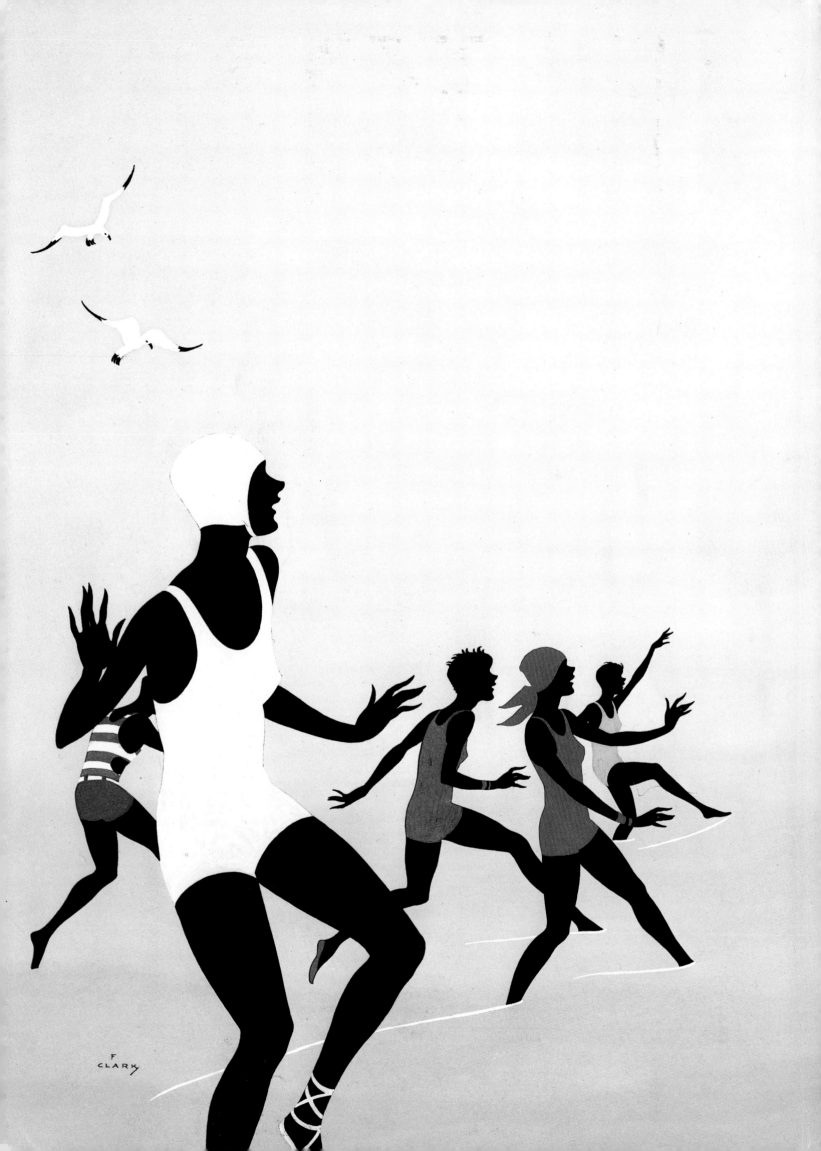

MAKING

Swimsuits

and the

Undressing

of America

Lena Lenček
and Gideon Bosker

Chronicle Books
San Francisco

WAVES

Printed in Japan.

**Library of Congress
Cataloging-in-Publication Data**

Lenček, Lena.
Making waves.

Bibliography: p.
Includes index.
1. Bathing suits – History. I. Bosker, Gideon.
II. Title.
GT2077.L46 1988 394'.3 88-18151
ISBN 0-87701-398-5

Distributed in Canada by Raincoast
Books, 112 East Third Avenue, Vancouver,
B.C., V5T 1C8

10 9 8 7 6 5 4 3 2 1

Chronicle Books
275 Fifth Street
San Francisco, California
94103

Contents

Acknowledgements

Bringing this book to completion required the collaboration and cooperation of many individuals and institutions. Our gratitude is due, first of all, to all the actors in the drama, especially the designers, seamstresses, and manufacturers whose swimsuits have graced generations of Americans, and whose written records, photographs, and illustrations have found their way into various libraries and archives throughout the country. Museum curators, photographers, and members of the fashion community—survivors of bygone eras and fresh young talents alike—have been more than generous in discussions and in enduring our questioning. Their lively perspectives and recollections continuously renewed our enthusiasm for exploring the rich collective imagination that has been at work shaping this intriguing item of fashion.

Our special thanks go to Arthur McArthur, Rosemary Ridenour Huserik, and Julie Lane of Jantzen Inc.; Ann Cole, Kerrie White, Lisa Rubin, and Deborah Mobley, Cole of California; June Wiley, Catalina; Karen Cotrell and Norma Kamali, Norma Kamali, Inc.; Tom Bennemann, Speedo America; Linda Horvath, Elizabeth Stewart; and Shelley Bernstein, Roxanne. Professor Patricia Cunningham of Bowling Green State University provided both a thorough and fascinating account of the history of B.V.D. swimwear and contributed a number of photographs of B.V.D. suits from her personal archive.

A book relying so heavily on visual material could not have come to fruition without the assistance of various libraries, picture agencies, and individuals who were kind enough to supply and reproduce the illustrations, photographs, and sketches appearing in this volume. Henry Kessler, Metric Products Co, Inc., deserves special mention for his personal recollections of Rose Marie Reid and for having the wisdom to save a vast quantity of the company's archival material, which he graciously shared with us. Alicia Kay Smith, retired public relations director of Rose Marie Reid, was a priceless source of information. Ed Whittington, the creative linchpin and critical geneological link in the "Dick Whittington" photographic dynasty of Los Angeles, was unusually giving of his time and resources. Culled from a vast archive of 1.2 million negatives, his images of beach scenes and bathing beauties have provided an invaluable perspective on the cultural and social aspects of beach fashions. Jane MacGowan, award-winning photographer of the Cole "Scandal Suit" of 1964, opened her entire visual inventory for this project and gave unselfishly of her time and resources. We are indebted to photographer Tim Street-Porter, who was especially kind in permitting use of his exquisite photographs of sunglasses from the 1940s and 1950s, and to Evelyn Burkhalter, owner and curator of the Barbie Doll Hall of Fame, Palo Alto, California, for arranging a glittering line-up of swimsuit-clad Barbies from 1959 to the present.

For expeditious and kind service—as well as for minimizing the usual tangle of red tape and byzantine regulations that impede photographic archival research—we wish to thank a number of individuals and picture agencies and museums: Ken Johnston of Bettman Archives; Nancy Davis and Fran Dobbins, Bettman Newsphotos; Clark Maurer andd Tom Logan, Culver Pictures; Courtney Andrews, Life Picture Archives; Laura Sinderbrand, Fashion Institute of Technology; Beth Alberty, Metropolitan Museum of Costume Art; Monica Brown, Philadelphia Museum of Art; Claudia B. Kidwell and Eleanor Boyne, Smithsonian Museum of History and Technology; John Miller, University of Akron; Joyce Albers, Los Angeles Public Library Photo Collection; Academy of Motion Pictures and Arts; Janice Burr, Popperfoto, London; Dave Kent, The Kobal Collection; Bruce Henstell; and Tom Ettinger, *Sports Illustrated* Enterprises, Inc.

For their patience, unusual level of competence, and enlightened guidance in obtaining archival photographs and assisting in our research we would like to offer special thanks to Ned S. Comstock, Archives of The Performing Arts, University of Southern California; Kayla Landesman and Hilda Bohem, Department of Special Collections, UCLA Library; Susan Mogul, Photographic Collection, California Historical Society; and Audrey Van deVorst, Costume and Textiles Collection, Los Angeles County Museum of Art. In the area of bibliographic research, we would like to thank Penelope Hummel and Frank Le Pezennec for their enthusiastic assistance and informed strategies for obtaining articles, key historic references, and rare books in the area of swimwear and beach culture.

In the course of this project, a number of devoted friends and interested loyalists appeared on the scene who, without solicitation, took the time to send clippings and photos and to convey names of contacts that helped us piece together the story of the American swimsuit. In this regard we offer a special debt to Lawrence P. Ashmead, Jim Vegher, Jerry and Catherine Peters Graham, Richard Pine, Vivan McInerney, and Arlene Holmes.

As is the case with every project, certain individuals provided seemingly tireless assiduity in hunting out records and materials to illuminate the subject under study. Certainly our enterprise would never have come to fruition without the generous help of Arthur McArthur, former director of public relations and "historian in residence" of Jantzen Inc. Mr. McArthur made himself available for almost daily consultation for a period that extended more than three years. Offering wisdom, guidance, and a bountiful supply of anecdotal humor, he not only gave us free reign of the Jantzen archives but spent countless hours in a claustrophobic vault tracking down rare swimsuits, photographs, and paintings that would to help illustrate this story.

We also owe a special debt of gratitude to Edward Maeder, Curator of Costumes and Textiles at the Los Angeles County Museum of Art. Mr. Maeder, flashlight in hand, took us through hundreds of foamcore coffins packed with spectacular swimsuits and baroque accessories. He offered hours of perspicacious commentary on the rise and fall of the female breast as it related to swimsuit fashions and provided hands-on assistance in preparing the museum's costumes for photographic documentation.

It is a special pleasure to acknowledge our agent, Richard S. Pine, whose excitement for the subject, genteel diplomacy, and good humor nudged the project to completion. As the going got rough, we were spurred by Mr. Pine's conviction that the story of how America undressed in public was worth telling and would find an audience.

We would like to express our appreciation to Chuck Robbins for his sensitive and intelligent copyediting. For their efficiency, care, and commitment to this project, we are deeply grateful to the entire staff at Chronicle Books and would like to single out David Barich, Heidi Fritschel, and Nion McEvoy. Finally, for his encouragement, wise guidance, and unfailing warmth and trust, our heartfelt thanks to William LeBlond, our editor at Chronicle Books. Without his editorial panache, conviction, and visual imagination this book would not be what it is.

Lena Lenček and Gideon Bosker

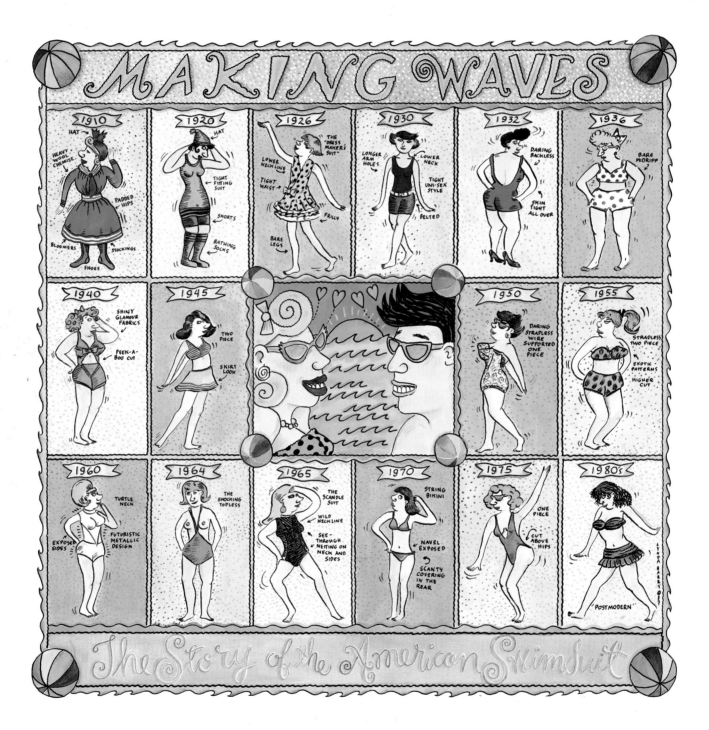

Lynda J. Barry ©1987

Introduction

The history of the American swimsuit is the square-inch-by-square-inch story of how skin went public in modern times. In an equally important sense, it is also the story of how flesh and fabric have come together to serve sport, sex, and culture.

The unexpurgated—and oftentimes steamy—saga of this classical garment can be seen as a tug of war between skin, machine, and cloth choreographed by the forces of concealment and disclosure, and performed against the shifting sands of civilization and its discontents.

Not surprisingly, much of this story reads like a case study from the notebooks of Sigmund Freud, who suggested that "the progressive concealment of the body which goes along with civilization keeps sexual curiosity awake." Clothing is erotic because it arouses curiosity about the body as a whole. Seen in this light, the swimsuit has functioned as a kind of sartorial italics that, over time, have been refocusing erotic attention on various parts of the human body. Modifications in swimsuit design have continually refreshed, revitalized, and remystified what is in essence a rather banal mannequin.

Early development of the bathing costume required an unprecedented solution to an unprecedented problem. The challenge went beyond the obviously utilitarian program of designing a seaworthy garment. It was a matter of inventing, virtually anew, a vocabulary of fashion that would be functional and, even more important, infinitely expressive. This new item of apparel would have to accomplish what no other piece of clothing had ever been called upon to do: It would have to conceal and to reveal, to mollify and to arouse, to pass from the bath to the promenade with all its material and decorative highlights still intact. It had to do this without substantial additions or deletions of parts. Indeed, this amphibious costume would have to be something of a sartorial paradox: a form of undress that functioned as a symbol of dress.

Introduced in 1918, the knitted woolen one-piece suit became the dominant look in swimwear for the next ten years. Here, strategically placed diamond patches in contrasting colors relieve the austerity of the "tank" suit and pay homage to the geometric imagination of Art Deco.

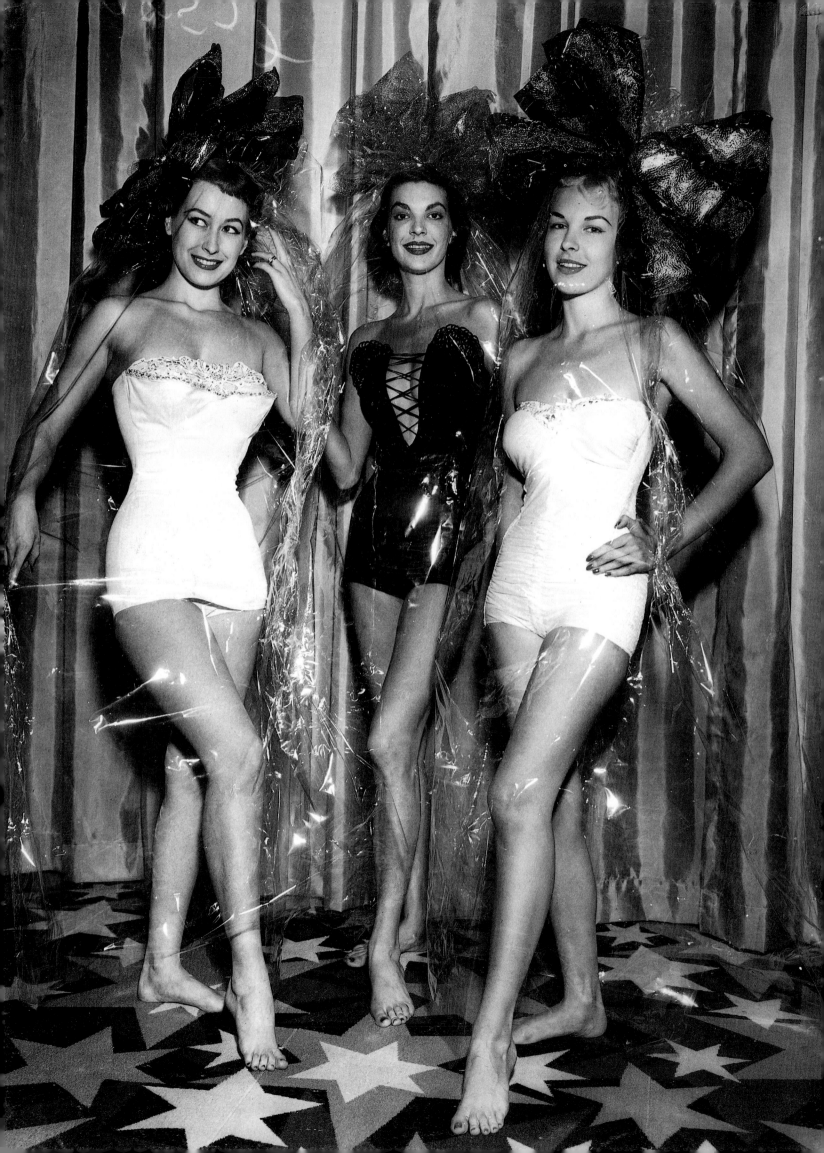

Kitschy, kinky, or refined, swimsuits would become conspicuous signposts of fashion against which American culture would register its economic, aesthetic, sexual, and—when it came to materials and fabrics—even its technologic milestones. Whether festooned with the fripperies of a bygone era or packaged in the sleek, form-hugging spandex of the present, these costumes have been at once protective and ornamental, symbols and playthings. Finally, the bathing costume has been time-pegged, circumscribed by history, and inextricably rooted in fantasy and desire, which is why it moves us with the passion it does.

As a novelty item, the swimsuit has advertised everything from beauty pageants and Chryslers to presidential candidates and sacrosanct American virtues. In the process, this scanty item of attire has exposed a powerful parodic nerve and fueled a healthy instinct for scratching the humorous underbelly of Eros. Sheathed in the suit of the day, the so-called bathing beauty became a permanent fixture on the American landscape, and shapely girls in swimsuits have been a feature of almost every celebration of American commercial or civic spirit.

But it did not stop there. Devising rituals for the beach has been as central to opening the libidinal energy of our population as changes in the swimsuit itself. Americans have been wizards at concocting "novelty" beach pastimes. Often, what began as a legitimate sport—swimming, water skiing, and snorkeling—was soon transformed into a baroque extravaganza, fully equipped with its own ceremonial mythologies and signature costumes. The beach, in short, became a pretext for unleashing the unexpurgated carnival spirit associated with aquatic culture.

Glamorous swimsuits were the mode of the day during the 1950s. Having acquired a new prestige in fashion circles, they marked the return into vogue of a "ladylike" silhouette that had not been seen in over a century. It was as if American beachgoers of the 1950s were dressing themselves for one nonstop postwar homecoming parade.

For 1953, Cole of California proposed three formal swimsuits for girls who "prefer to look dangerous when dry rather than wet." "Diamond Lil," on the right, featured a nude nylon bra encrusted with "diamonds" and edged with a stand-away cuff. The "Man-Trap," center, laced like a Merry Widow corset and was designed to appeal to men "who like those wide open spaces." The "Treasure Chest," on the left, supposedly made "a girl's figure her fortune."

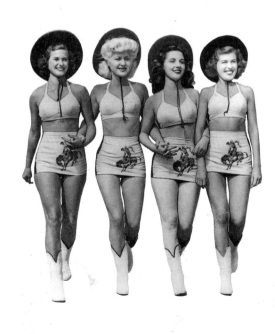

In 1946, Wild West bathing costumes, Hollywood style, featured cowboy hats, boots, and bucking bronco insignias.

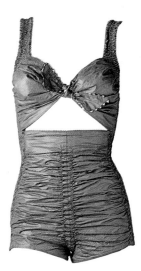

In the balmy southeast, Cypress Gardens established itself as the center for dizzyingly choreographed water-skiing exhibitions and fabulous underwater frolics. Even though beach follies were launched on the East Coast in such fantasy lands for the masses as Coney Island, Atlantic City, and Cypress Gardens, it was Southern California where Americans staged their most imaginative and wildly implausible beach events. There, under sunny skies, coastal communities sponsored endurance contests which tested the competitors' ability to sit on ice blocks while balancing beach girls in their laps. Pig races, roller skating derbies, chess and bridge tournaments drew participants in full bathing attire.

As early as 1914, when Mack Sennett recognized the box-office appeal of parading bathing beauties on the silver screen, the cinema began to carry on a passionate love affair with the swimsuit. Film stars watched their careers take off like rockets on the strength of publicity shots showing them in swimsuits. And manufacturers capitalized on styles modeled by such box-office hits as Marilyn Monroe, James Garner, Loretta Young, Dick Powell, and Esther Williams.

Special genres developed that showcased the bathing costume. The Tarzan films of the 1920s relied on scanty clothing for much of their appeal, as did the aquacade extravaganzas of the 1930s. But it was during the sixties that the beach movie took firm hold of the popular imagination. Teenage heartthrobs such as Elvis Presley and Annette Funicello warbled and gyrated on American beaches in Hawaiian shirts and bikinis, thrilling millions of adolescents.

For more than 100 years, the swimsuit has served as the preeminent vehicle for the public undressing of America. In turn, some of the country's largest swimsuit manufacturers—Cole of California, Jantzen, Catalina, Rose Marie Reid, and many others—have played a major role in determining exactly where the battle lines between flesh and fabric would ultimately be drawn. Their designers would set the standards for how the human body should be nipped, tucked, and exposed. Not infrequently, their vision collided violently with legislative bodies and municipal authorities that had a different view of what was socially acceptable.

Designed to fit both in and out of water, the 1922 line of swimwear featured clinging knits in vibrant solid colors.

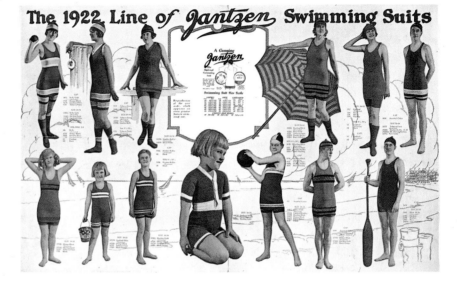

As beaches became an increasingly important part of smart summer life, accessorizing the sleek new swimsuit demanded a finely-tuned fashion sense. Mass market manufacturers simplified the task by translating haute couture ideas into a handful of easy rules for color coding accessories to harmonize with the wearer's complexion, hair color, and suit.

The Southwest Cactus Breeders Association selected Universal Studios star Mary Castle as "Miss Cactus of 1953." Known to film audiences for her appearances in "Gunsmoke" and in "The Lawless Breed," Miss Castle was chosen for having "the most beautiful leafless limbs in the movies."

Since 1964, *Sports Illustrated* has been showcasing beautiful, athletic bodies in skimpy suits that have done much to establish the physical ideal of "the California look."

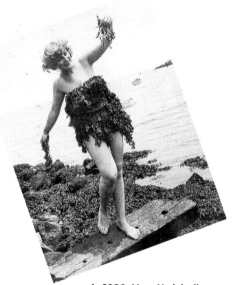

In 1923, New York ballet dancer Peare Howell donned an unusual bathing suit made entirely of seaweed.

Like other creations issuing from the world of fashion, the swimsuit struggled to be a product of its time. Major movements in architecture, industrial design, and the visual arts continually exerted an influence on clothing which translated new ideas into a rich variety of textiles, techniques, and structural devices. Although it provided the anatomic underpinning for these garments, the human body was a mere frame—a glorified coatrack, usually concealed—to which structural contrivances and ornamental drapings could be applied to achieve the desired effect.

In this respect, the swimsuit was severely handicapped. The particular challenge of the swimsuit was to exhibit the same critical stylistic innovations of an era as did other works of fashion. But it had to do so within the meager framework of a square yard of cloth. What's more, the bathing costume had to convey its stylistic message in competition with the obdurate human body which continually seeks to impose its own form and to broadcast its own biological imperative. And yet, when all was said and done, despite these enormous obstacles, the best swimsuits have always managed to crystallize the dominant stylistic themes—architectural, artistic, and technological—of their times.

If clothing is a language, then a bathing suit is a telegram: a few brief lines packed with information that commands instant attention. Also unique is the fact that the swimsuit is one of the few things in the world which critics consistently accuse of having reached the end of its revolution or evolution. Happily, nothing could be farther from the truth. Understood in its fullest sense, the story of the American swimsuit embraces the entire gamut of human activity from politics, advertising, and corporate takeovers to art, fashion design, and the engineering of aquatic spectacles. In this important sense, the metamorphosis of the swimsuit can be seen as a catalogue of the symbols and aspirations of its wearers and designers: their dreams, social myths, and taboos, as well as their religious beliefs and visions of the future.

Under the influence of America's most innovative and influential designers—among them Margit Fellegi, Norma Kamali, Claire McCardell, and Rose Marie Reid—the swimsuit has undergone a staggering transformation. Not merely its hems and inseams, but its very fiber and tweed have been rewoven into some of the most revealing and innovative garments the history of fashion has known. In more recent years, swimsuit design, like architecture, has exhibited a kind of free-form eclecticism and historicism: a merging of forms, fabrics, and decorative elements in an increasingly unpredictable fashion. Myriad styles, from the classical one-piece maillot to the rigidly structured Hollywood-inspired suits of the 1950s, have been ransacked from the smorgasbord of history. Under this historicist spell, older styles and fabrics are resurfacing and postmodernist impulses have clearly influenced this item of attire. Contemporary swimsuits are being conceived more and more according to schemes that reveal an evolving repertoire of stylistic and decorative strategies that have extended the classical language of swimwear fashion to current techniques, fabrics, athletic functions, and cultural sensibilities.

Since the early years of this century, the American swimsuit has served not only as a medium for projecting cherished fantasies, popular trends, and ancient myths but also as a marker for serious movements in fashion. In the end, there has existed no costume so minimal with the capacity for revealing so much about American life. And for doing so with as much humor, excitement, and wicked intelligence.

Hollywood's most famous mermaid and tycoon Esther Williams poured her famous curves into a "shockingly pink" sequined suit for MGM's 1944 water opera "Bathing Beauty."

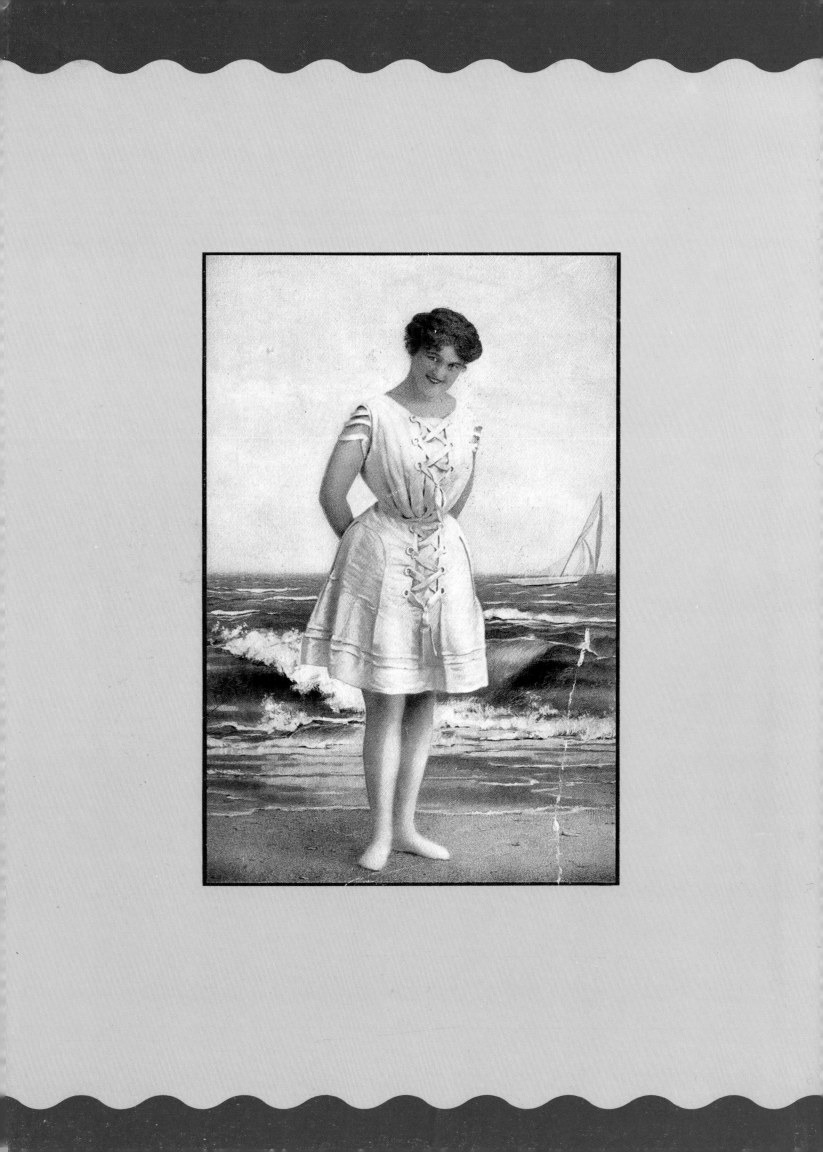

1

Suddenly thrust into view, arms received considerable attention in fanciful sleeve detailing. Fashion drawings of the time showed high-cut armholes finished by caps, petals, slashed sleeves, and "sleevelets," innovative demi-sleeves that extended across the armpit and left the outer arm bare beneath a network of lacings.

The first recorded use of bathing costumes was in Greece, around 350 B.C., when public bathing was practiced by women of beauty and fine form. Streetwear togas were worn, as they were in Rome 150 years later, when the popularity of bathing and swimming reached its zenith in the ancient world. Over the years, bathing attire underwent a radical change. A mosaic wall from a fourth-century A.D. Sicilian villa depicted young girls dressed in scanty garments that look remarkably like the modern-day bikini. After the decline of the Roman Empire, water sports went out of style, and Europeans eventually came to regard the sea primarily as a source of medicinal treatments.

Early in the eighteenth century, however, spas—natural springs where bathing was carried on publicly—began to appear in France and England. Attire for this new leisure activity was appropriately archaic and consisted of a togalike garment for both men and women that paid homage to the classical origins of the bathing institution. Soon thereafter, the fad began to catch on in America, but in a sartorially simplified version. In those early days, men and women bathed rarely, and, for the most part, a typical seaside foray consisted of little more than a brief plunge into the water, gentlemen on one isolated stretch of sand, ladies on another.

Medicinal bathing acquired a certain cachet among the more progressive members of Colonial America. Specialized mineral springs were established at points along the East Coast. Society ladies, among them Martha Washington, frequented spas such as the one at Berkeley Springs, West Virginia. There, a collection of rude log huts and canvas tents was thrown up around a bathing pool, which consisted of a large hollow scooped in the sand. A screen of pine brush provided privacy. The pool was used alternately by ladies and gentlemen, and the time set aside for each sex was announced by the blast of a long tin horn. Segregated from the men, genteel matrons would slip into the pool wearing monastic linen gowns hemmed with lead disks to keep the women decently clothed underwater.

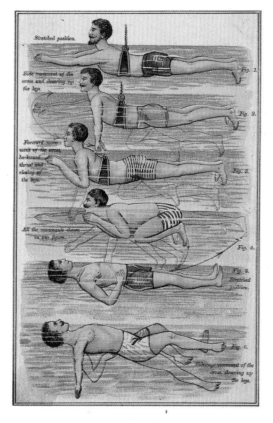

At the turn of the century, swimming was still awaiting resuscitation as a pleasurable exercise since its heyday in classical Greece and Rome. Always ready to promote new fads, the popular press rallied to the cause of this long-neglected sport with articles extolling the benefits of aquatic sports.

Reassured by inspirational sketches of waterborne males, the timid reader was urged to believe that any "reasonably normal individual between the ages of infancy and senility can be taught to swim."

In the early 1800s, Americans were suddenly seized by a desire to use the beach for recreation. Technology, leisure, and changing notions of healthful pursuits made the bucolic simplicity of spa-bathing obsolete. By a quirk of cultural development, the waves abruptly threw up the human body as a virginal field for sartorial experimentation. By 1850, swimming had become a popular pastime in the fashionable American resorts dotting the East Coast. Over the next several years, there developed many new activities from surf-bathing and swimming to diving and sunbathing. The popularization of seaside amusements produced a revolution in fashion. A special costume was needed that retained modesty of dress yet freed the body for sports.

Aside from the toga, however, there were no precedents for bathing attire in the clothes closets of history. The repertoire of nineteenth-century sporting costumes held little inspiration for this new recreation. Underclothing was equally unsuited to furnish a sartorial model. At the time, underclothes were thought of as a prelude to dress and totally inappropriate as outerwear. With their elaborate system of stays, bindings, bands, corsets, crinolines, and pads, undergarments were contrived to create the shapes that fashion of the day dictated. Because they were styled to thrill with the delicious shock of the erotic, underclothes spoke too loudly of the boudoir to do for the public strand.

Ironically, the most direct predecessor to the swimsuit was not to be found in an item of apparel at all. It is a beguiling incongruity of Western culture that swimming—the sport requiring the least equipment—should have produced the most elaborate encumbrances. In fact, the first formalized bathing costume was not, strictly speaking, an item of clothing. It was a product of architecture: the remarkable bathing machine.

Half carriage, half cabin, this hybrid structure was developed around 1735 in Great Britain. Resting on four wheels, it was, at first, a crude box measuring four-feet square with doors at either end. Some models even boasted architectural pretensions such as arched doors, diminutive windows, and daintily peaked roofs that allowed passengers to stand while changing.

In the novel *Humphrey Clinker*, Tobias Smollet described how bathing machines were used at seaside spas: "The bather, ascending into this apartment by wooden steps, shuts himself in, and begins to undress, while the attendant yokes a horse to the end next to the sea and draws the carriage forwards, till the surface of the water is on a level with the floor of the dressing-room, then he moves and fixes the horse to the other end—The person within, being stripped, opens the door to the sea-ward…and plunges headlong into the water—After having bathed, he reascends to the apartment, and puts on his clothes at his leisure, while the carriage is drawn back again upon the dry land."

Combining dressing room, beach buggy, and diving platform in one cumbersome package, the bathing machine permitted Victorians to conquer the waves with a minimum of specialized attire—and without endangering decency. Because of its cleverly designed awning—the so-called modesty tunnel invented by Quaker John Beale in 1753—the bathing machine was especially beloved by fastidious ladies. This device was a canvas tent suspended from the sea-end of the machine to cover the patch of water where a woman could bathe shielded from the eyes of the public and the rays of the sun.

Long a fixture on British, French, and German beaches, the bathing machine made a fleeting appearance in America early in the nineteenth century, but the idea never really caught on in the United States. Americans had little patience with rituals of modesty that involved middlemen and horsedrawn vehicles. Then, too, there was the faint whiff of scandal that clung to the bathing machine. It appeared that occasionally female bathers preferred to be handed into the waves by male bathing attendants who could more readily rescue them from the swells. "This custom," wrote a British observer in 1829, "which is very far from being general, has given rise to ill-founded stories of want of delicacy on the part of American females."

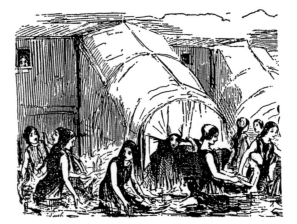

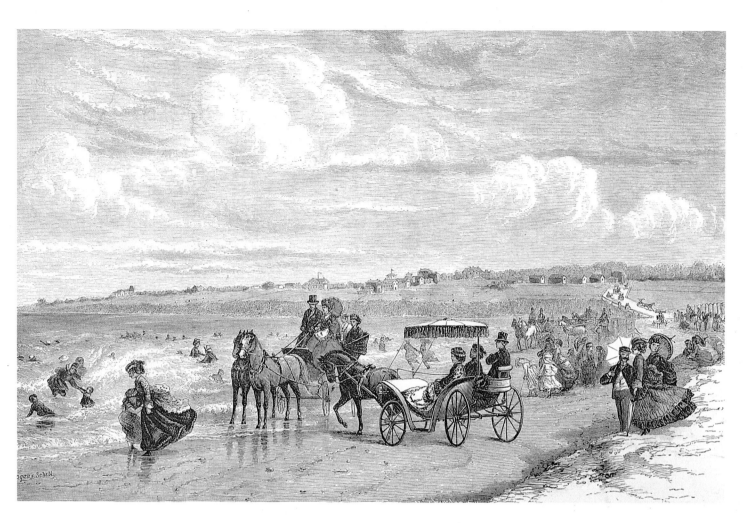

In 1872, the fashionable, monied set flocked to Newport, Rhode Island, establishing its reputation as the undisputed "Queen of American Seaside Resorts." As surf bathing gained in popularity, "full costume" became obligatory when the white flag was hoisted, and especially so during the popular hour before noon.

Combining dressing room, beach buggy, modesty screen, and diving platform in one cumbersome package, the bathing machine was a standard fixture of nineteenth-century British, European, and Australian resorts. Because of its cleverly designed awning—the so-called modesty tunnel—the machine was especially beloved by fastidious ladies.

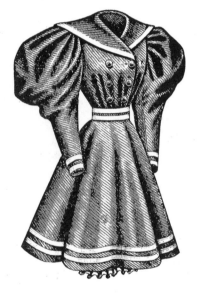

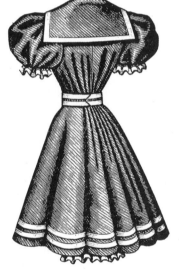

Magazines such as the *Delineator, Godey's Lady's Book* and *Harper's Bazaar* issued detailed instructions for sewing bathing costumes with short puff sleeves, long bishop sleeves, or leg-o'-mutton sleeves that ballooned at the shoulder and tapered at the wrist for a snug fit. The sailor collar, which along with the straight standing collar had been a favorite for decades, was shown in a variety of sizes and styles.

Inspired by the sailor suit, the child's bathing suit (top) covered the body from chin to knee. In addition to hats, shoes, and stockings, a five-year-old wore a costume that used at least two-and-one-eighth yards of thirty-six-inch-wide fabric.

Knickerbockers, joined directly to the underbody, stopped just below the knee, to reveal the leg clad only in lightweight silk stockings.

By 1850, both sexes had started bathing together in public on a regular basis. An illustration from *Godey's Lady's Book* entitled "Scene at Cape May" in August 1849 depicted a spectacle of wild abandon. Couples frolicked in the surf in attitudes suggestive of intimacy. In the foreground, a pair of clad buttocks vanished into a wave, while not far off, two naked feet thrust skyward amid a tumble of outstretched arms. Noted a correspondent for *Peterson's Magazine* of August 1856, "All are wild with excitement, ducking, diving, splashing, floating, rollicking and in the surf."

The gaiety and thrill of mixed bathing, with its relaxation of stiff etiquette and its enchanting possibilities for flirtation, were irresistible. Sea-bathing was all the rage, and, wanting a clearly defined aquatic costume, swimmers thrashed about for a stylish look on the beach. During these years, bathing costumes consisted of the most fantastic assemblies. Ladies improvised as best they could. "Some wear bloomers, buckled nattily about the waists, with cunning little blue-veined feet twinkling in the shallow water," one observer reported, while "others wrap themselves in crimson Turkish dressing gowns, and flounder through the water like long legged flamingoes; some wear old pantaloons and worn out jackets." Colorful and mad the costumes might have been, but a pretty sight they were not.

Evolution was slow. The cumbersome bathing machine was replaced by an equally awkward bathing costume that was as innocent of utility as it was of comfort. In regard to its design, what has come to be known as the Victorian bathing dress drew its inspiration from the promenade or lawn dress. Customary garb for bucolic afternoons, the frothy lawn dress carried the right connotation of chaste, picturesque amusements in the open air. It also furnished the full arsenal of needed protective gear. With its accessories such as parasols, gloves, and scarves, the promenade dress was something of a portable shelter against the elements, transforming its wearer into a mobile garden gazebo.

By the late nineteenth century, customary bathing dress consisted of a pair of drawers and a skirt reaching to about three inches above the ankles. It billowed from a deep yoke nearly to the ankles and was secured at the waist by a fabric belt. The drawers were plain or edged with lace and tightly banded at the ankle.

The designs of men and women's costumes were markedly different. Victorians liked their genders unambiguously differentiated. In the case of the male, boxiness and solidity contrasted with the sinuous exaggerated curves of the female. On the beach, men cast off the somber coloration and rugged textures that in daily life lent them the solid aura of the Rock of Gibraltar.

The resemblance between a man's ordinary undergarments and beach attire was so striking that he was compelled to accentuate their differences. His striped knit pullover-and-pants may have looked remarkably like his underwear, but that appearance was only superficial. In color and pattern, the striped tricot swimsuit was a triumph of hilarious implausibility and tended, even in the judgment of contemporaries, toward the ludicrous. "Barefoot as a mendicant," so one observer described the typical male bather of 1891, "your hair disheveled in the wind, the stripes on your clothes strongly suggestive of Sing Sing, your appearance a caricature of human kind, you wander up and down the beach a creature that the land is evidently trying to shake off and the sea is unwilling to take." Undress for the Victorian male inhabited the realm of comedy. It was the victory of the carnival over the drawing room.

By contrast, clothes for the fashionable Victorian lady represented the triumph of the machine over nature and the merging of architecture with fashion. The machine, in this instance, was the corset. Cunningly crafted to stiffen the spine, constrict the waist, and thrust the bosom and buttocks into prominence, the corset was the invention of an age that fervently believed man not only could, but should improve upon nature.

Regardless of their size, modish ladies coveted the corseted eighteen-inch waist that crowned the apex of a billowing "pedestal" skirt. By the end of the century, the ideal form swelled to the Wagnerian mold of "amply displayed bosoms counterbalanced by a backward movement of hips and buttocks in an S-shape, joined by a waist so small that but for its steel girder of corset one feels it would snap." Wire mesh bustles and crinolines—portable scaffolds and buttresses of segmented steel—imparted a machine-stamped uniformity to the most diverse female bodies.

In effect, the corseted woman announced to the world that she was not a tramp. Her libido, concentrated in the waist, was not only under wraps but under the most rigid of controls. But a deeper symbolism might have lurked in the mental stays of the corset and the architectonic substructure of crinolines.

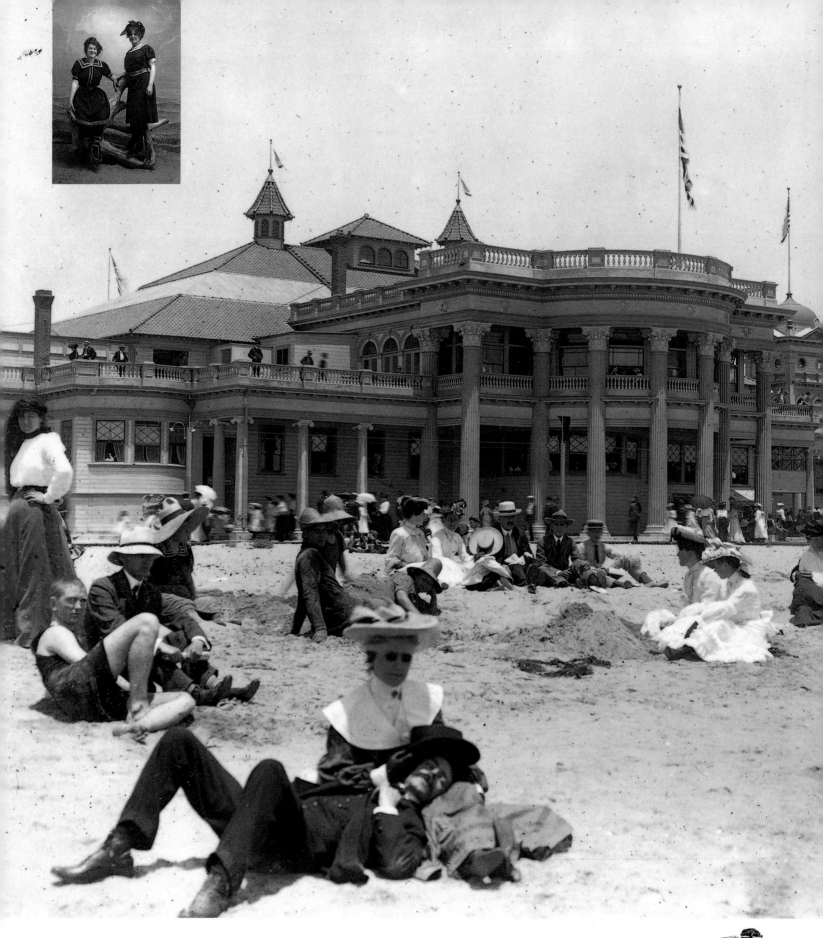

In 1902, *Outing* magazine issued detailed instructions for the graceful sport of surf bathing: "Standing in the break, there are two ways of putting a woman through the surf. One is to place a hand on each side of her waist. The other involves both standing sideways to the breakers, you with your right hand holding her belt, and your left, her right elbow; she with her right hand holding your left elbow and her left resting on your shoulder."

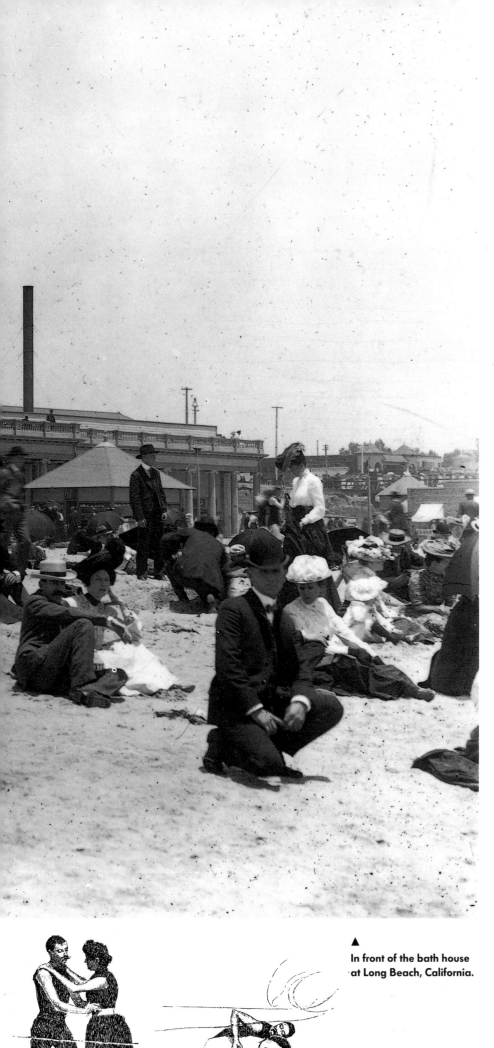

In front of the bath house at Long Beach, California.

By molding the body into shapes of extreme artificiality, the corset announced the domination of humans over their environment and machine over heredity. The body of the Victorian woman became, in a sense, a symbol of man's break with nature. To a certain extent, the Victorian female was man-made: a natural force, harnessed and shaped to serve the whimsical imagination of her mate. And, if she was—or aspired to be—a lady, she continued to parade this idealized form on the beach. Undaunted by the threat of corset diseases—disorders which, it was speculated, ranged from hemorrhoids to cancer—or the hazard of splitting steel stays, she clung to the conviction that the corseted body was an asset. Thus, well into the 1890s, women wore corsets beneath their bathing dresses, even when they ventured into the water, where the contraptions were known to induce cramps.

With characteristic thoroughness, the Victorian mind transposed its ideals of social stratification, formal order, and clearly defined sexual roles to the beach. The bathing costume remained but a small part of an ornate bathing environment that included bathing machines, bath houses, follies, spas, bathing pools, and subtle rituals of behavior.

From Bar Harbor, Maine to Miami Beach, Florida, resort life rapidly expanded, and then the craze leapfrogged across the country to fashionable outposts on the California coast such as Coronado Beach. At the first sign of summer, ladies and gentlemen of the better sort flocked to the seaside. They looked forward to a busy social season filled with dinners, concerts, balls, promenades, carriage rides, boat races, and, of course, dips in the surf. An architectural backdrop of magnificent pavilions, boardwalks, and verandas brightened the proceedings. Summer resorts had developed into fashion laboratories where the well-to-do came to experiment with new styles of dress and behavior.

Reigning as the undisputed queen of American resorts, Newport, Rhode Island set the tone for stylish beach activities. Every year between June and September, ultra-fashionable men and women made the rounds of each other's magnificent villas, and Newport women made a fetish of ocean-bathing. The rage for the waltz and the polka at Narragansett Bay and Newport rapidly spread to the surf where couples performed intricate maneuvers that allowed for considerable love play. A visitor to the beach at Newport observed delightedly that knee-deep in the frothing surf, gentlemen in clinging tights "handed about their pretty partners as if they were dancing water quadrilles."

In 1902, *Outing* gave a cachet of formality to this enchanting sport, laying out detailed guidelines. "And now, if you are indeed a good surfman, both courtesy and inclination may lead you to offer escort to one of the sex...that can meet surf almost with the best." But this treatise warned that "unto such activity go you, in fitting humility of soul. Make no promises...Above all, *never* agree that a woman won't get her hair wet, for of such agreements come disappointment and distrust." Steps for arabesquing in the surf were then spelled out in exacting detail: "Standing...in the break, there are two ways of putting a woman through the surf," ran one set of instructions. "One is to place a hand on each side of her waist...[The other involves] both standing sideways to the breakers, you with your right hand holding her belt, and your left, her right elbow; she with her right hand holding your left elbow and her left resting on your shoulder."

There was little resemblance between these intricate water ballets and their rudimentary forerunner, practiced at the eastern end of Long Island by the mass of commoners. "Every Saturday morning or afternoon, as the tide willed, throughout the summer," wrote a correspondent for *Outing* in 1902, "big farm wagons trundled down to the beach and were swung around abreast of the line of breakers. Old fish houses served the purpose of modern bathing pavilions, and the sea costumes were those of last year's village street." A long rope was secured to the wagon wheel, and some sturdy ex-whaler or sailor wrapped one end around his wrist and waded out with it into the surf. In his red flannel shirt and old trousers, he pulled the line as taut as it would go while women and children clung to it, shrieking and wallowing and exulting in the foaming breakers.

Nowhere did carnival abandon reach greater heights than in Coney Island, New York. Playground of the urban masses, it received some ten million visitors annually. Strolling puppeteers, vendors, musicians, gamblers, and prostitutes presented a riveting garnish to permanent attractions such as the colossal elephant with restaurant and dancing rooms in its interior, the freak shows, and the thrilling rides. Naughtiness was in the air and in the saucy poses struck by young bathing beauties.

The belief that physical exercise was beneficial to the constitution gave strong momentum to the popularization of water sports. Following the lead of Britain, large American cities began to provide "swimming baths," the most popular of which was the series of floating bathhouses in New York City. Moored among the docks from the Battery to Harlem, these rickety structures bobbed and groaned in the wash with each passing ferry and barge. The large wooden buildings were built around a space of forty-by-seventy feet, which was filled with cool, green tidewater.

During an average summer at the turn of the century, three million bathers used New York's floating stations. Beginning at dawn, vast hordes of sweaty, weary immigrants lined up for a bracing swim. Every bather was allowed twenty minutes in the pool and ten minutes for dressing. At the end of each session, a big gong would bang a warning and, as Ralph D. Paine recounted in the July 1905 *Outing* magazine, "the shouting, splashing welter of swimmers scramble ashore with amazing concord of obedience, for to linger or rebel is to be put on the black-list and to be cast into outer darkness next time you are just dyin' for a swim."

The masses who streamed to these municipal pools came attired in the most motley array of improvised bathing clothes: old dresses, sawed-off trousers, ragged jerseys, forlorn tights, and gay patchworks of the most mysterious origin. Youngsters, of course, thought nothing of going naked. Not until the late teens and early twenties, when bathing costumes were made available at a reasonable price and on a grand scale by mass manufacturers, would swimming fashions begin to percolate to the vast public.

One of the great contributions of these floating houses was that they provided instructors paid by the local boards of education to teach the rudiments of swimming to all who applied. Swimming began to be promoted as "a national exercise." Formal instruction in the sport popularized the activity among young men and, gradually, among women of "progressive" views.

To help Americans get in the swim of things, popular magazines regularly ran features on beach activities. Ranging from step-by-step instructions on basic swimming strokes and surf-bathing to descriptions of fanciful aquatic machines, many of these stories took an uncommonly serious slant on the subject. Fun, it appeared was not sufficient justification for the American Victorian, who required a hefty dose of morality and enlightenment in all leisure activities.

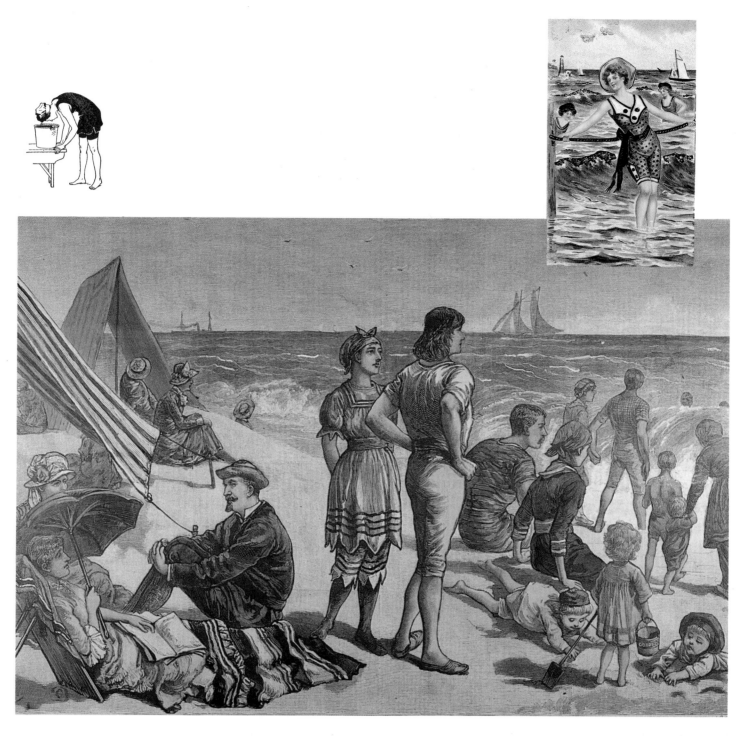

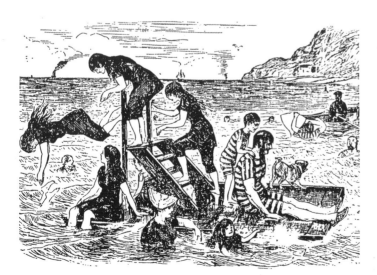

▶ *The Ladies' Home Journal,
Collier's* and *Outing* pub-
lished elaborate articles
geared toward teaching
women how to swim and
featured illustrations of
female swimmers in the
new, more hydrodynamic
costume.

Even members of the clergy joined in the chorus of voices singing the praises of the sea. "Oh the glee of sea-bathing!" gushed the good Reverend T. DeWitt Talmage in the *Ladies Home Journal* of August 1891. "It is a tonic for those who need strength, and an anodyne for those who require soothing, and a febrifuge for those who want their blood cooled; a filling up for minds pumped dry, a beviary for the superstitious with endless matins and vespers, and to the Christian an apocalyptic vision where the morning sun gilds the waters, and there is spread before him 'a sea of glass mingled with fire.'"

Medical authorities went so far as to promote bathing as a living lesson in the evolution of species. Dr. Woods Hutchinson, a well-known promoter of aquatic sports, painted bathing as "a return to primitive ancestral conditions, the halcyon days of the sea-squirt and the amphioxus, and sets the nerves vibrating as almost no other influence can." The same observer discriminated between bathers of superior and inferior constitution, implying that short dips in the surf were a sure admission of evolutionary inferiority.

The popular press also lured its readers to the beach in articles saturated with pseudoscientific diagrams, technical drawings, and an elevated lexicon. Reassuring their readers with inspirational sketches of waterborne males or dramatic photographs of diaphanously clad sirens, journals urged that any "reasonably normal individual between the ages of infancy and senility can be taught to swim."

In the event that nature failed to endow Victorians with the talent or temerity to breast the waves, there were artificial aids aplenty to help them. Mechanical contrivances of all sorts materialized as additions to the already cumbersome bathing costume. There was no end of cunning inventors who applied themselves to the challenge of propulsion devices. Among the most popular were so-called swimming plates—large, generally flat surfaces made of wood, tin, leather, or waterproof fabrics—that were attached to the swimmer's limbs. Properly manipulated, they would propel a body through water at amazing speeds, or so their inventors claimed. As bathers of all sizes and shapes tumbled in the surf, the hierarchical world of Victorian society went topsy-turvy. It seemed that the ocean's water was capable of breaking down innumerable barriers. "Hundreds of bathers, clad in garments of every shape and color were gaily disporting before me," wrote a correspondent to the *New York Herald* in 1853. "The blooming girl, the matronized yet blushing maiden, the dignified mamma, were all playing, dancing, romping, and shouting together, as if they were alive with one feeling."

Seaside life was a burlesque for the masses where everyone was welcome and the price of admission was the cost of a bathing costume. For Americans, the resort and the public beach were very much about status, social climbing, and health. And about vanity and fashion. But, beneath it all, they were also about sex and sensuality. Paintings of the period, in which late-Victorian bathing beauties bared milky limbs and pneumatic bosoms, interpreted the beach as one vast erotic theatre. Humorous trade cards in the 1880s depicted "day-trippers" cavorting in the carnival atmosphere of the strand while decorous couples strolled by bath houses and bathing machines, seemingly oblivious of the titillating spectacles within.

Americans flocked to the beach not only to ogle and relax but to revel in an unprecedented liberalization of morals. There was something magical about the bathing dress that dissolved constraint and melted reserve. "The haughty dowager, the exquisite maid, the formal-minded matron, the pompous buck, the pretty dandy," wrote an enchanted wanderer during the 1890s, "donned with their unconstricting garb of bath-flannels, a devil-may-care disregard for the modes and conventions of fashion…."

By the end of the century, Americans were flinging themselves into the sea with an abandon that was deliciously at odds with their restrained costumes and strict rules of conduct. Furnished with a voluminous cape, the Victorian lady's three-piece outfit was intended to conceal her body from prying eyes. And yet there were young women—even from the very best families—whose standards of modesty seemed to be loosened under the impact of the pounding surf. American artist Winslow Homer recorded a group of these wanton creatures rollicking at Bailey's Beach, a private section of an exclusive Newport resort. In his painting "Mixed Bathing," several ladies submerged to their waists were shown clinging to their male companions or splashing in the waves *without* hats, gloves, or even wrist-length sleeves! If only in the rarified enclaves of the rich and famous, the first minute steps were being taken to flaunt convention. Increasingly bare and brazen, American skin was beginning to be exposed to the public gaze.

Poles, slings, and "chump's rafts" were endearing contrivances designed to help swimmers. The latter consisted of four smooth planks nailed together in the form of a square, with the end of each plank projecting a foot or more beyond the lines of the square in which the novice swimmer was suspended.

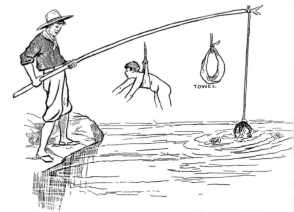

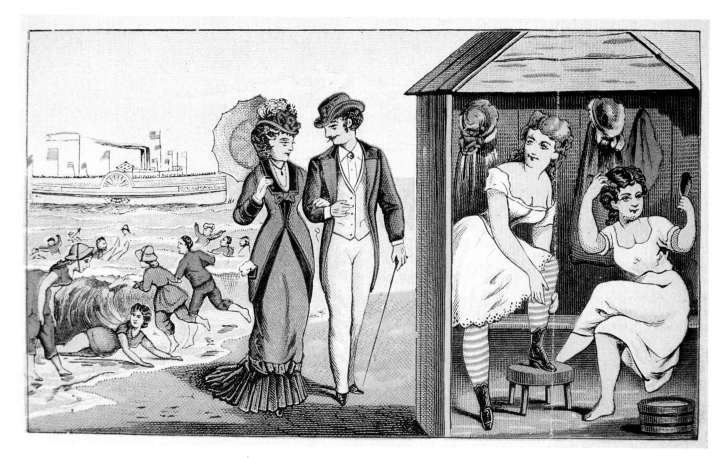

A humorous trade card from the Gay Nineties depicts "day-trippers" cavorting in the carnival atmosphere of the strand while a decorous couple strolls by a bathhouse, oblivious to the titillating spectacle within. The comely bather on the right is actually printed on the reverse side of a hinged door which swings shut to conceal her buxom companion. This "peek-a-boo" motif was characteristic of the last decade of the nineteenth century, when stylistic experimentation, echoing the psychological theories of Sigmund Freud, tended to probe beneath the prim surface of societal life to expose the turbid wellsprings of human action and desire.

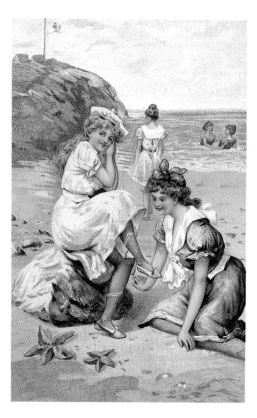

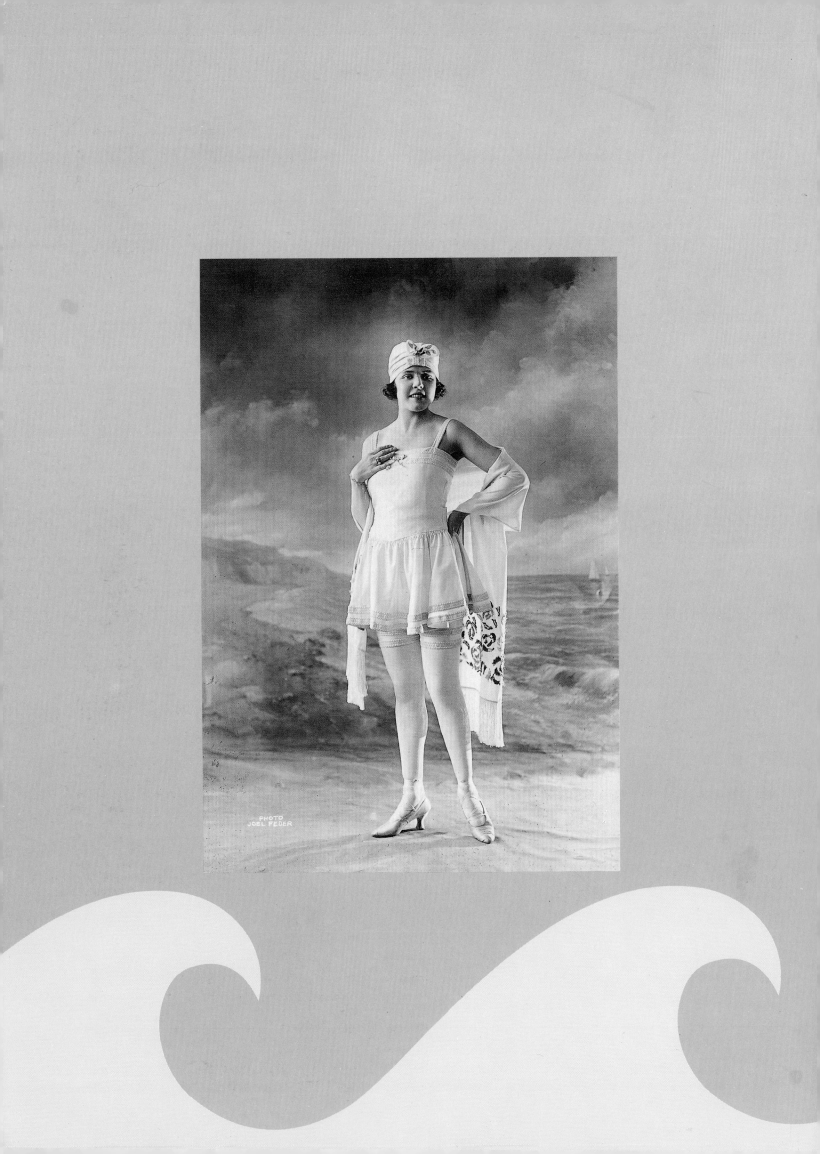

PHOTO
JOEL FEDER

2

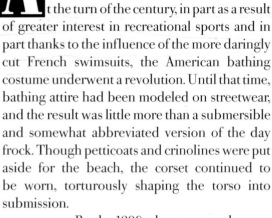

At the turn of the century, in part as a result of greater interest in recreational sports and in part thanks to the influence of the more daringly cut French swimsuits, the American bathing costume underwent a revolution. Until that time, bathing attire had been modeled on streetwear, and the result was little more than a submersible and somewhat abbreviated version of the day frock. Though petticoats and crinolines were put aside for the beach, the corset continued to be worn, torturously shaping the torso into submission.

By the 1890s, however, underwear began a relentless if slow migration outward that would come to a full, triumphal exposure in the bikini of the 1960s. Beachwear for men had traditionally kept close to the clinging profile of skivvies. But, for women, the earliest exteriorization of underclothes was inspired by a breakthrough in undergarments that led to the development of the "princess style" bathing dress. Combining the chemise and drawers into a single garment, the princess style featured a long overskirt that buttoned to the waist for modest coverage on land and was then removed for swimming.

Although a wide range of fabrics was found appropriate for the beach—everything from serge and flannel to alpaca, mohair, and silk—the color palette ran strictly to somber shades of black, navy, maroon, gray, or olive. The typical three-piece costume, scaled for "a lady of medium size," required up to eight yards of thirty-six-inch-wide fabric. Add to this an equal amount of cambric and cotton for lining, and keeping afloat became problematical indeed. Perhaps due to the handicaps presented by bathing fashions of the day—which encumbered their wearer with twenty-two pounds of sodden clothing—women were perceived as something less than seaworthy.

A subtle variation in sleeve lengths and hemlines marked an important shift in thinking about the relationship between costume and body. As long as the corset-shaped body was the norm, the entire issue of anatomic "haves" and the "have-nots" never fully surfaced. The corset, in essence, had kept the issue of whether the body was an asset or a liability under wraps.

The predecessor to the dirt bike, the autoped was introduced at beaches along the Atlantic Coast in the late teens. Demonstrating its stability was actress Miss Lillian Lorraine, here shown speeding from her dressing room for her morning dip at Long Beach.

◀ As demonstrated by Rena Parker, star of "Flo-Flo" at New York's Cort Theatre, the smart beach costume of the late teens was designed for parading rather than paddling. Of white washable satin and embroidered silk trim, the two-piece suit integrates skintight bloomers into the overall design. Teamed with the beribboned cap, the white-and-red fringed scarf adds a rakish note.

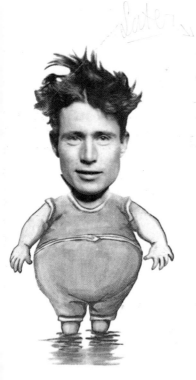

The prototypes of the "modern" swim trunks left much to be desired. They were extremely heavy when wet—the first Jantzen suits weighed nine pounds when fully soaked—and had a tendency to fall down.

When, at the turn of the century, bathing attire dispensed with the corset and retreated from the global coverage of streetwear, the erotic appeal of the human form was cast in a radically new light. In fact, so revolutionary were the ramifications of redesigning this single item of apparel, that the first three decades of the twentieth century would negotiate each shifting inch of fabric to the tumultuous cacophony of public debates, controversies, and conflicts. At stake was not merely the disputable matter of taste. Rather, changes in the bathing suit would lead to a sweeping reassessment of the ways in which costume was capable of eroticizing or de-eroticizing parts of the human anatomy that had never before been considered fair game for public viewing.

Because uncorseted seaside fashions were so constructed that they no longer equalized or camouflaged the contours of the human shape, the task of eroticizing the body, albeit in gradual increments, was taken over by flesh itself. By permitting ever greater exposure of skin, the evolving bathing costume of the early twentieth century inadvertently benefited one segment of the population, while simultaneously penalizing the overwhelming majority. Those with the "right" bodies strutted their allure, while those who deviated from the ideal became victims of the bathing costume's merciless exposure. The shrinking bathing suit, more than any garment which preceded it, thus polarized the sea-going population into two camps: the beauties and the beasts.

Long before the bathing costume underwent its reductive surgery, women had begun to murmur against the restrictive costume for practical reasons. Their complaints were eventually taken up in the pages of popular magazines. For a surprisingly long time, public opinion had claimed woman's hydrophobia to be an innate characteristic. "Most women are afraid of the water and it is this fear that makes it difficult for them to learn to swim." Slowly, however, this view would give way to the notion that female timidity was a learned response to the death-trap that went by the name of the Victorian bathing costume.

As early as 1888, *Outing* magazine proposed that "one of the chief reasons why males learn to swim easier than females is that they wear fewer and closer-fitting garments in the water—when they wear any. A woman's clothing interferes much with the free play of muscles, and when wet, constitutes a drag as the body is forced through the water. Too much importance, therefore, cannot be put upon the choice of a bathing suit." Fashion, unfortunately, was slow in changing. Eight years later, the publication was still dwelling on the same point: "Our women must go to considerable trouble before they are ready for a dip, and to yet more trouble before they are again presentable after the bath. These facts are quite sufficient to keep many from the water, and in addition they have costumes to wear which effectually prevent the popularizing of the best possibilities of swimming."

If the old costume was recognized as an impediment to sport, the new, pared-down bathing suit ironically threw up a major obstacle to its own adoption. Stripped down and freed of corsetry, the new suit required something few women of the period boasted: confidence in the stylishness of their figure. Because the new swimsuits relied on the body for shape and ornamentation, a "fashionable" body was needed, toned and contoured by the exercise of swimming.

For many luxuriantly proportioned Victorian matrons, the emergence of a stripped-down suit was an event bordering on catastrophe, and for many of these Junoesque women, the experience of wearing the one-piece suit was a humiliating ordeal.

"In an abrupt resolve to do the thing right," wrote Florence M. Peto, a middle-aged wife trying to rekindle her husband's interest, "I had donned a one-piece suit. I am not a large woman, not fat; that is, not as fat as many others whom I could name, but a one-piece suit stretched over a one hundred and eighty-five fairish pounds, feels as conspicuous as a red lantern. I know."

With the introduction of the new bathing costume, claims for the benefits of swimming began to shift radically in tone. Writers abandoned their once obsessive preoccupation with swimming as a social recreation or spiritual rejuvenator and increasingly stressed the usefulness of the sport in directly reshaping the human form. In an article revealingly entitled "Swimming, The Ideal Exercise," L. de B. Handley argued that, "in the long run swimming tends toward physical perfection. In the over-stout, it acts as reducer, eliminating by degrees the excess of fatty tissue; in the unduly thin, it adds bulk and muscle…. It is, in fact, a great normalizer, leading insensibly to the ideal standard of manhood and womanhood. One has but to attend a water carnival for either sex and glance over the competitors to realize what enviable results are obtained by indulgence in swimming. The graceful, symmetrical bodies, with long, clean, well-rounded muscles, speak loudly in every line of health, strength, and efficiency."

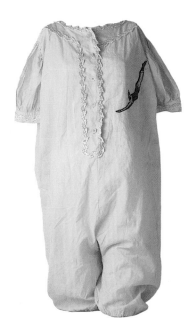

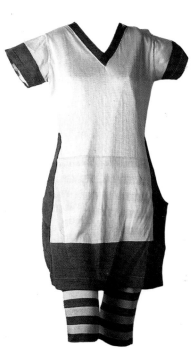

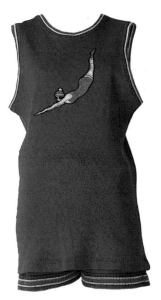

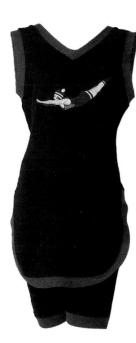

Equipped with an unbreakable rubber button, the first Jantzen swimsuits boasted a number of other features that "guaranteed perfect fit regardless of body type." First, the fabric was knitted using the Jantzen "rib stitch." "No need to waste your energy dragging a wrinkled suit through the water," the company's advertising brochures announced. "You can slip through the waves as smoothly in a Jantzen as in your own skin." The rubberlike material retained its shape wet or dry, and, unlike earlier knits, did not have a tendency to soak up vast quantities of water.

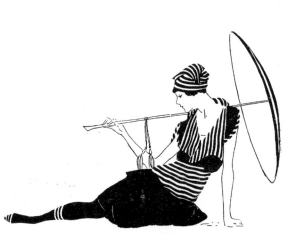

By 1910, the earnest female athlete could finally look forward to the functional swimsuit. And appropriately, it was a woman who started the whole modern trend of trimming excess yardage. She was Annette Kellerman, an Australian polio victim who had taken up swimming to strengthen her legs and ended up as a world-renowned champion swimmer. Famed for her spectacular form—both in and out of the water—and as a star of swimming meets, vaudeville, and motion pictures, Kellerman was the first to prove that, when it came to practicality, less was decidedly more. In 1907, this striking brunette offered the first practical alternative to aquatic nudity in the form of an improvised, tight-fitting black wool one-piece that nearly overnight made her name a household word.

"I want to swim," Kellerman announced to a disbelieving public. "And I can't swim wearing more stuff than you hang on a clothesline." The original Kellerman suit did away with skirts and sleeves but kept the trousers, though cut off two inches above the knees. When she appeared in Boston's Revere Beach dressed only in this body stocking, Miss Kellerman was arrested for indecent exposure and was denounced as a wanton. Dark prophecies were made as to the future of America. However, when only two years later Adeline Trapp, the first woman to swim the East River, emerged from the waves in similar attire, she was unmolested by the law.

When a practical swimming suit finally became available, the history of the bathing costume took two divergent tracks. On one side stood the ornate bathing dress, and on the other, the wool knit swimsuit. One—decorous, ornamented, and impractical—was squarely within the camp of fashion, keeping pace with developments in outerwear and reflecting changing notions of the ideal female form. The other—immodest, stripped down, and practical—stood cleanly outside the territory of style. It was a piece of athletic equipment and thus uniquely chaste. As long as the wearer exercised discretion and remembered that each suit had its place, there were no problems. Suits which were clearly meant for sports were one thing. They might have demystified the mechanics of the female anatomy, but naughty they were not. The aura of sport spared them that connotation.

It so happened that fashion in the Western world changed at just about the time Kellerman introduced her suit. A minor revolution was in progress in cultural visions of the ideal female form. Sometime around 1912, corsets and stays disappeared, to be replaced by the human body as the sole basis and shaper of form.

Suddenly, fashion magazines were filled with drawings of lithe, columnar elegantes in dresses that bared graceful arms and exposed delicately stockinged legs at the knee. The tunic and peg-top line current in other modes made their appearance on the shore, though in greatly shortened form. One popular model in moire silk featured a short-sleeved, V-necked blouse with a skirt that was gracefully draped in peg-top or pannier effect at either side. Another favorite for women and children was the Russian blouse. A high-necked, long-sleeved tunic that buttoned along one side, the Russian blouse had a jaunty air and, even more important, was becoming to the uncorseted figure. Overwhelmingly, the tendency ran toward dressy styles that involved artful draping, delicate smocking, contrasting embroidery, and inventive trimming.

The "Annette Kellerman" suit became a favorite among women with a serious interest in swimming. The woolen suit was named for its originator, the Australian-born swimmer and vaudeville actress who, in her passion for unfettered swimming, had adopted the one-piece suit designed for boys. When presented to His Royal Highness King Edward VII as the world's first aquatic glamour girl, Kellerman sewed black tights to her suit in order to spare the royal eyes the scandal of bare legs.

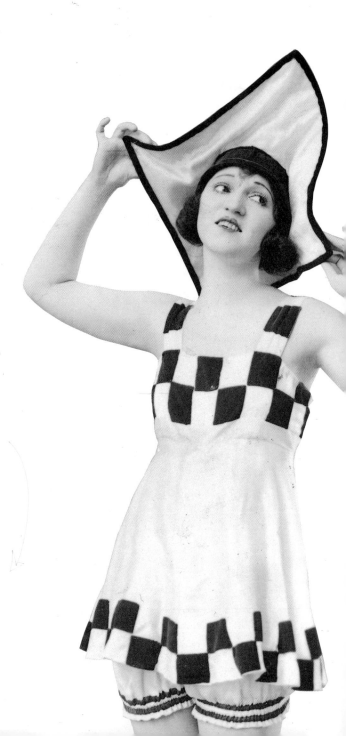

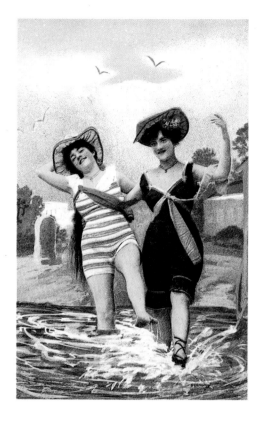

By the end of the First World War, bathing suits were decidedly keeping pace with fashion. As modelled by Bothwell Browne's Bathing Beauties, women's swimwear was rigged out with all the sashes, embroidery, and flamboyant color of more formal feminine attire. Mannered hats, trimmed to match the short-skirted costumes, were de rigueur, as were silk stockings and delicate lace-up slippers.

It was not long before Hollywood and the real estate industry discovered the endlessly remunerative possibilities of dressing young women in formfitting swimming suits. As if made to order, a new breed of female champion swimmers emerged, dripping from training sessions at pools such as the Women's Swimming Association (WSA). The WSA developed the aquatic talents of young secretaries and career women, among them the astonishing Gertrude Ederle, the first woman to swim the English Channel. While Ederle was not distinguished for her sireny looks, an impressive number of her colleagues went on to capture the public eye and imagination with their lovely forms. Helen Wainwright and Josephine McKim, the inimitable Eleanor Holm, and the voluptuous Esther Williams were only some of the great bathing beauties who lent credence to the claim that swimming shaped beautiful bodies.

Rigged out in luxurious versions of the newer, stripped-down bathing costume, these swimming stars were often seen on the front pages of newspapers and on the main stage of Madison Square Garden, where, on "Bathing Suit Day," held May 26, 1916, men turned out in unprecedented numbers to view the latest parade of fashion for the beach. Not the least of the attractions was the zebra-striped costume exhibited, to slow music, by its creator, Kathleen Grace from Alabama. "Well," a man from Ohio was reported as saying, "it may be her own creation, but I know she didn't have to work overtime to create it. A spider could create as much in about three minutes."

The same censors who drew the line at publishing photographs of burlesque queens did not bat an eyelash at pictures of equally undressed swimmers. Such was the redeeming innocence of sports. According to sportswriter Paul "Uncle" Gallico, an "appreciable part of the great Florida real estate boom was built upon photographs of girl swimmers used in advertising." In just about every popular magazine of the day, a "Kill 'em dead" motif began to sound in editorial copy describing the new bathing suit. Stories stressed the fatal allure of the new mode. "There is no doubt what the wild waves will say when they see maid or matron in this bathing suit...," ran the caption to a blue satin suit with giant white polka dots, featuring a long, loose torso, surplice collar, and separate bloomers cut straight across the knee.

The July 1917 *Delineator* accompanied a sketch of a fetching, short-skirted suit modeled on the sailor costume with a timely reference to contemporary military operations. "Let submarines beware when a young thing comes down the beach in a new blue-and-white bathing-suit." A year later, the same magazine depicted a daring brilliantine-collared white suit. "To the dangers from U-boats and sea-serpents is added the greater peril from the mermaids of our own shores," ran the description, continuing the military motif by noting that the "sleevelet is an armament that will appeal to even the pacifist."

As it happened, however, when the "fashion" suit appeared on public beaches, it provoked, more often than not, decidedly *un*-pacifist responses. Surveying the contemporary beach scene, many observers were horrified by the spectacle of what they then considered half-nude men and women fraternizing in ways far too reminiscent of erotic play. As one eloquent opponent put it, "It's time we do something about young men in skin-tight, sleeveless, and neckless bathing garments, about a yard in length, and bare-armed girls with skirts and bloomers above the knee, lolling together in a sort of abandon."

Opposition to the new bathing suit reached a feverish pitch in 1913, when a woman wearing a short bathing suit at Atlantic City was assaulted by an outraged crowd. In fact, between 1910 and 1920, newspapers were peppered with accounts of respectable men and women running afoul of the law for doing nothing more reprehensible than donning what they considered to be sensible attire for swimming. Their crime, in most cases, consisted of subtracting the skirt—a requisite component of male and female costume—in the interest of securing freedom of movement and safety.

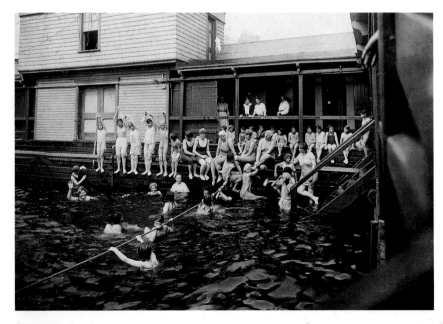

Large cities began to provide "swimming baths" such as this one in New York City, which made recreational bathing accessible even to those who could not afford the time or the money to travel to seaside resorts.

By the early 1920s, a plethora of luxurious summer resorts had sprouted all along the East Coast, from Mount Desert, Maine, to St. Augustine, Florida. As the clinging new suits covered less and less of the bather, the old reservations about the healthful effects of saltwater immersion dramatically dropped away.

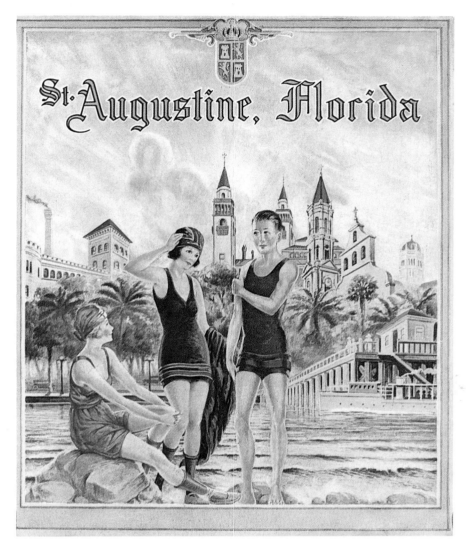

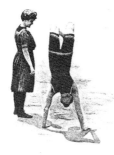

On occasion, the law's sensitivity could go to positively Kafkaesque extremes. Such was the case of a woman detained at Coney Island during the summer of 1919 for the heinous offense of wearing a bathing suit in public *under* street clothing. Her culpability was discovered by a vigilant policeman who detected the bathing suit. Fortunately for the history of personal liberties, the attending magistrate ruled that "the right of the citizen to self-determination in undergarments should be inviolate, so long as outer garments meet the demands of propriety; that wearing a bathing suit is a crime only in some circumstances; and that the police are not entitled to go about disrobing citizens to find out if they are wearing anything offensive to the official moral sense."

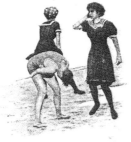

The campaign for modesty in swimwear was answered by an equally strident position calling for the liberalization of beach attire. In 1918, before the National Association of Drugless Physicians, Colonel Shingshah Ghadiall, founder of New York City's Aerial Police Squadron, voiced a strong protest against Atlantic City's beach law mandating all women in bathing raiment to wear stockings. "Why should beautiful women…be compelled by an unmoral, un-American and inhuman law to cover their limbs?" the Colonel declared in the midst of a discussion about "unexplained anatomy and the centers of psychic force in man." According to the *New York Times* piece covering Ghadiall's diatribe, the Colonel then added, with prophetic insight: "What is the difference I ask you between a woman's foot and a man's foot? If Atlantic City would be truly moral it would tell women to discard their clothing or don trousers. I hold she has that right no less than a man."

A full-page spread in *Ladies Home Journal* brought the horror of the new licentiousness of the beach before its readers in August 1913. "How Much of This Do You Want Your Daughter to Share?" shrieked the title of the editorial, surrounded by a collage of photographs meant to chill the blood of every mother. "The pictures on this page," the editorial explained, "are from photographs taken at the 'bathing hour,' on various public beaches that dot the Atlantic Coast from Cape May to Cape Ann. They accurately indicate the free-and-easy familiarity that is continuous on these midsummer playgrounds from the opening of the season to its close."

Young men in knit suits stood on their hands before admiring female adolescents. In a photograph at the top of the page, a solitary miss demonstrated rowing techniques to a band of half-naked youths. Another girl leapfrogged across the back of her male companion while her girlfriend looked on in mute dismay. One jovial group was caught in the act of burying one of its members in the sand, while the bottom of the page depicted two couples in languorous repose on the sand.

"Are these situations such as you would wish your daughter to have a share in," the editorial sternly inquired, "such as you would even care to have your daughter *see*? Where do you think such easy familiarity between the sexes leads? *Nowhere*, do you say? Would you be willing for your daughter to take the chance of such familiarity, leading—nowhere? Yet that is precisely the chance thousands of American parents do take when they permit their daughters' unrestricted indulgence in the 'attractions of our public bathing beaches.'"

Chaos was clearly threatening to erupt on the home front. While Europe was going up in flames and mustard gas, America seemed to be rushing toward rack and ruin on the backs of scantily clad bathers. Fashion was ripping apart the fabric of society. Something had to be done. While owners of private resorts and country clubs rushed to post dress codes, terrified civic leaders and moral arbitrators convened to draw up sumptuary rules and ordinances.

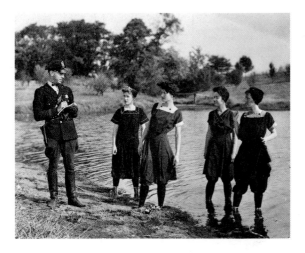

Sporting fashionable square-necked bathing dresses that display jaunty bloomers, Knox College students recreate a typical confrontation between "scantily" clad bathers and the law for the late-1930s Paramount film "At Good Old Siwash."

In May 1917, the American Association of Park Superintendents published its "Bathing Suit Regulations" in *The American City*. All-white or flesh-colored suits were discouraged on the grounds that they revealed too many details of the human anatomy when wet. Suits that exposed the chest lower than a line drawn on a level with the armpits were banned. For ladies, the rules stipulated that, "blouse and bloomer suits may be worn with or without stockings, provided the blouse has quarter-arm sleeves or close-fitting arm-holes, and provided bloomers are full and not shorter than four inches above the knee. Jersey knit suits may be worn with or without stockings, provided the suit has a skirt or skirt effect, with quarter-arm sleeves or close-fitting arm holes and trunks not shorter than four inches above the knee, and the bottom of the skirt must not be shorter than two inches above the bottom of trunks."

Similarly regulated, men's swimsuits had to be provided with a skirt or have a skirt effect. Alternatively, a shirt had to be worn outside of the trunks, except when flannel knee pants with belt and fly front were used. Trunks could not be shorter than four inches above the knee, and the skirt or shirt could not be shorter than two inches above the bottom of the trunks.

For all the attempts at "objective" criteria, regulations such as these left vast gray zones of interpretation that, in the decades to come, would release armies of policewomen, guards, and self-proclaimed modesty brigades onto the country's beaches. Armed with regulations, rulers, and handcuffs, these protectors of American Victorianism would wage a futile battle against the coming tides of fashion.

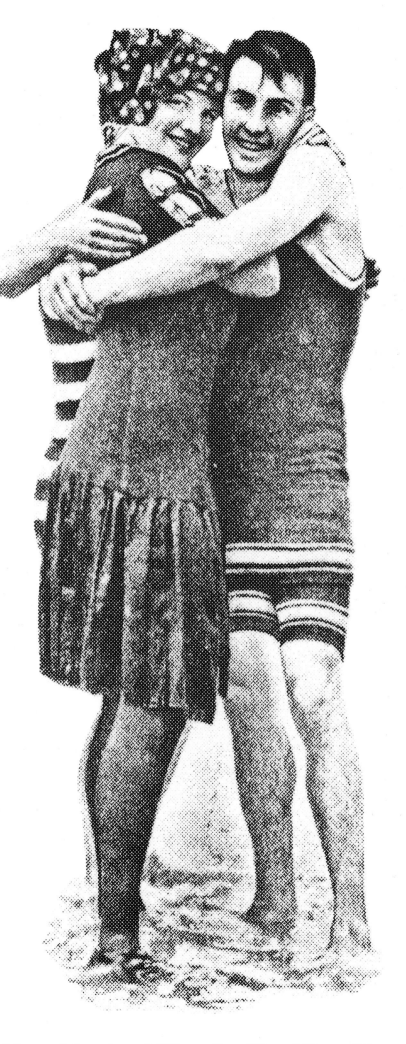

How Much of This Do You Want Your Daughter to Share?

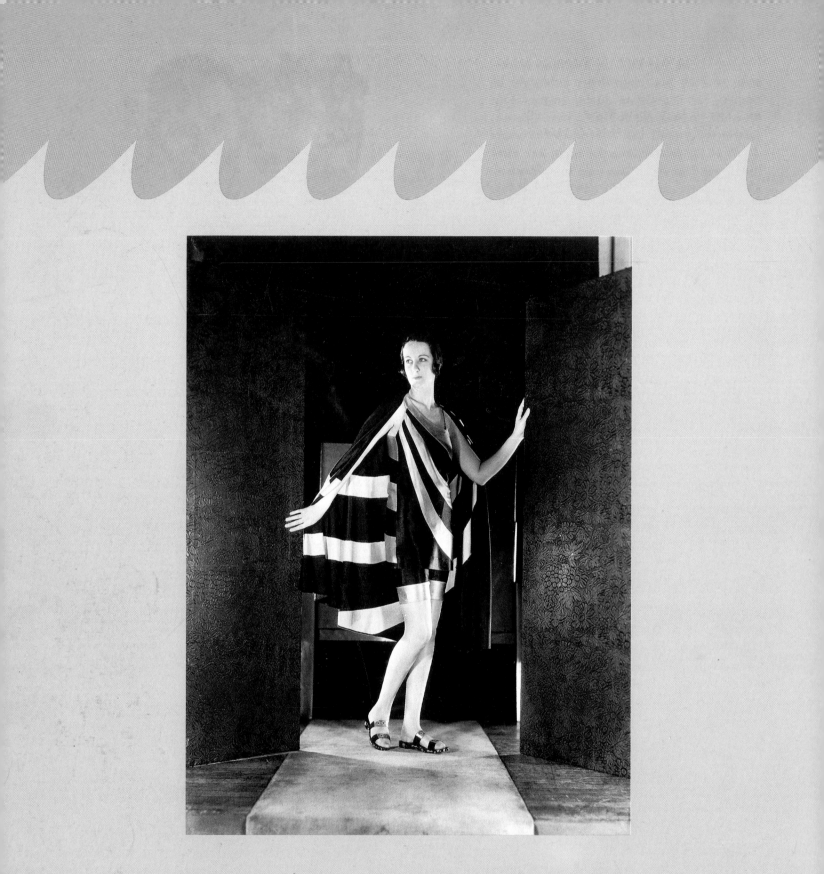

3

The 1920s were restless, lawless years. Exciting, controversial changes were taking place in every part of society. Prohibition, an increasingly prosperous economy, and, of course, the automobile fueled the fires of adventure and experimentation. Hard on the heels of World War I and women's suffrage, a new ideal of womanhood also emerged. Precipitous curves and valleys, time-hallowed signatures of femininity, fell out of favor, and the androgynous, tubular body was suddenly in vogue. Women of all ages bobbed, then shingled their hair, the bust was flattened, and, as corsets were cast upon the rubbish heap of history, waists disappeared. It was as though fashion had overthrown the classical female form, replacing it with a sinewy, prepubescent version of the male body.

In cut and fabric, male and female swimsuits were remarkably alike. While fashion magazines such as the *Delineator* continued to feature dresses in surf satin, brilliantine, or taffeta, the most sought-after style of the day was the slimline maillot. *Vogue* pronounced that "the newest thing for the sea is a jersey bathing suit as near a maillot as the unwritten law will permit." In the early twenties, the maillot was a two-piece swimsuit that consisted of a vest-shaped top extending to the upper thigh and shorts that steadily crept higher as the decade wore on. The garment bared a number of controversial territories including the upper arm, upper thigh, armpit, and back, but for all its liberalism, it still clung to Victorian standards of decency in one sensitive area: the groin. For most of the decade, suits for both men and women resisted streamlining this zone, providing a skirt in the form of the longish tunic top.

The swelling tide of permissiveness associated with the maillot made ragged progress against the obstacles of tradition, class snobbery, and moral rectitude. Newspapers were riddled with accounts of pitched battles fought between proponents of the new two-piece suit and its opponents who watched, horror-struck, as the beach was transformed into what they saw as the new Sodom by the sea, and who bristled with even greater disgust as the brevity of beach fashions infected streetwear. By mid-decade,

skirts had climbed to the unprecedented height of the knee. To sumptuary laws governing beach attire were added bills providing fines and imprisonment for short skirts. Never before had fashion generated such scandal.

The major point of dispute was the manner in which the human body should be clothed on the beach. While there was increasing consensus on the absurdity of suits that hampered movement in the water, there was little unanimity on what constituted skimpiness. "There is no set rule as to what kind of suit one should wear," wrote etiquette expert Lillian Eichler in 1922, "for one person can wear a thing that makes another ridiculous if not actually vulgar."

To make matters worse, legal authorities often lacked a consistent vision when it came to right and wrong. After participating in a women's lifesaving demonstration, the mayor of Boston came out squarely on the side of the new one-piece "California style" suit, in which the top and skirt of the two-piece maillot had been assembled into a single piece of fabric. "I don't see how they can swim at all in those clumsy suits," Mayor Peters was heard to remark, as he watched girls at the City Point beach struggling in the waves, wearing the three-piece costume of their Victorian mothers.

In Chicago's suburbs, controversy centered on male beachwear. The Board of Alderman in Zion City, Illinois was split over a new ruling that required the trunks of men's bathing suits to extend below the knees and a skirt to be worn over the thighs. "It's a comforting style for citizens with knobby knees and lean shanks," the *New York Times* editorialized in August 1921, "but for swimming, the Zion suit is little better than armor."

Directors of parks, playgrounds, and beaches in Cleveland, Chicago, and Miami posted detailed dimensions of permissible exposure that included the limits of sleeve coverage (one-quarter sleeves or close-fitting armholes) and the color of swimwear (white and flesh-colored suits were forbidden).

But even as authorities deployed measuring tapes and dispatched paddy wagons to public beaches, a newly emerging swimwear industry worked fast and furiously during the early part of the decade to render governmental standards of decency obsolete. When it came to diminishing coverage, the law might have been on the side of tradition, but history clearly supported fashion. Corporate influence over the swimsuit and beach culture was just beginning. As the decade wore on, the standards of public dress would be orchestrated less by governmental bodies and more by market-driven entrepreneurs seeking to capitalize on—and satisfy—vast hordes of American beachgoers.

Sleek, snappy, and streamlined, the tubular suit had that irresistible aura of utopian dreams bred by the great machines of mechanical reproduction. But when decorated accordingly, swimsuits of this period transcended mere aquatic utility. As might be expected, the overall look of the finest one- and two-piece suits of the era borrowed much of its inspiration for the ideal female form from Art Deco's iconographic bestiary: from its deer, gazelles, antelopes, greyhounds, thrusting dancers, and lissome nudes.

If the Parisian salons of Sonia Delaunay, Jean Patou, Lanvin, or Schiaparelli whetted the popular appetite for glamorous beachwear, it was American knitting mills on the West Coast that would eventually deliver affordable fashions to millions of bathers. The bathing suits of Europe were exotic, interesting, and alarming, but they were rarely practical and few were within buying range of most people. America changed all that. Within the span of a decade, the design and fabrication of bathing garments were taken out of the designers' studios and centered in the knitting and sewing departments of mass-production factories.

Almost simultaneously, three apparel manufacturers from Oregon and California launched their swimwear lines. Each of these companies—the Portland Knitting Company of Portland, Oregon, and the Los Angeles-based Bentz Knitting Mills and West Coast Knitting Mills—had specialized in knitted underwear and sweaters. By the end of the decade, Jantzen, Catalina, and Cole—as they would eventually be known—would develop into the "Ford, Chrysler and General Motors of the swimwear trade." By drastically cutting prices, they succeeded in popularizing fashion for the beach and, coincidentally, in dictating standards for taste and decency.

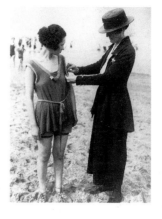

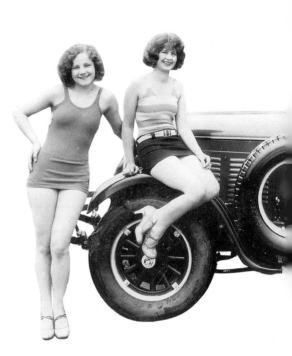

Foxtone used Jantzen suited models to hype its products.

Flaunting cigarettes and shockingly skinny suits, 1920s beach bunnies celebrate youth, sex appeal, and modernity.

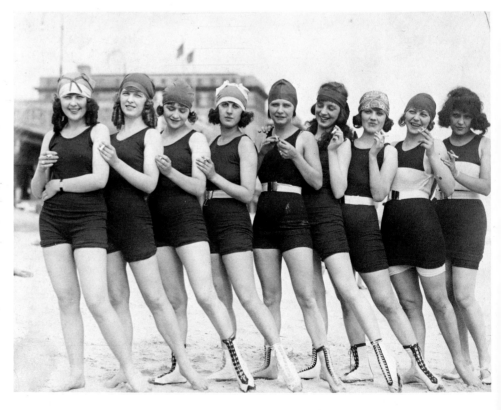

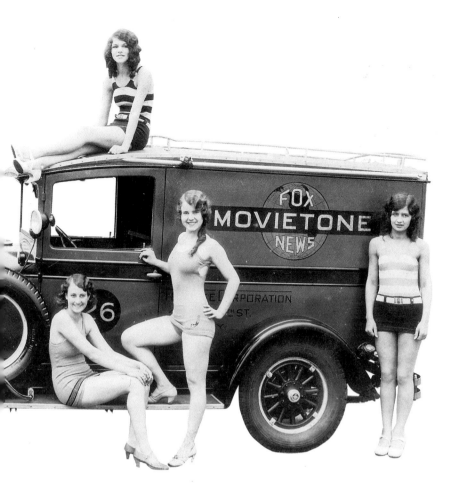

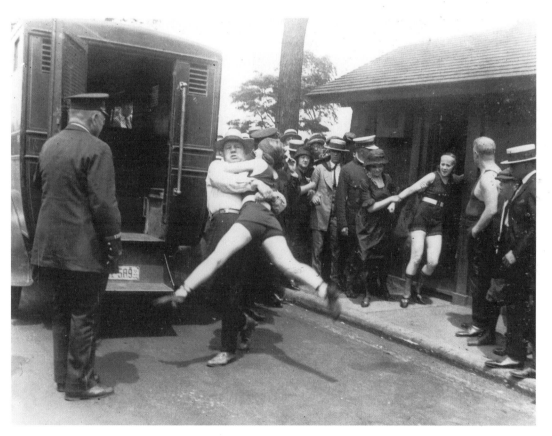

Throughout the twenties, newspapers were filled with accounts of pitched battles between the proponents of the new one-piece suits and the guardians of public morality. Here two bathers are arrested for defying a Chicago edict banning scanty beachwear in 1922.

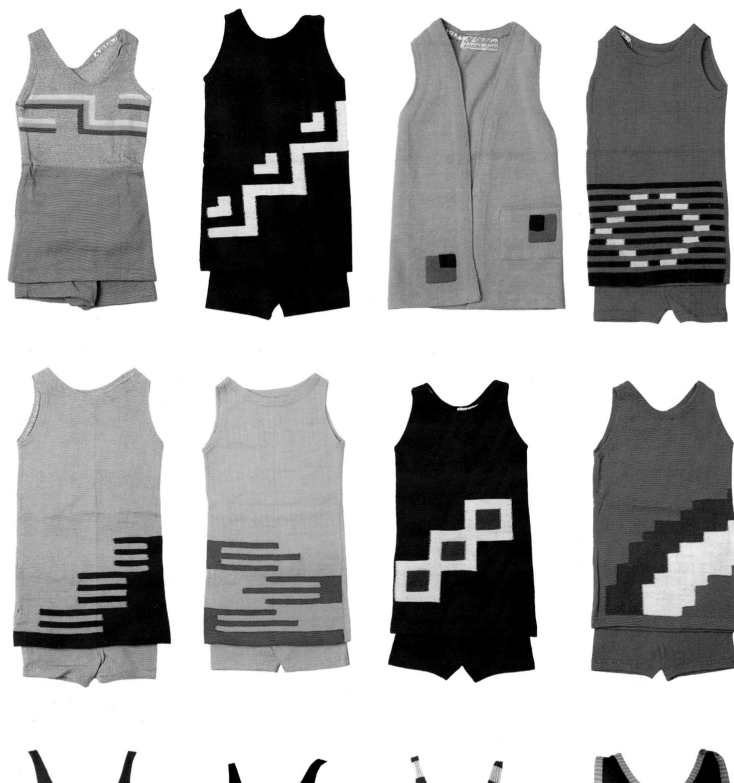

American swimwear was influenced by French swim suits. These scaled-down salesmen's models demonstrated how the sophisticated design sensibilities of Art Deco could transform a garment that was, in essence, an overscaled body sock into a revered work of haute couture. Appliqued with the vivid patterns of Aztec-Deco or with a bijouterie of diamonds, dots, and zigzags, the tubular suit came to represent the dizzying horizons of European fashion and propelled its wearers into the future.

◄ Made of wool knits, the tubular maillot clung to the body like a second skin. Though unforgiving of anatomical imperfections, this new style gained enormous popularity. In the process, it generated heated battles between, on the one hand, religious groups, civic authorities, and self-appointed spokesmen for virtue, and, on the other, fashion faddists, swimming buffs, civil libertarians, and exhibitionists.

The spark plug that set the machinery of America's swimwear revolution in motion actually came from an Oregon rowing enthusiast seeking a pair of trunks that would stay up without a confining drawstring. "Make me a pair of rowing trunks knitted in a rib stitch like the cuffs of a sweater," the man suggested to Carl Jantzen one afternoon. Jantzen and his partners John and Roy Zehntbauer, owners of what was then a floundering venture, obliged him as well as dozens of other rowing club members who eventually came to covet the remarkable "special order" garment. Some weeks later, the same rower returned and asked for a bathing suit made from the same stitch. "Too heavy to wear," replied Jantzen. But being passionate swimmers, the partners could not pass up the challenge. They acted on the sportsman's request and worked out a primitive prototype of the ground-breaking "elastic stitch" suit that quickly became—and would remain—the cornerstone of the Jantzen empire for more than fifteen years.

The "elastic" or "rib" stitch used by Jantzen required two sets of mechanized knitting needles rather than one. Each set worked at right angles to the other, one set pulling the ribs out on one side of the fabric, and the other set pulling alternate ribs out on the other side. With ribs on both sides of the fabric instead of only one, as in the case of jersey, the rib stitch garment offered about twice the elasticity of jersey. It was, in short, the perfect stitch for a suit that would cling like a second skin. Shortly after manufacturing prototypes with the elastic stitch, the Jantzen trio invested in knitting machines custom-built to their specifications and began adding bathing suits to their inventory.

From its very inception, the Portland manufacturer had a flair for hyperbole. In 1921, the company unleashed what, according to its in-house publication, *Jantzen Yarns*, was "the suit that changed bathing to swimming." It was a clinging, one-piece, abbreviated "combination" suit that gave with every motion of the body. Manufactured in both men's and women's styles, the suit featured a scoop-necked, sleeveless tunic top joined at the waist to trunks, and was decorated in bold horizontal stripes at chest, hip, and thigh.

Jantzen also developed and patented a radically different method for assembling components of the suit, resulting in a snugger fit over the hips and groin. "Providing roominess without wrinkles, and imparting the suggestion of slenderness" was the "bow-trunk" pattern, which required that the trunks be cut on a curve and then sewn on a straight seam. A special "non-rip crotch piece"—a kite-shaped insert at the base of the trunks—was engineered to provide unhampered freedom for every swimming motion. The result was the so-called California style—a one-piece garment that gave the appearance of two.

For a brief interval between 1921 and 1925, the California style spurred municipalities to adopt restrictions against one-piece bathing costumes. Ironically, in the Jantzen version, the garment was almost aggressively wholesome, especially when teamed with the Jantzen swimming sock and pompon-topped swimming cap. With very minor variations in the cut, the suit was available in men's, women's, and children's models, so the entire family could look as if stamped from a single mold.

From the outset, Jantzen garments carried a solid connotation of the athletic, an attitude the company reinforced with the introduction of every new product. Coverage—or more accurately, a lack thereof—is where skin and capitalism met in one of the nation's most successful fashion business stories. Jantzen's growth rate between 1917 and 1930 was astronomical. In 1917, the company sold about 600 bathing suits; in 1919, the figure had reached 4,100. By 1930, Jantzen was the world's leading manufacturer of swimming suits. That year alone, the Portland plant sold 1,587,388 suits for a total of $4,753,203—a record in dollar value and in number of suits sold.

Jantzen's success was, in great part, due to its daring and innovative advertising department, which pulled out the stops on a number of occasions, pioneering promotional ploys and campaigns that broke new ground in the still untrodden terrain of swimsuit advertising. Jantzen realized early that in order to sell swimsuits, and continue to sell them, the American public would have to be convinced to embrace swimming as a major leisure activity.

To this end Jantzen inaugurated the coast-to-coast "Learn-to-Swim-Week" campaign. Complete with "graduation" certificates, competitions, and department store tie-ins, this high-powered advertising program expanded the market for Jantzen's products. Newspaper ads, posters, and store displays announced the dates of local "Learn to Swim" programs. Swimming clubs spread across the country, and plugs for the sport were offered by spokesmen drawn from the ranks of champion swimmers such as Duke Kahanamoku, Norman Ross, Lewis "Happy" Kuehn, and William "Buddy" Wallen.

While Jantzen representatives were out in the field recruiting swimmers and overseeing pool construction, artists and graphic designers labored in a Portland studio drawing up sketches for the corporate logo. In fact, when it came to brand recognition, this obscure knitting mill would produce a milestone in the history of American advertising. The winning formula was born in 1920 with the "Red Diving Girl." Gracefully diving with outstretched arms, the "Jantzen girl"—as she would eventually be known—was part icon, part pinup. Poised against a blue background in her spanking red suit-sock-and-beanie ensemble, this arched-back female was the consummate embodiment of intangible American ideals: youth, grace, sex appeal, and athletic prowess. When it came to a corporate logo, Jantzen had no peer. By 1928, its red-suited beauty would rank seventh in the list of best known pictorial trademarks in the United States.

Undergoing a number of costume changes through the years, the company's trademark was reproduced in dozens of artifacts, gadgets, and gizmos that were used to spread the Jantzen name. She blossomed like a gracious infestation, appearing on everything from automobile hoods and tire covers to tie clasps, ashtrays, store mannequins, packing boxes, and billboards. And, of course, she flashed from the haunches of millions of swimmers on beaches all over the world.

The Diving Girl exceeded the wildest dreams of even the most optimistic advertisers when she was manufactured as a decal for automobile windshields. The idea originated with an Oregon farm boy who cut out the image from dozens of 1922 catalogue covers and plastered his father's car with it. Getting wind of the gambit, a company executive gave the order to manufacture a preglued cutout for distribution to dealers. Eventually, Diving Girl stickers found their way onto the locomotive and Pullman cars of a special train inaugurating a Shriners' Convention in Washington, D.C. Word got around that Jantzen officers on board were passing out the stickers at stops on route. In Billings, Montana the train was mobbed by taxi drivers, and in Pittsburg streets leading to the station were blocked by motorists threatening to riot unless they were given the decal. By the time the train reached the nation's capital, it had garnered the sobriquet "The Diving Girl Special."

By 1928 the little red diver had become a fixture in the pantheon of American logos. More than three million decals had been distributed by that date, although in some states strenuous objections were raised against the "scarlet bathing ladies." In Rockford, Illinois the chief of police declared that, "Keeping an eye on the figure of the bather and the other on the road is an impossibility," and demanded fines for persistent offenders. But all this hullabaloo only served to make the "most widely traveled lady in America" a superb saleswoman.

The company's marketing staff understood the importance of packaging its swimsuit line as part of a comprehensive fashion scenario that stressed athletic freedom. To accomplish this, the firm enlisted the talents of some of America's preeminent artists, among them, Frank Clark, McClelland Barclay, Ruth Eastman, Coles Phillips, George Petty, and Alberto Vargas. Between 1920 and 1947, these illustrators promoted an evolving aesthetic of the human form in the pages of all the major magazines of the day, from *The Saturday Evening Post*, *Collier's*, *Cosmopolitan*, and *The New Yorker*, to *Vogue*, *Vanity Fair*, and *Harper's Bazaar*.

Creating "mood" settings for swimsuits, Jantzen's graphic designers worked in all prevailing styles of the day. Coles Phillips' 1921 rendering of a red-suited bather conveyed an air of statuesque sensuality that would soon give way to the more athletic image which became Jantzen's ideal for the modern woman. Frank Clark's illustrations came closer to this vision. Appearing on style catalogues, merchandising brochures, packing boxes, and ads, Clark's drawings furnished elegantly didactic tableaus for a generation of bathers.

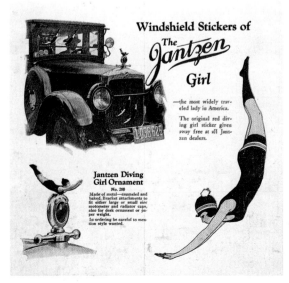

Windshield Stickers of
The **Jantzen** Girl

—the most widely traveled lady in America.

The original red diving girl sticker given away free at all Jantzen dealers.

Jantzen Diving Girl Ornament No. 200

McClelland Barclay, another illustrator in the Jantzen team, depicted the ideal woman of the 1920s as slender, youthful, and sophisticated, sexually understated and elegant. Barclay's poster design for Jantzen's National Swimming Suit of 1923 showed a finely muscled, red-cheeked girl exhibiting impeccable form as she maneuvered into an improbable somersault.

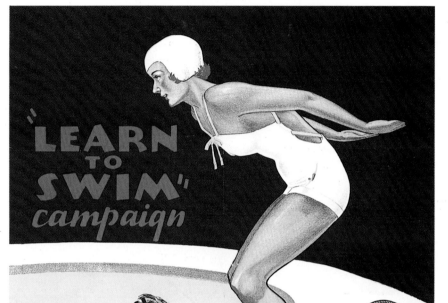

To create a mass market for its swimsuits, Jantzen launched the nationwide Jantzen Swimming Association in 1926. Newspaper ads, posters, and store displays announced the onset of local "Learn to Swim" campaigns. Successful completion of the free course of instruction was rewarded with an official certificate.

Market saturation strategies did much to popularize – and democratize – the allure of swimming: Jantzen's trademark "Diving Girl," for instance, appeared on everything from the haunches of swimmers to the hoods and windshields of Model T Fords.

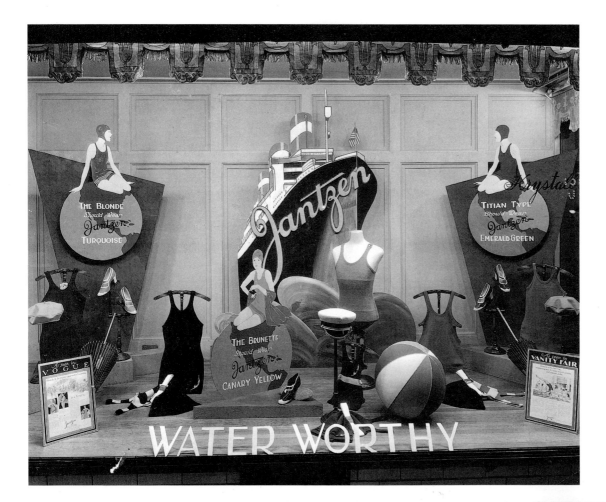

Throughout the decade, bathing suit mania spread from the beaches onto Main Street, U.S.A. Fueled by a Jantzen promotional campaign, department stores across the country turned their display windows and merchandise floors into stage sets for inspirational beach-related scenarios. In 1925 the Portland manufacturer sponsored a coast-to-coast competition for the most glamorous vitrines. These often featured very complex dioramas of fashionable beach life. Others took a less narrative approach, offering collages of merchandise and beach paraphernalia that showed the impact of the recently unveiled Art Deco style. Bobbed and rouged in the latest "flapper" style, store window mannequins broadcast the new "soigné" aesthetic for bathing.

In many respects, Jantzen promotions for swimwear took a thinly veiled educational approach hinging on the promise to turn the ugliest ducking into a captivating siren. Consumers were coached on improving their beach presence with "Color Charts" in which accessories, belts, caps, shoes, and swimsuits could be matched to the customer's hair color. Five-foot high Animated Color Wheels by Hazel Adler were offered to stores in order to counsel female swimsuit customers on how to "scientifically" select an ensemble that was most flattering to their complexion. If the color wheels did not do the trick, the company offered the Jantzen Size-O-Weight, a device that registered *size* on the scale, rather than pounds. "Hundreds of alert merchants have installed the Jantzen Size-O-Weight over the past year," read an ad to retailers. "They have found it *makes* sales. Because the dial registers size not pounds, it overcomes the *reluctance* of some customers to give their weight and obviates the *unconscious* mistakes of others."

Greater skin exposure called for more emphasis on creating the illusion of dress through makeup, geometric hair styles, and costume accessories. One reason for this was that bathing by the sea had undergone a major change. Swimming was no longer practiced during a brief hour before noon, as just one of the activities of a busy resort schedule. Bathers now invested long stretches of time lolling by the water. Beach robes became the most important accessory of the decade. For men, these were roomy terrycloth cover-ups. For women, they ran the gamut from diaphanous, oversized foulards and crisp beach pyjamas printed in bold geometric shapes to tentlike bathing cloaks and rubberized beach capes. In contrast to the serviceable wools and jerseys used in swimming suits, textiles for these cover-ups tended toward such extravagances as crepe de chine, linen, shirting, cashmere, and silks in luscious Cubist patterns.

By changing bathing to swimming, Jantzen had put the American swimsuit on the map. But some 872 miles down the beach from Oregon was another swimsuit entrepreneur, Fred Cole, who saw things differently. For Cole, the swimsuit was not so much a garment to swim in but something to look beautiful in. Formerly a young actor at Universal Studios, Cole had a passion for glamour, beauty, and theatrical women. While Jantzen was churning out practical suits that transformed bathing into swimming, Cole was determined to create beautiful fashion suits.

The history of California's premier swimwear manufacturer began as a prodigal son story. By all accounts, the young Fred Cole had always found his family business something of a bore, if not an embarrassment. In the early 1920s, the West Coast Knitting Mills owned by his family specialized, exclusively, in drop-seat underwear. Throughout this early epoch of the company's growth, Fred dreamed of spectacular women with the velvety eyes and shapely limbs of silent screen actresses. He envisioned them in dramatically cut bathing suits that transformed the body into a living theater of the id.

Fortunately for the future of fashion, Cole's film career was short-lived. His family pressured him to do something "respectable," so, in 1925, he joined the family-owned factory in Vernon, then a suburb of Los Angeles. As his parents soon learned, however, "it was easier to get Fred Cole out of Hollywood than it was to get Hollywood out of Fred Cole." He balked at knitting long johns and turned his energy instead to fabricating women's swimsuits. His first model, billed as the "world's first fashion swimsuit," was called the "Prohibition Suit." With its deeply scooped front and armholes, low-slung waist, and diminutive skirt above short trunks, the suit delivered a dizzying vision of sexuality.

Cole's Hollywood connection would become the firm's distinctive approach to beachwear. Through the ensuing decades, the relationship between the manufacturer and Hollywood costume designers would only grow stronger with Cole crafting suits for film stars and cinema costumers designing suits for Cole. With Fred Cole at the helm, the average American woman on the beach could look forward to owning a suit dripping with every bit as much glamour as those worn by Esther Williams in her films of the 1930s and 1940s.

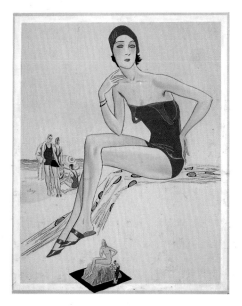

While Cole's knitting mills spun out suits that turned Plain Janes into bombshells, another California firm was crafting swimwear that would eventually grace the bodies of America's bathing beauty queens. Catalina began as an underwear manufacturer by the name of Bentz Knitting Mills. In 1912, when it added knitted swimwear to its inventory of products, the firm changed its name to Pacific Knitting Mills and, in 1928, became Catalina. Catalina's suits steered a course midway between Jantzen's stylishly sporty look and Cole's theatricality. Catalina introduced two important styles in 1920. The unpromisingly named "Chicken Suit" was anything but. Done up in big, bold stripes, the suit was shockingly brief for the time. So was the men's "Speed Suit"—a one-piece model with deeply slashed armholes and sloped leg trunks. The "Rib Stitch 5" for ladies followed, ushering in the daring silhouette of the near-backless suits of the late twenties.

Just as Americans were exposing more of their bodies at the beach, a New Jersey hotelier was feverishly at work concocting a scheme for making less generate more. At issue was the power of less clothing to generate more business.

H. Conrad Eckholm, owner of the Monticello Hotel in Atlantic City, hit on the scheme of displaying female bodies outside the confines of the vaudeville review. He devised an idea for a beauty pageant with the bathing suit competition as its centerpiece, and then he convinced the Atlantic City Business Men's League to sponsor a Fall Frolic that would keep tourists on the beach after Labor Day. As part of the festivities, the Miss America Beauty Pageant was born.

The inaugural competition encouraged contestants to don conventional attire. The winner, sixteen-year old Margaret Gorman, was clad in the traditional sleeveless taffeta chemise with bloomers. However, several candidates threw caution to the winds and showed up in clinging maillots. Noticing that the judges and sponsors raised no objections, others gladly peeled down their stockings to explose dimpled knees and well-turned calves. The bathing beauty contest was an instant hit, and the form-hugging costume was on its way to achieving respectability.

The contest became particularly important to Catalina. Its swimsuits were adopted as the official garment of the Miss America Pageant, and the annual display of its suits placed an automatic seal of approval on Catalina's fashions.

The classic Catalina pageant suit was a chaste, one-piece model with a high-cut panel, a sort of vestigal skirt stretching across the crotch. The attraction of the panel, as Miss America Beauty Pageant historian Frank Deford noted, was most mysterious, inasmuch as the cut was neither flattering nor especially modest. Deford found that, "since it is constructed at the bottom with sort of an attached underpants effect, it has the very disconcerting property of riveting attention right to the crotch...."

As the decade careened to the inglorious Stock Market Crash of 1929, beach life took on a momentum of its own. A spirit of madcap improvisation seized beachgoers who delighted in transferring the most inappropriate activities to the seaside. Suddenly, young women were holding ice-block races in Long Beach, California, and dimpled flappers stripped to Prohibition Suits to compete in baby pig races. Something about trimming a Christmas tree in a swimsuit lent a piquant flavor to that most decorous of activities. Professional and amateur photographers always seemed to be on hand to record these odd proceedings.

But the maddest of all the aquatic diversions was carried on in the territory of the suit itself. By the middle of the decade, the new phenomenon of "novelty" suits had latched fast to the American imagination. Newspapers and tabloids carried photographs of costumes running the gamut from the predictable—the seaweed suit—to the mind-boggling, such as the rabbit-fur suit.

But the 1929 wooden bathing suit was perhaps the epitome of this trend. Though it provided ample coverage, this clunky two-piece swimsuit was a monument to disutility. Only after massive sales of functional suits by Jantzen, Cole, and Catalina could the popular imagination turn to mocking form and turning function on its head. Thus, the decade which had marked the most dramatic advances in the development of a utilitarian swimming costume, ultimately produced its own parody: a swimsuit whose form adamantly and joyously refused to follow the function for which it was intended.

Girls in Hoquiam, Washington, try out unique wooden bathing suits that are fashioned along the lines of the more conventional swimming attire from the late twenties.

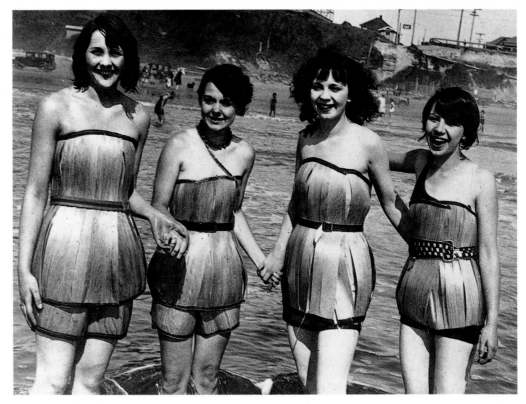

Designed to fit both in and out of the water, the new 1922 line of swimwear featured clinging knits in vibrant solid colors.

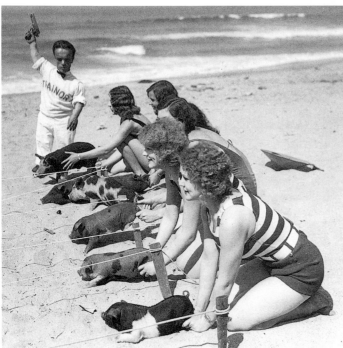

Caught up in the fun-loving delirium of the pre-depression years, Americans improvised far-fetched diversions for the beach, the newest play-ground for the masses. In a California resort, a midget presided over pig races in the sand.

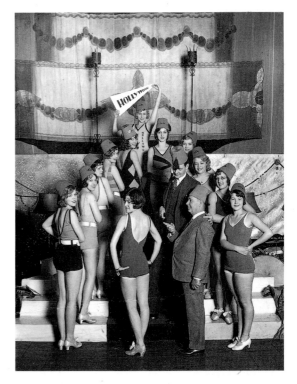

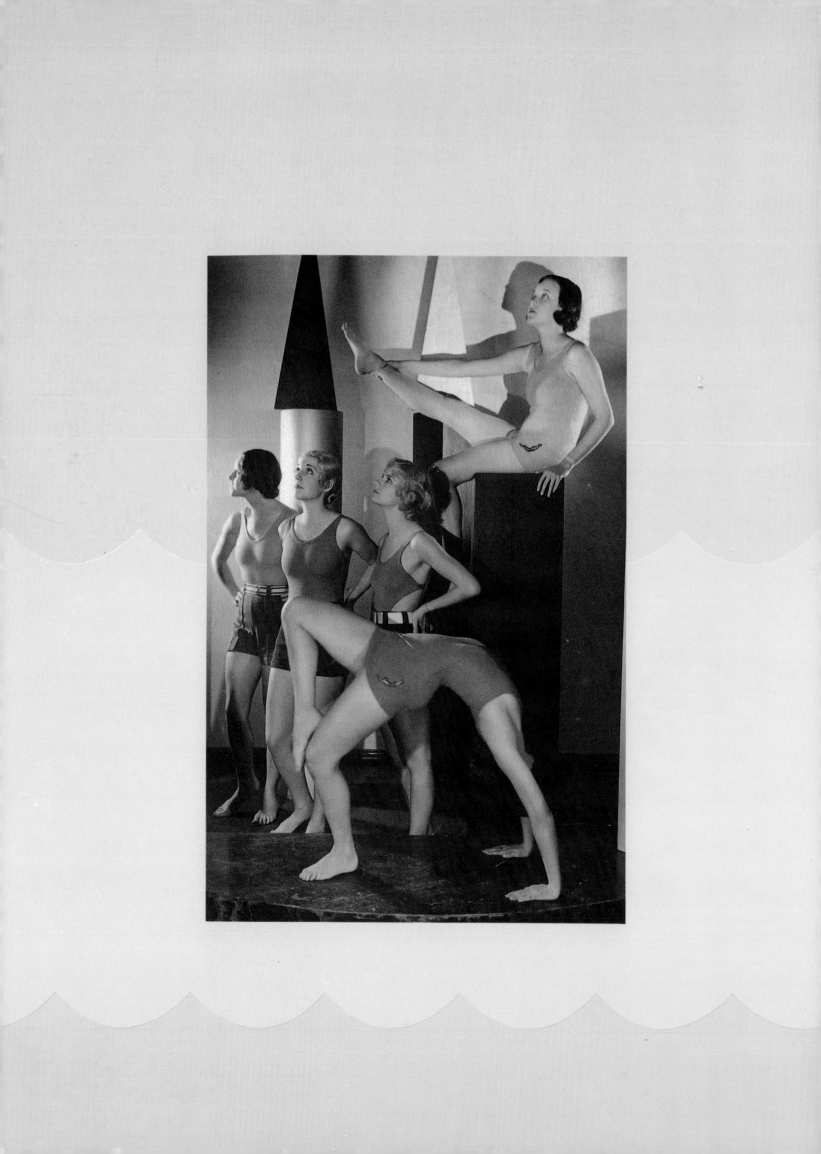

4

Posed in a landscape of piously thrusting cones, cylinders, and pyramids reminiscent of the futuristic sets in Fritz Lang's "Metropolis," this pubescent quintet displays the signature look of the early depression years. The daringly cut bib suit in the center, dubbed the "Sun Goddess," represented the extreme in beach nudity in 1931.

In the fevered atmosphere of the 1930s, the twentieth century came of age. The famed Bauhaus style, based on the "machine aesthetic," banished all decoration and ornament, leaving only an austere beauty compounded of form and function. A new generation of American industrial designers such as Raymond Loewy, Norman Bel Geddes, Henry Dreyfuss, and Walter Teague revolutionized the look of contemporary life by bringing the principles of streamlining to virtually every aspect of the man-made environment.

The economy of the 1930s may have been sluggish, but, to make up for it, the human body was transformed into a perpetual motion machine. Suddenly, the new moving pictures were full of the syncopated counterpoint of prancing limbs and the gossipy choreography of gestures. Busby Berkeley crammed the sets of his extravagant musicals with gorgeous pattern dancers in fabulous swimsuits. Fred Astaire and Ginger Rogers floated across the screen, dancing their way—cheek-to-cheek—through "Top Hat," "Silk Stockings," and the bathing acrobatics of "Flying Down to Rio." Leggy and lithe, this elegant duo swept in a new mythology of romance as a never-ending pas de deux played out in clothes that moved, moved, moved. The bias cut was in. So was femininity. Dresses got longer, clinging to every inch of bosom and waistline, both of which were reemerging with a vampish vengeance.

It is not surprising that a new look emerged for the human form that was functional, sleek, and, above all, streamlined. Fashion models of the period struck poses that emphasized the continuous flow of lines from gracefully pointed toes to minimal, head-hugging hairdos. And photographers delighted in showing women in motion: leaping across puddles, striding down a boulevard, or simply walking. In the pages of popular magazines, illustrators such as George Petty and Marty Ray stressed the aero- and hydrodynamic qualities of the human body.

Reacting to the increasing popularity of beach activities, a number of knitwear manufacturers and designers threw their hats into the swimwear market. The principal competitors of the period included Jantzen, Cole, B.V.D., and Catalina. Other important companies were Bradley, Munsingwear, Travolo, Sacony, and Gantner-Mattern. B.V.D. was the largest Midwest fabricator of swimwear. Named after its founders, Bradley, Voorhies, and Day, the company began producing swimsuits in 1929, about a decade later than its West Coast competitors.

It was an exciting time to be in the business of designing and manufacturing swimsuits. As early as 1930, *Men's Wear* had noted that "manufacturers are selling women's bathing suits that are scantier than ever. Backs are open to the last vertebrae, armholes are wider and altogether women's bathing suits…will be practically nothing to speak of."

Under the impact of revised attitudes toward dress, new technology, and a reassessment of beach activities, the swimsuit would become a thing of fashion, responding to the same fluctuations in the semantics of style that governed full dress attire.

By the end of the decade, the basic design of the female swimming suit would enlarge to include four types: the maillot, the sheath, the two-piece, and the "dressmaker." Functional improvements in the cut of swimsuits were complemented by changes in decoration and colors. To create variation and interest, designers affixed shells, bows, and nautically inspired trimmings of all sorts. It was Elizabeth Arden who stressed that the maillot should be beautiful as well as functional. Apparently, it was Arden who urged B.V.D. to adopt the evening gown look and include crochet and braid trimmings on this style of swimsuit.

The maillot was, nevertheless, predominantly a serviceable costume, but for those with less than a perfect figure, it presented some awkward dilemmas. For this segment of the population the so-called dressmaker suit had been devised late in the 1920s, becoming a fashion staple by the next decade. The dressmaker borrowed its neck and shoulder line directly from streetwear and retained the same effect of the skirt but abbreviated it to the proper height above the knee. In the essentials, this suit was remarkably like the maillot: snug through the chest and under the arms so that the straps could be let down for sun-tanning. But the variations of the dressmaker suit were deliciously intriguing. Little slit aprons in back and front concealed the trunks below them. In other models, side pleats gave width to the skirts. There were also out-and-out trunks, tailored so they did not bag or pull, but with clever pleats in the front so that at first and second glimpse they seemed to be skirts.

While the dressmaker had great appeal, it took a quiet back seat to the clingy knits conceived in response to the public's demand for formfitting, freedom-of-movement beachwear. As *Collier's* announced in mid-decade, "Even though our moral habits are unimpaired by the scarcity of clothing, our eating habits will surely be affected."

The style catalogue entitled "The Jantzen Beach Revue" was designed in the form of a cabana. When opened, it unfolded to reveal a series of bathers filing to the waves, balancing beachballs and trailing giant foulards.

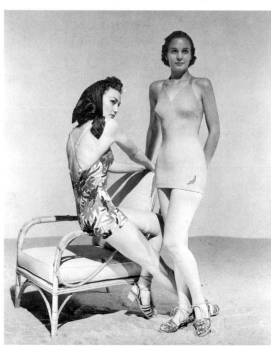

Plunging to new depths in the back, the 1934 suit hugged the body and was often specially constructed to allow shoulder straps to be discreetly lowered for tanning. The bust, though gently uplifted by strategic seaming, was not given particular accentuation.

Two new Lastex fabrics were introduced in 1939 – "Velva-Lure" and the rayon blend "Satin-Knit" – which clung seductively to every curve and dimple, yet, thanks to the "proper ratio of two-way elasticity," afforded a comfortable, flattering girdle fit. A harbinger of things to come, the bosom was molded by a brassiere constructed to provide good uplift. Both suits made a nostalgic reference to the skirted bathing dress in the vestigial skirt which shielded the base of the torso.

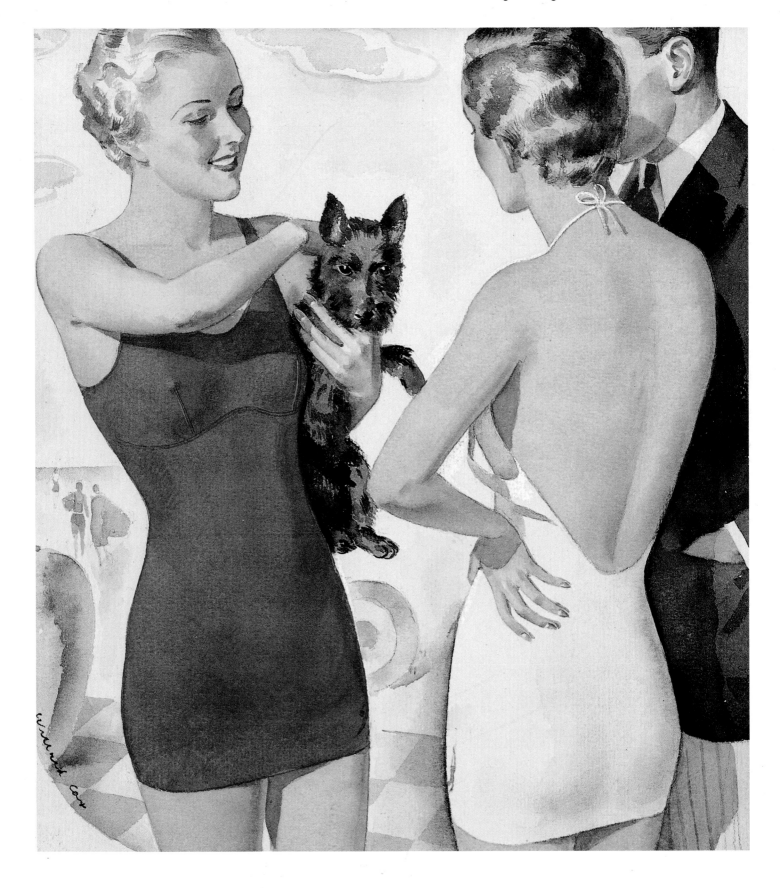

On the whole, design advances were aimed at improving the female figure in the revealing maillot suit. The bosom gradually rose to prominence, gently "uplifted" and molded by darts as in the "Ladies Uplifter" by Jantzen, an adjustable, skirted garment featuring "that desired uplift effect, molding figure to fashionable, youthful lines." The self-adjusting "uplift brassiere" advertised by B.V.D. was another example of intentional body sculpting. According to former B.V.D. model Patricia Flesh, it took a "battle" to persuade Frank Shipley, president of their manufacturing company, that swimsuits should support the breasts. Gaining the imprimatur of a Parisian corset designer, Mrs. Flesh convinced Shipley that the flat-chested look in vogue during the 1920s was out, and it was, indeed, possible to construct swimsuits with the support for which women were clamoring.

Archivist Patricia Cunningham examined extant B.V.D. suits and reported that the "uplift" was achieved by cutting separate pattern pieces for the brassiere portion of the suit and by using darts to shape the cup. Elastic was strategically placed along the interior portion to give support. Other manufacturers also featured the upward thrusting bra-top. An unorthodox Elsa Schiaparelli design placed the brassiere on the exterior of the bathing suit.

In 1937, Gantner-Mattern promoted women's suits featuring a "patented and exclusive Floating Bra (semi-detached, 'floating' inner uplift brassiere)." The uplifting qualities of the new swimsuit were advertised heavily between 1937 and 1940. One promotion beckoned its reader to "Be Beautiful...be glamorous...be lovely! Sculpture your figure, lady, in these silhouetting swimsuits by B.V.D.—with every artful stitch designed to mould you, hold you, reveal the alluringest and most glamorous you."

When it came to square inches of skin that counted, apocalypse seemed to be in the air. Every inch of displaced fabric, every innovation in textile, were accompanied by breathless prophecies of imminent nudity. Fashion—and the swimsuit—could go no farther. Or so it seemed to rapt observers who greeted each new cutout and innovation as a prelude to the end of the swimsuit and the beginning of bare flesh on the beach.

Dear
I'd like to sit down
and write a long letter
But resting is fun
and sleeping is better.
When duty confronts me
With deeds to be done
I buckle right in
--With a snooze in
the sun!
 Lazily yours,

Only a *Jantzen* fits so perfectly

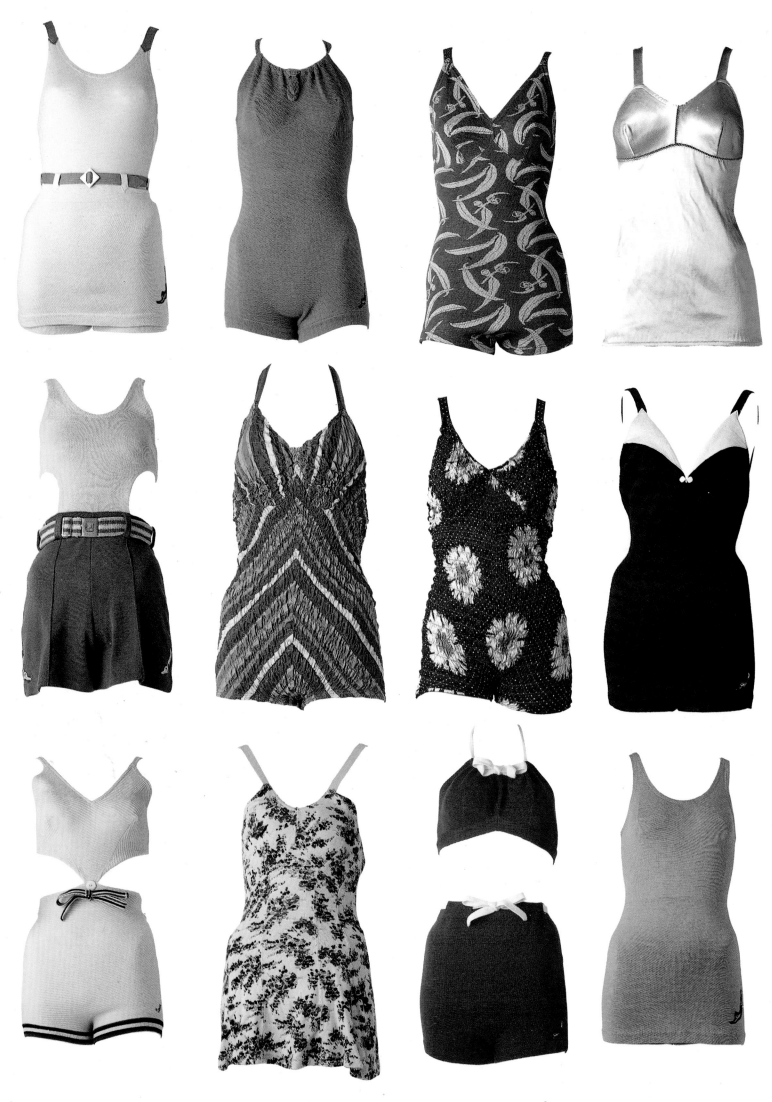

The maillot's basic "tube" line remained the signature shape of the decade, though in the hands of designers it acquired panache through beguilingly placed decolletages, ingeniously engineered straps, and frivolously placed cutouts. The tunic-like sheath suit covered the entire torso and was constructed over a full, attached panty. Sometimes the tunic effect was limited to the front, with the back resembling the maillot. This was the so-called "panel" suit that retained the memory of the skirted bathing dress in the form of the vestigial skirt. At mid-decade, a very modest two-piece appeared, exposing a few inches of bare flesh between a boy-leg panty or a skirted pareo and some sort of top. This was typically a generous brassiere or an unconstructed halter, a biblike bodice drawn up on a cord and tied around the neck. Dressmaker suits were made in silk prints, acetates, polka-dot silks, and vivid cotton plaids. Because this type of suit was most often fashioned from intricately patterned fabrics or elaborate weaves, knitwear manufacturers began to include them in their lines. However, these knit dressmakers did not fit nearly as well as the maillot and were not as serviceable in the water.

In 1930, psychologist John Carl Flugel published an influential study called *Psychology of Clothes* in which he voiced a sentiment that was to become typical of the entire decade. "Dress is after all destined to be but an episode in the history of humanity," Flugel wrote, "and man (and perhaps before him woman) will one day go about his business secure in the control of his body and of his wider physical environment, disdaining the sartorial crutches on which he perilously supported himself during the earlier tottering stages of his march towards a higher culture." It was a curiously utopian sentiment, part and parcel of the escapist fairy tales into which the culture retreated during the gloom of economic and political hard times. Ironically, nudity in those days did not suggest poverty. Rather, it had the mystique of innocence, evolutionary advances, and boundless opportunity for motion and, by implication, for promotion. To the futurologists of the thirties, the brave new world could only be nude.

It was in swimwear advertisments that the full dimensions of this fad for fewer clothes came to the fore. If one could not totally dispense with clothing on the beach, one could at least give the appearance of nudity. When the new "Molded-fit" swimsuits were introduced in 1933, they were proposed as "the answer to nude bathing."

"What is Jantzen's answer to nude bathing?" read an ad in 1933. And the response: "Jantzen's Molded-Fit swimming suits, super-light, super-soft that flex with every body movement like one's own skin! The thrill of swimming without a suit, but, at the same time being perfectly and stylishly dressed for the beach.... There is a new freedom—a new thrill— in these unbelievably light and snug-fitting suits."

Harper's Bazaar raved about the revolutionary elastic yarns used in the 1934 suits because, "No other human device can even approximate that utter freedom, that perfection of fit, at rest or in motion, that airy but *strictly legal sense of wearing nothing at all.*" A 1938 billboard design for the new Jantzen "Wisp-O-Weight" took the liberty of depicting the suit in a flesh color that gave its wearer the appearance of nudity. This "nude" look was made possible by the injection of new materials—rubber and the rubber-based "miracle fiber" Lastex—into the traditional repertoire of silks, woolens, and cottons.

In 1932, before Lastex gained a foothold, the U.S. Rubber Company, Kleinert (originally a girdle maker), U.S. Kool-Tex, and a handful of lesser-known manufacturers introduced the all-rubber swimsuit. A year later, *Rubber Age* observed that "during the past few months a new rubber product has been receiving a great deal of attention in the press— rubber bathing suits." The rubber fabric made by U.S. Rubber was dubbed Krepe-Tex, while the Miller Division of B.F. Goodrich called their rubber fabric entry Knittex. All fabrics were manufactured from rubber sheeting with an embossed surface "simulating silk."

In 1936, the Seamless Rubber Company introduced a new suit made from a crinkled rubber fabric called "cloque," which was made by passing rubber sheeting through a series of calenders. By 1937, Kleinert was offering a printed-crepe-rubber maillot. Available in smooth, crinkly, or embossed surfaces that simulated knitted fabrics, rubber suits clung wonderfully to the figure and seemed the ideal amphibian material. "They dry easily," claimed Elizabeth Arden, who favored rubber suits throughout the thirties, "and are marvelous for swimming." They also came in a dazzling range of tints: everything from raspberry red to aqua and maize, with white leading as the newest and most sophisticated color. When worn with matching berets and flat shoes that laced up the ankle—in rubber, of course—these new suits had something frankly futuristic about them.

Economic hard times and a nudity fad set in together as Americans looked to the simple things in life for diversion from the mounting fiscal fiascos. "Molded-fit" swimsuits were proposed as "the answer to nude bathing."

Although lined with a thin layer of fabric and "tested to withstand a stress of three hundred pounds," rubber suits had serious shortcomings. They were hot, clammy, and had a tendency to rip. Even worse—but to the great delight of teenagers—they were known to peel spontaneously off the wearer's torso in the pounding surf. Although by 1935 it had already become clear that the all-rubber suit was an evolutionary dead end, the material itself—especially in combination with woven fabrics—would play a pivotal role in shaping the swimsuit and the American body of the 1930s.

The swimwear industry was revolutionized in 1931 by the introduction of Lastex, a rubber yarn manufactured and patented by Adamson Brothers Company, a subsidiary of the U.S. Rubber Company. Prior to 1930, elastic yarn used in apparel was cut from sheets of rubber. Finally, a technique was developed for extruding liquid latex into a fine, round rubber thread. When covered with two tightly wound layers of yarn, the thread could be used in a wide variety of swimsuit fabrics. Cotton, rayon, silk, wool, and acetate were the most common materials used to sheathe the latex rubber threads.

While marking a significant advance in swimwear construction, this new yarn also had several limitations. For one, the rubber thread at the core did not take dyes readily and showed or "grinned through" when the yarn was stretched. It also tended to lose its elasticity, primarily because the rubber was susceptible to deterioration from contact with natural body oils, cosmetics, and suntan lotions.

In the excitement of discovering a formfitting "miracle fiber," swimwear manufacturers were not in the mood to dwell on shortcomings. Every major firm claimed the distinction of being the first to introduce the yarn, and by the end of the decade, the repertoire of Lastex-based fabrics included the shirred-cotton Matletex, the shimmering, velvety "Velva-Lure," and the lustrous rayon blend "Satin-Knit."

A woven fabric, Lastex differed radically from earlier knits that had very little "control." The rubberized textile molded to the body, giving the wearer fit with freedom, while offering foundationlike control. For the woman who was concerned that the swimsuit was the only thing between her ungovernable flesh and the unforgiving world, Lastex was the perfect solution. Patterned or plain, the stretchy fabric provided figure control touted to make its wearer a beach sensation and to turn even staid males confronting mid-life crisis into hunks of irresistible sex appeal. "What's he got that I haven't got?" queried a chubby male specimen staring dumbfounded at "Mr. Muscles" preening for a cluster of bosomy beauties in a Catalina ad for Lastex trunks. "LASTEX APPEAL—that's what he's got!" was the snappy reply.

Unlike knits, the new material dried rapidly and "fit with sleek perfection" in or out of the water. Lastex "fits you perfectly and makes you look better *than any suit you have ever worn*," claimed Catalina. "It has the ideal ratio of two-way stretch, molding and holding your body in the natural lines of youth. It softens contours, slims and slenderizes you, firmly yet comfortably." Jantzen praised Lastex for its ability to produce "a swimming suit with figure control qualities of a foundation garment." Oddly enough, only ten years earlier, when the clingy woolen suit appeared, the same advantages had been attached to the sport of swimming. Now, the new miracle fiber was going to take the work—and the sport—out of looking good at the beach.

The shaping power of Lastex led to a whole new way of thinking about swimwear and the ways in which the human body could be exhibited in public. Since every curve and dimple was faithfully reproduced in the fabric, it became desirable, once again, to find ways of suppressing anatomical "defects," smoothing over taboo zones, and enhancing strengths. A variety of structuring devices were devised. Three-inch bands of stretch-power net were attached inside the pantie to keep the tummy flat and the waist trim. To point up the bosom, various tricks were engineered that ranged from subtle darting and pleating to the "surplice" cut which crossed two triangular pieces of fabric in the front. Men's suits also benefited from the Lastex revolution. Athletic supports—known as "Sunaka" supports—were sewn directly into the trunks, where they provided "daylong comfort and trim front appearance."

◄
Increasingly throughout the thirties, war was in the air, and not only in the military theaters of Central Europe and the Far East. In Long Beach, California, a girl's rifle drill team provided an odd coupling of Eros and Thanatos.

As though enacting a Freudian nightmare, rubber-capped sailorettes scrub down the cannon of the Battleship Oregon in 1930.

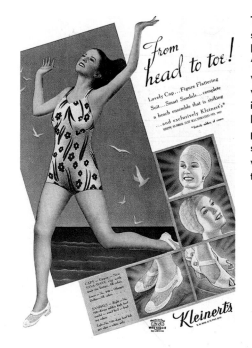

From head to toe!

Lovely Cap...Figure Flattering Suit...Smart Sandals...complete a beach ensemble that is striking ...and exclusively Kleinert's

Kleinert's

The all-rubber suit, passionately recommended by the *Delineator* of 1934 "because it rises from the waves as tailored as it went in," did not live up to its promise. Inadvertently, however, it catered to proponents of the nude look, since even a mild wave was sufficient to peel it off the swimmer's torso.

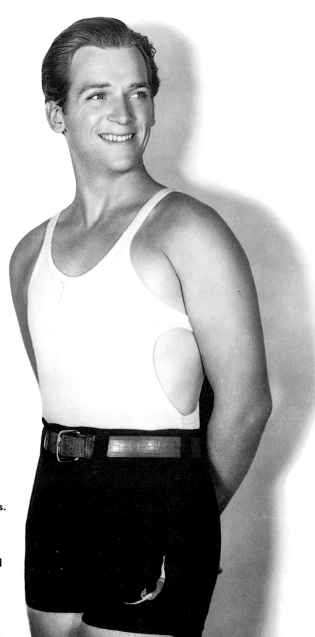

Douglas Fairbanks, Jr., was among the screen stars engaged to model the latest swimwear styles. The photograph was airbrushed to remove hair from the chest and arms so that the film star would conform to the procelain-skinned male ideal.

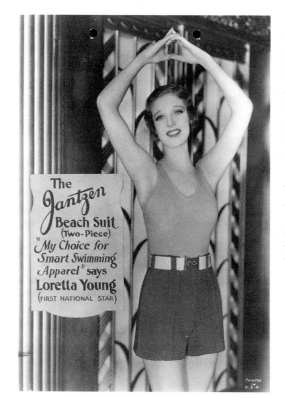

It was not until 1930 that a swimwear manufacturer realized the economic spinoffs of the Hollywood connection. That year Jantzen began a promotional tie-up with First National and Warner Brothers movie and singing stars. Loretta Young, a First National Star, was elected Jantzen girl for 1932. She appeared on countless posters and life-size cardboard figures modeling the elegantly tailored two-piece "Beach Suit."

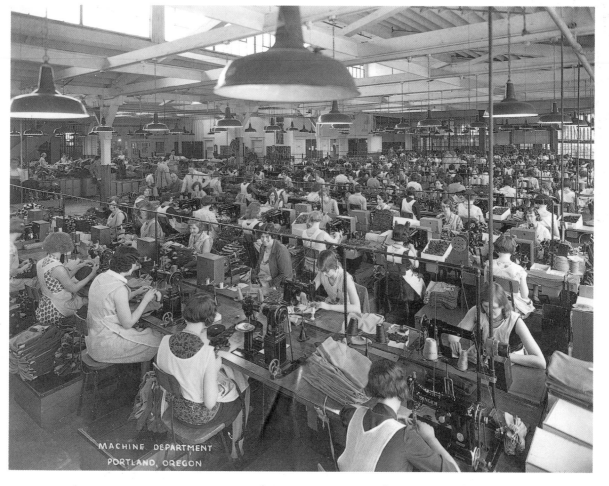

Seamstresses at the Jantzen Knitting Mills assemble suits.

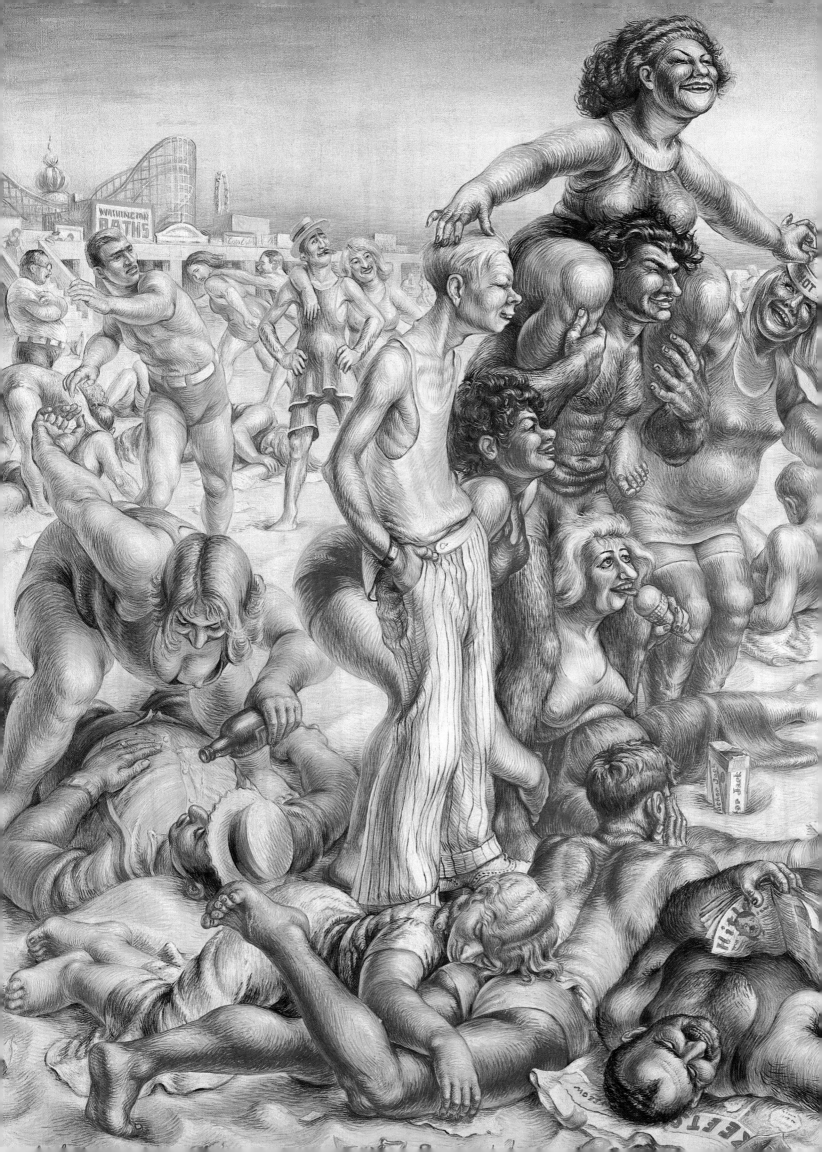

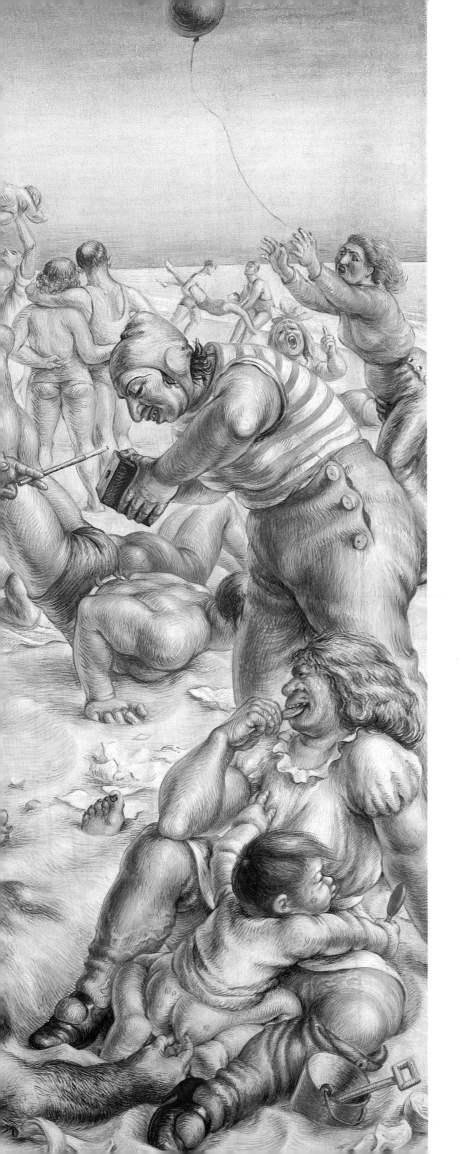

**Coney Island by Paul
Cadmus, 1934.**

It was at this time that technology took the handsomely sculpted body out of the realm of nature and genetics and made it available to anyone willing to put in the sweat to create one. New York's Abercrombie and Fitch advertised a workout device to correct every defect of the human physique. It included a "combination horizontal bar, punching bag, rowing machine, and chest-weight contraption on which three people can exercise at once." Shaping up for the beach was only a small spin-off of a general fitness mania that swept America. New Deal social programs had a tremendous impact on the popularization of swimming by sponsoring the construction of swimming pools throughout the country. The shortened work week contributed more leisure hours, while lower incomes made neighborhood pools and beaches increasingly attractive alternatives to long, costly motor trips. As historian Lois W. Banner pointed out, "more people than ever before personally participated in sports, and sports clothes became a major field of fashion design."

Public interest in sports spilled over to athletes, particularly to women swimmers. Ever since Gertrude Ederle had swum the English Channel in 1928—becoming the first woman to do so—and New York had celebrated her exploit with a ticker-tape parade down Broadway, Americans had nourished a fascination with swimming celebrities. The names of Esther Williams, Eleanor Holm, Aileen Riggin, and Helen Wainwright were much better known that those of their male counterparts. The Olympic Games in 1936 brought the fitness craze to a climax and firmly fixed the new identity of the body as a "machine" for living.

If, in the 1920s, swimming had played the decisive role in transforming the bathing dress into a functional garment, the design generator for the swimsuit in the thirties came from the new "sport" of sunbathing. Adaptation to water may have stimulated swimwear design in the 1920s, but during the 1930s, it was the sun that induced new twists and radical modifications. Tanned skin was all the rage during the Depression. Dr. Shirley W. Wynne, commissioner of health for the city of New York, promoted tanning as a cure for everything from tuberculosis to surgical conditions. "The sun-tan fad is the best thing that has ever happened to the people of America," the health commissioner decreed. "The sun is the greatest bottle of medicine in the universe."

At least in part in response to this sun-worshipping craze, a series of radical reductions was introduced into the basic maillot design. The overskirt of the bathing costume shrank to almost nothing. The armholes were enlarged, and the décolletage was cut much deeper. Finally, the back of the suit was stripped away nearly to the waist. Styles with names like the "Sungoddess," the "Sunaire," and the "Shouldaire" offered what were then unprecedented expanses of uncovered skin, most of it located in the back.

It is difficult to establish, of course, the precise combination of events and attitudes that precipitated the epic diminution of the American swimsuit, but clearly, two factors were at work. The tanning craze and the belief in the beneficial effects of sun exposure did much to motivate suit reduction. It is also conceivable that this fabric surgery came about as a rationalization for the desire to disrobe in public. There was no sunshine at night to justify the vertiginous drop in the backs of evening dresses, which came hard on the heels of the backless swimsuit. Appearing first in 1931, the so-called evening back suit was little more than a dressmaker bathing suit cut to reveal a large portion of the back.

This interplay between flesh and fabric came to life in the prophetic projection made by the Chicago's Fashion Art League in 1931 of what swimming attire in 1981 would look like. While such predictions were very popular throughout the thirties, this one would prove uncannily accurate. It depicted a one-piece jersey suit reaching from shoulders to toes, but one so riddled with holes at the bosom, midriff, hip, and thigh, that one would have thought it devised by a punk rocker of the late 1970s. The photo's caption predicted that, "the swimming suit of the future will…have enough cutouts in the bodice to make the present day suit look like a cover-all." The idea of strategically placed cutouts and key-holes was tremendously exciting to the imagination of the thirties. It was also vastly disturbing to more conservative factions of the population.

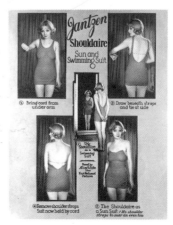

In 1931, despite the depression, 12 million suits were sold to American women. One of the most versatile models was Jantzen's "Shouldaire," engineered to go strapless without compromising modesty or mobility.

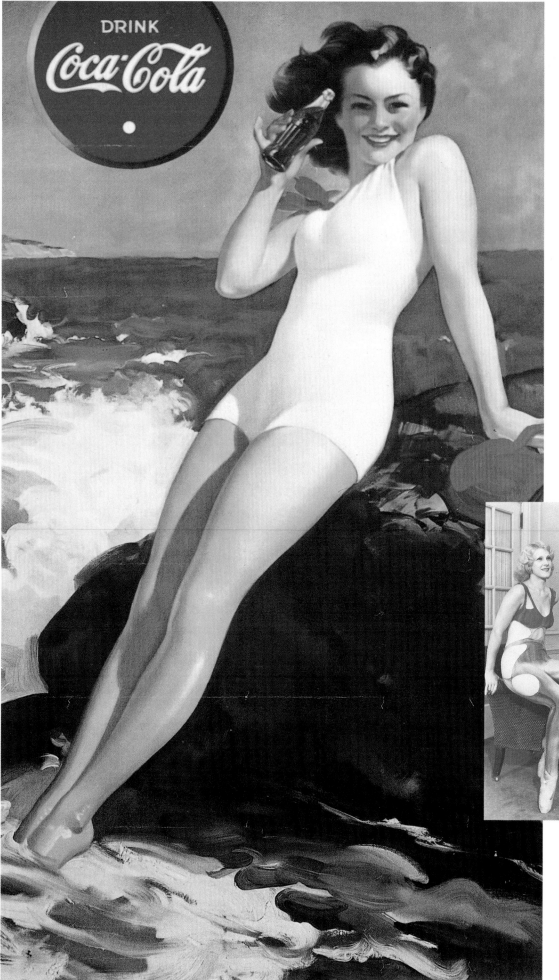

White suits, long taboo on beaches for their supposed transparency when wet, were enthusiastically embraced when teamed with opaque synthetics. Ads for everything from Coca-Cola to Kodak film paraded the new American dream girl in suits that camouflaged waistline bulges, played up long American legs, and showcased healthy bosoms.

With an uncanny flair for prophecy, the Fashion Art League of Chicago looked fifty years into the future and came up with the 1981 bathing suit. "Legs no longer will be anything to look at – uncovered. For the swimming suits will have legs of jersey, with enough cutouts in the bodice to make the present day sun suit look like a cover-all."

Male styles kept pace with the shrinking trend in women's suits. But the battle to expose the male chest was long, arduous, and far from decisive. Ambivalence and vacillation, in fact, were built into the male swimsuit in the form of convertible styles that permitted the top to be removed. Growing stylistic pressures on men to abandon the upper half of the conventional suit and go topless in a "Depression Suit" led to the development of a two-piece garment with a removable shirt that could be tucked in, buttoned, or fastened to the trunks with a zipper. Ellery Gordon of the National Knitted Outerwear Association recommended beach jackets to solve the problem of toplessness and the vagaries of censorship. The concept remained popular throughout the thirties.

For men, the new "thrill" in 1933 was unquestionably the "Men's Topper," admirably modeled by Warner star Dick Powell who, as it turned out, had the hair airbrushed off his chest in the promotional photograph. "Zip! In six seconds the change is made from a complete swimming suit to smart high-waisted sun shorts…the patented fastener makes the change effortless without fumbling with buttons and belts arrangement."

Unlike any suit that preceded it, the Topper was a belted, two-tone wool suit that offered its wearer the option to bare or not to bare. The deeply scooped top was attached to the front of the trunks—or, more accurately, to an athletic supporter worn beneath the trunks—by means of the new Talon fastener, or "zipper," introduced two years earlier. The back of the suit was not connected to the trunks but instead featured a special "Y" arrangement of the straps to secure the top snugly to the chest. If a swimmer wanted, he could detach the top simply by unzipping it. Many men did and often were arrested for indecent exposure.

The B.V.D. Company retained Johnny Weissmuller in 1933 to suggest improvements in male swimsuits and to wear new models to promote the B.V.D. line. The Olympic swimmer recommended extra-low-cut armholes on tank tops, a natural waist, and an extra-full seat. High-waisted trunks in knits were big sellers and shirts covered less of the body in 1934. A year later, "Jockey bathing trunks" appeared for the first time in France, and while these scantier types of swimming attire were available in America, the conservative two-piece suit still reigned into the 1935 season.

When, for the first time in the history of men's swimming attire, the bathing trunk became available, the climate changed quickly. Men could purchase the so-called half-hitch trunks, cut high in the waist and low on the leg. To give more of an appearance of "dress," the trunks often showed a simulated or real fly front and some sort of belt or buckle effect. The greater the streamlining, it appeared, the more critical the need for dressing up the suit with emblems of street attire. Hammered silver buckles, coin pockets, and webbed or worsted belts contributed nothing to the garment's serviceability or coverage, but they did decisively set off the half-hitch from the genre of men's underwear and so added immensely to their respectability.

Men finally won the right in 1937 to put their swimsuit tops on a hanger and go down to the sea in trunks. In the summer of 1936, the "no-shirt" movement was a hot issue. The United Press reported that topless men were banned from the beaches of Atlantic City, New Jersey because the city fathers wanted "no gorillas on our beaches." Cleveland held out for men's trunks covering the navel. Galveston insisted on tops for men's suits, "but no special regulations concerning color or style of garment worn by women."

The threat of public nudity was always hovering on the sidelines. Perhaps nothing did more to keep that spectre in the wings

Jantzen's popular "Sun-nette" model, launched in 1931, was recommended for its "full body exposure to the healthful ultra-violet rays of the sun." The strappy design would meet little sympathy thirty-three years later, when, blown up to adult proportions, the identical suit would come back to haunt public beaches as Rudi Gernreich's scandalous Topless Suit for women.

The battle to liberate the male chest for public exposure was long, arduous, and far from decisive. The "Topper," one of the earliest "emancipated" styles, dating from 1932, offered its wearers the option to go bare by providing a detachable top. A zipper held it to the trunks – or, more accurately, to an athletic supporter worn beneath the trunks. If a swimmer wanted, he could detach the top. Many men did, and often were arrested for indecent exposure.

The STREAMLINE

Jantz[en]

NEW WISP-O-WEIGHT S[UITS]

From 1935 through 1939 illustrator George Petty created a national sensation with his swimwear illustrations for Jantzen showing hyperbolically endowed male and female bathers. His flat-headed men, their necks sweeping directly into the back line, recalled the rear end of Greyhound Scenicruisers designed during the "streamlined decade." Beachwear manufacturers pushed the hydrodynamic aesthetic with style names such as the "Speedaire," the "Speed Suit," the "Streamliner," the "Dolphin," and the "Aquabat."

en

WIM SUITS

"WHAT'S HE GOT THAT I HAVEN'T GOT?"

L. A.—LASTEX APPEAL—that's what he's got! The secret of such social success is simple: the snappy Satin Lastex Trunk, created by Catalina! These sleek "seat-covers" were a sensation in 1937. And the 1938 Catalina Lastex Trunk styles are snappier than ever! Backed by a year's Lastex experience, we have produced the most outstanding line of trunks you have ever seen. So—be sure to see them!

Catalina
**LASTEX
TRUNKS**

PACIFIC KNITTING MILLS, INC.
443 SOUTH SAN PEDRO STREET, LOS ANGELES · 325 SOUTH MARKET STREET, CHICAGO

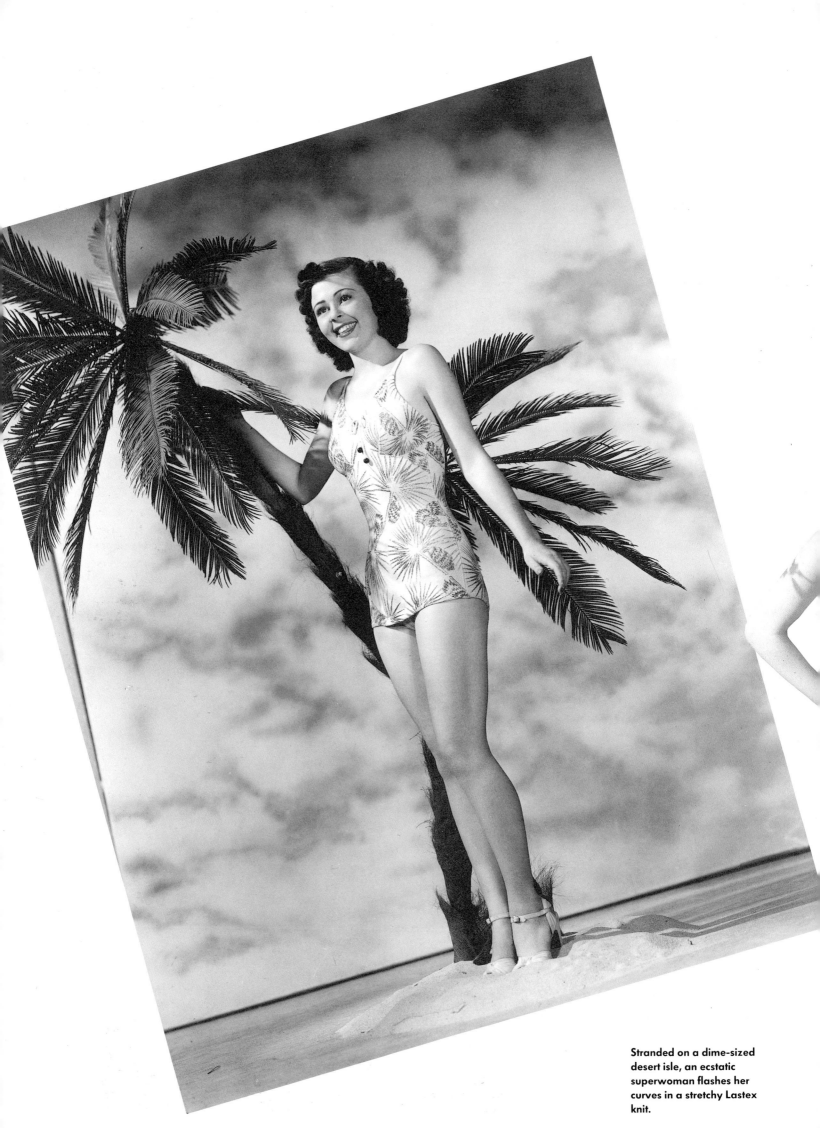

Stranded on a dime-sized desert isle, an ecstatic superwoman flashes her curves in a stretchy Lastex knit.

than the new moving pictures issuing from Hollywood. Because cinema was the one form of entertainment that everyone during the Depression could afford, Hollywood became a major source of style ideas. Starlets and swimsuits had been a natural combination since the early teens when silent film director Mack Sennett introduced his scandalous "Bathing Beauties." But it was not until 1930 that a swimwear manufacturer realized the economic spin-offs of the Hollywood connection.

That year Jantzen turned to the flash and dash of screen personalities to sell its products and began a promotional tie-up with First National and Warner Brothers movie and singing stars. Interestingly, no money ever exchanged hands in the deals between the movie studios and Jantzen. The basic concept, from Jantzen's point of view was, "I'll sell your movie star, if you sell my bathing suit." There was no end to the ingenuity of the linkups between the manufacturer and local movie theaters and retail stores. In 1931, Loretta Young, a First National Picture Corporation star, was elected Jantzen Girl of the Year. "She possesses every qualification…youth, personality, beauty, talent…to attract youthful buyers—your potential market," read her hype public relations release. Young

appeared on countless posters and life-size cardboard figures modeling the elegantly tailored two-piece "Beach Suit." Local theater managers were asked to alert store owners when a Loretta Young film was scheduled at their theaters. The manufacturer would then furnish the merchant with photographs to be used in the store as well as posters suitably imprinted with the theater's name and Loretta Young wearing a Jantzen. "Of *course*, Loretta Young wears a Jantzen," was the company's rallying cry of 1931.

B.V.D. began its association with the film industry when Johnny Weissmuller was chosen by MGM to play the role of Tarzan. Alfred Flesh, a B.V.D. vice-president, negotiated with MGM to allow Weissmuller to play Tarzan and, at the same time, continue promoting B.V.D. products. The agreement also stipulated that other MGM stars would wear B.V.D. swimwear for endorsement purposes as well. Following B.V.D.'s success using a swimming champion for promotional purposes, other manufacturers took the cue. A 1935 Catalina advertisement featured world champion diver Mickey Riley, and in 1937, Gantner-Mattern employed Buster Crabbe and Herbert Walsh, an aquaplane champion.

It was not long before the entire swimwear industry divided the fertile terrain of the entertainment world. Catalina engaged Warner Brothers costume designer Orry Kelly to style rayon dressmaker suits, which were then modeled by Busby Berkeley musical stars Lola and Rosemary Lane. The Hollywood connection lent mass-produced suits an enticing cachet of glamour and high style that translated into hefty sales figures. Catalina had learned about capitalizing on beauty through its association with the Miss America Beauty Pageant, and the firm began a campaign to identify its suits with some of the most photogenic stars of the screen. Gigantic blowups of Joan Crawford, Ruby Keeler, Joan Blondell, and Anita Page, all in Catalina suits, were produced and circulated in stores from coast to coast.

The Rabbit Fur Breeders of Southern California contributed pelts for this cuddly harlequin bathing suit.

Olivia De Havilland poses in the typically tubular suit of the day.

Meanwhile, Catalina's competitor and neighbor, Fred Cole, was busy working out what became an immensely lucrative Hollywood connection of a slightly different sort when he engaged the services of Margit Fellegi, the "crazy Hungarian" from Chicago who was to be his stellar—and sole—swimwear designer for the following four decades. Trained at the Chicago Art Institute as a costume designer, Fellegi developed a sterling reputation working in the Hollywood theater circuit. A tiny woman who barely filled out a size one frock, she revolutionized the swimwear industry with the introduction of the "Matletex process," which enabled cotton fabric to be gathered on elastic thread. A cotton swimsuit made with Matletex process could fit the contours of the body just as tightly as the Lastex knits, allowing Fellegi to offer several models of the Matletex suit in maillot, sheath, and strapless styles that came in vibrant and, for the time, unprecedented floral and geometric prints.

Her particular genius lay in finding that unexpected approach to the body that made it at once disturbing and seductive. Sometimes the effect depended on using materials such as "moonlight" velvet and sequins that were patently antithetical to water. Sometimes it was the way she arranged fabric on the body, as in the asymmetrical suit that draped to the side. Whatever the device, there was always an element of shock in her suits. They were all designed in close collaboration with textile manufacturers who were challenged to come up with innovative fabrics that would do what Fellegi envisioned. Oddly, for a designer who created her suits from the thread up, Fellegi had absolutely no idea what it was like to actually wear one. She was so small and so thin that she shrank from the idea of slipping into a swimsuit with the dismissive, "Don't be silly, darling, I'd look like Mahatma Gandhi in that suit!"

Amidst all the theatrical fanfare, there was at least one curious exception. While the big mass-market manufacturers cloaked their swimsuit fashions in Hollywood allure, a New York designer with the unglamourous name of Mrs. Bert Schnurer was manufacturing swim garments she called "the Fords of Fashion." Her clothes stressed function, witty innovation, and fit at a reasonable price. Carolyn Schnurer went directly from teaching music and art in New York's public schools to designing swimming suits for her husband's petticoat business. In the thirties, when her seaworthy fashions gained her a solid reputation, Schnurer was a plump and benign lady with graying hair and steel-rimmed glasses. There was nothing about her appearance to suggest that she was the kind of designer who, as *Collier's* magazine observed, "dedicated her life to persuading other women to take off as many clothes in public as possible."

Her own less-than-perfect dimensions may have been responsible for some of Schnurer's most inspired designs. Every summer the ungainly figure of this mousy designer could be spotted in Europe's most spectacular resorts, looking over each brief and outrageous number appearing on the beaches. Schnurer understood that American women wanted something eye-catching, even theatrical, to wear by the water, but that their bodies were seldom up to the look. To solve this problem, she wielded scissors and thread in a way that would help these women not to conceal their bad points but to reveal their good ones. She was a great adaptor, translating European whimsy and dash into American fit and wearability.

Schnurer introduced the bra-top and pants combination in 1931, the forerunner of the two-piece suit. Her own showroom models were so horrified by the unprecedented exposure of bare midriff that they refused to put it on. Finally, a strapping blonde was found with the temerity to model this wanton garment at a fashion show. It caused a furor and sparked a modest demand among a select group of extremely wealthy women, leading Schnurer to formulate her famous axiom that, "the more money a woman has to spend on clothes, the less she wears whenever possible."

Fueled in part by New Deal programs that sponsored the construction of swimming pools, swimming became immensely popular in the 1930s.

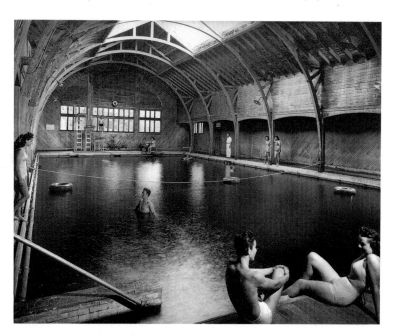

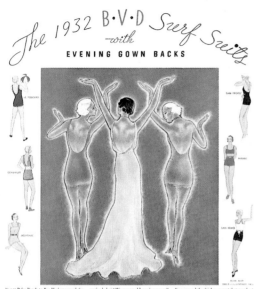

The 1932 B·V·D Surf Suits
—with—
EVENING GOWN BACKS

From Palm Beach to Bar Harbor spread the news of a great revolution in bathing suits. B.V.D. did it. B.V.D., with famous New York stylists and artists, had designed the smartest bathing suits that ever appeared on a beach or balloted a breaker.

... bathing suits with low-cut backs! ... bathing suits as smart, and as flattering, as the new evening gowns!

These new 1932 models are a triumph superimposed upon a triumph. They have the look of the hand-knitting of France. In this year of grace, 1932, you simply have to wear perfi-knit or ripple-knit! Wear your old evening gown if you must. But don't step out into the brilliant sunshine of the beach in anything except this new kind of bathing suit!

High waist-lines are out in these suits — grand lines around the thighs — a cup that your best dressmaker, even if she lives in Paris, couldn't excel. These new B.V.D. Surf Suits are a success — the Florida season proved it.

Old style suits are out—definitely out. You might as well wear bloomers and mutton-leg sleeves! But if you want to look over the grandest bathing suits you have ever seen, send in your name and we will have a shop in your vicinity smart enough to have ordered them. We will be happy to send you the name and address of the shop.

The B.V.D.Co.,Inc.,Empire State Bldg., N.Y.C.

B·V·D

Socialites primp in cellophane suits, alleged to permit full-body tanning.

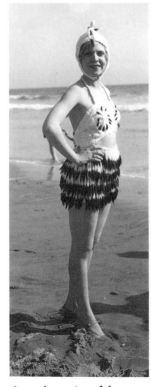

An early version of the peek-a-boo suit with bared midriff was made entirely of ermine tails.

77

The development of swimsuits in the 1930s unrolled against a background of economic upheaval, national disillusionment, and confusion. It was a period that called for dramatic solutions and challenged the imagination. Most of all, it was time that stimulated dreams and fantasies of tomorrow that would grant everyone everything the present had denied. Designers—along with artists, actors, and filmmakers—kept pumping the adrenalin of optimism into America's veins. By the end of the decade, the dread Depression vanquished, the era's brilliantly innovative designers seized their greatest challenge when their talents were recruited for the 1939 New York World's Fair.

The theme of the fair, "Building the World of Tomorrow," was the perfect culmination for an era of deprivation and the ideal vehicle for the talents of the new designers. Together, they summoned up a vision of a future where science, technology, and design molded a healthy, just, and happy society. Symbolic architecture, models, dioramas, murals, multimedia pageants, and participatory exhibits enacted this utopian preview for an audience of millions. At the ideological core of the fair lay *Democracity*, a "symbol of a perfectly integrated, futuristic metropolis pulsing with life and rhythm and music." It was a scaled down miniature rendition of the ideal city. Unhappily, *Democracity* was a barren place, a city without the laughter and shriek of people giddy with the sun and the sea and the air. It was, moreover, too abstract and remote in its perfection to serve as much of an inspiration.

There was, however, an alternative already in existence some 3,000 miles to the west. On the banks of the Columbia River stood Aquacity of Tomorrow, an amusement park conceived around the theme of water and its joyous benefits. Jantzen Beach, as the park was called, was a "clean, wholesome outdoor playground" that sprang from and catered to the messy vitality of the popular imagination. In 1926, Paul H. Huedepohl, an outdoor amusement expert, had joined Jantzen Knitting Mill's promotional arm. A visionary authority on water sports, he nourished a "dream to build the perfect swimming pool." Before long, his idea mushroomed into a plan for a lively amusement park that would become Portland's answer to New York City's Coney Island. A local architect, Richard Sundeleaf, was engaged to design a place "where thousands came to ride the Big Dipper, swim in the pools, have a family picnic under the trees and then dance the night away, to the big band sound in the Golden Canopy Ballroom."

Part palace, part warehouse, and part mausoleum, the Golden Canopy Ballroom melded Beaux-Arts gentility with industrial pragmatism. To keep in shape for those long nights of "Dancin' at Jantzen," Portland's fox-trotters spent their daytime hours pursuing the "secret of health and beauty" in the crystal waters of the park's four swimming pools. "Health builds a likeable personality," ran the company's ad, "and swimming in the great outdoors in clean safeguarded pools is the ideal place to find it." The Natatorium, as the bathhouse was called, and a spectacular poolside fountain gave this healthful pursuit a delicious aesthetic dimension. A cascade of graduated streamlined plates, "over which a million gallons of pure crystal-like water flowed each day," was placed in the mammoth bathing pool, and its perimeter was buried beneath several tons of Columbia River sand, justifying the park's appellation of "beach." Unfortunately, the sandy experiment was short-lived since the sand was chronically clogging the pool's filtration system. Some 2,500 bathers passed through this aquatic Eden every day, and a good number of them flexed their muscles and tucked in their tummies in zippy Jantzen suits.

By night, Aquacity of Tomorrow was ablaze with thousands of flickering electric lamps while the soft river air vibrated with thunderous bass notes emanating from the Golden Canopy Ballroom. In its heyday in the 1930s and 1940s, as many as 4,000 dancers crowded nightly into the Jantzen Beach Golden Canopy Ballroom to hear the swing kings of the time. They danced to Tommy Dorsey, Stan Kenton, Benny Goodman, Dick Jurgens, and Woody Herman, gaining musical—and aquatic—respite from the cares of the Depression and war years.

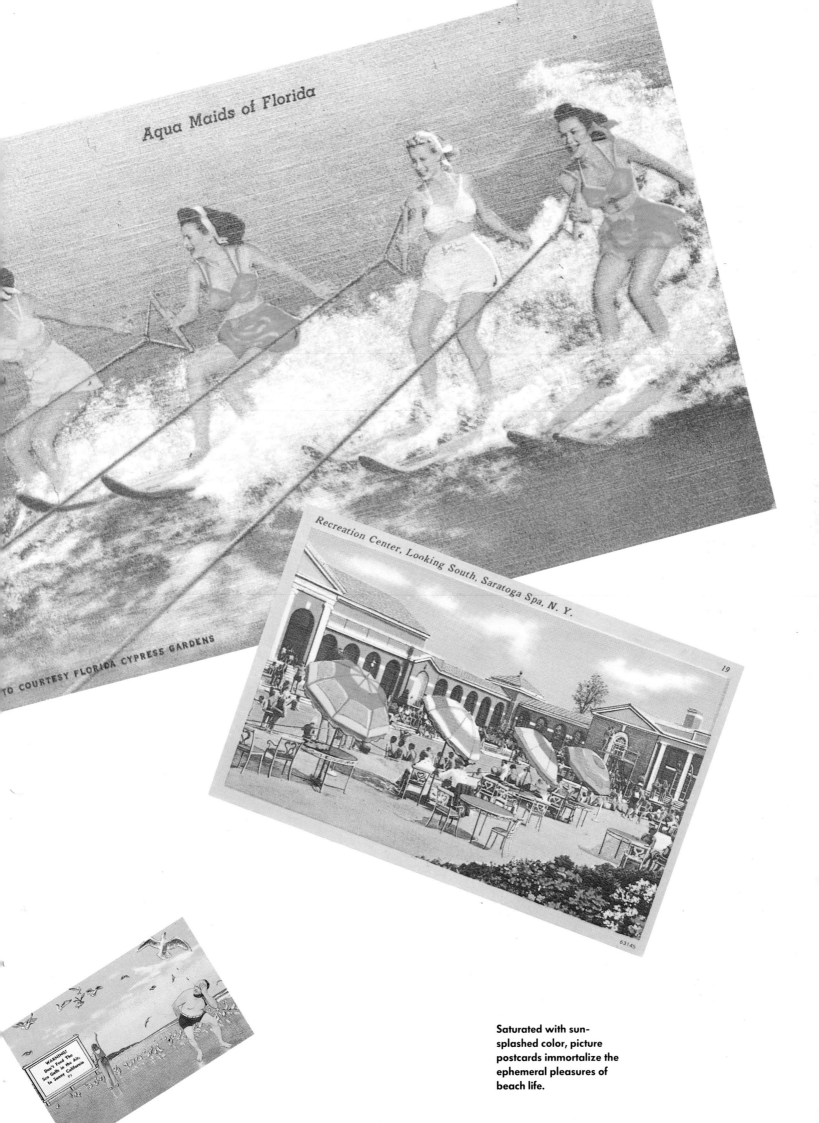

Aqua Maids of Florida

TO COURTESY FLORIDA CYPRESS GARDENS

Recreation Center, Looking South, Saratoga Spa, N. Y.

Saturated with sun-splashed color, picture postcards immortalize the ephemeral pleasures of beach life.

5

lthough far from the bombs and bullets
of World War II, Americans in the early 1940s
were obsessed with themes of survival, aggres-
sion, and procreation. Films, magazines, bill-
boards, and popular music crackled with the
tension of international conflict and the fatigue
of wartime.

Reflective of the significant changes
caused by the war, the abstract ideal of the female
torso was being reshaped. By the end of the de-
cade, the streamlined vision of the thirties siren
had sprouted traditional female curves. The
bosom gained new prominence, and women of
all endowments could count on clever founda-
tion garments to provide the bustline of their
Hollywood-inspired dreams. When it came to
camouflaging waistline bulges, playing up long
American legs, and offering unlimited opportu-
nities for built-in, figure-flattering gadgets, the
one-piece suit was the uncontested favorite.

Since the 1930s, however, the two-
piece suit had become an important presence on
American beaches. Exposing a mere five inches
of midriff, the divided suit was always equipped
with a generously styled bottom, but as the
decade progressed, fanciful cutouts began to
appear along the sides of the swimsuit. In
Jantzen's "Taboo"—a model described as "a
dream come true"—a diaper trunk was tied into
large bows at the back of the waist and at the
thighs, leaving a tantalizing smidgeon of hip
exposed to the sun.

While the human back remained as
exposed as it had been in the thirties, it took on a
minor role, mainly as counterpoint to the promi-

In 1943, as American troops helped bring about Italy's surrender, the "bust decade" was being pre-pared in design studios at home. The era of the pinup girl, exemplified here by Rita Hayworth, was erupting from sea to shining sea.

Modeling the 1946 "Savage" suit and Lastex swim trunks, the young James Garner was the personification of healthy male adolescence.

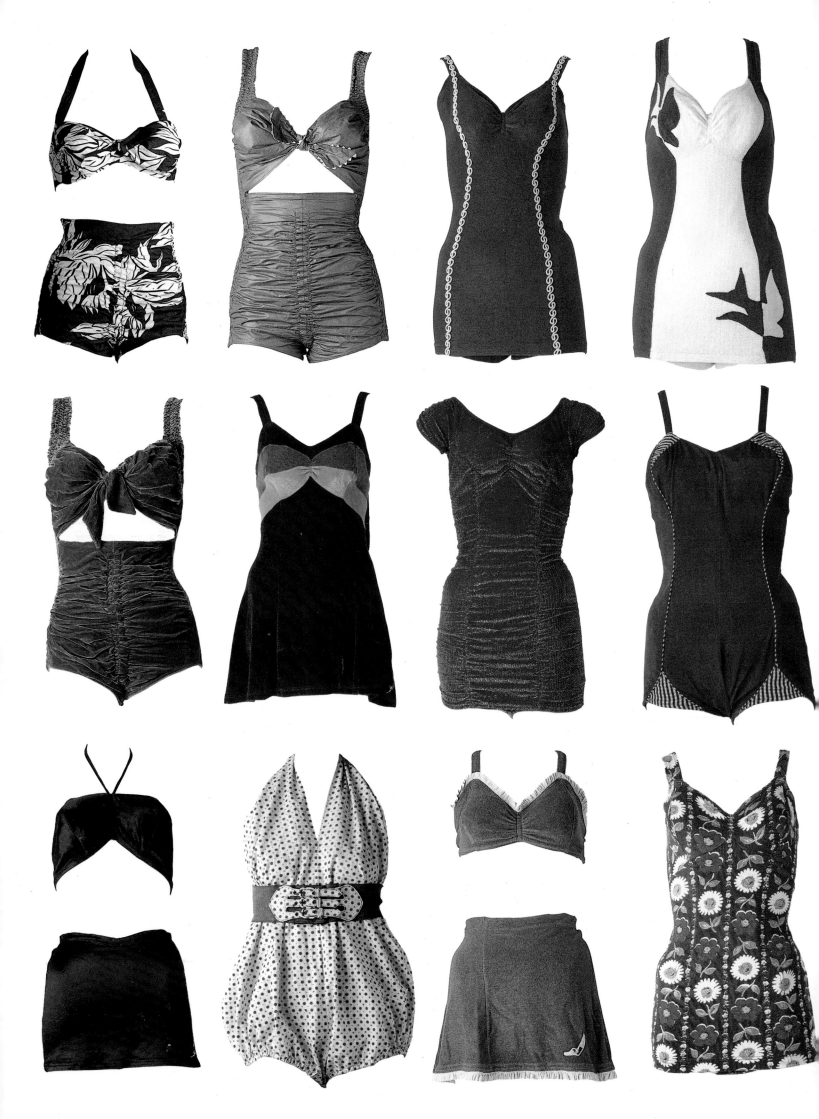

nently showcased front. Structured to mold, control, and stay put, the new suits were the product of the same engineering skills that had created the deadly marvels of modern military technology. Beneath a simple yard of material was concealed a multitude of ingenious tricks: built-in wire bras, stretchable shoulder straps, and skirts with the cling of a girdle. A skillful combination of shirring, cutting, and tucking drew the eye to the bustline, while powerful Lastex panels disciplined the hips and the abdomen.

Torpedo-shaped tops presented the breast as a deadly weapon. With the help of foundation features such as Jantzen's "Beauty-Lift Bra," a high, graceful bustline was within reach of every woman.

Men's swimsuits replicated the narrow hips and smooth abdomen of women's styles, resembling girdles in the strict control they imposed on the lower torso. Most manufacturers continued to stock convertible swimsuits through the 1942 season. The "boxer" short became an increasingly popular style, available in geometric prints, batiks, and picturesque South Sea island designs. Dressier swimming attire for men featured high-waisted shorts with zippered closure, tailored coin pockets, and side pleats.

The war required the swimwear industry to put its knitting machines and cutting rooms at the disposal of the military. Jantzen's production lines spat out everything from sleeping bags and tents to cardigans and caps. Cole of California specialized in parachutes, producing some 250,000 by the end of the war and garnering the first wartime Army-Navy award for parachute making. Fred Cole would recall that his biggest thrill came on June 6, 1944, when he received a telephone call from an American officer. "Mr. Cole," the excited voice on the line informed him, "4,000 Cole parachutes have just landed in Normandy."

Although rationing was in effect between 1942 and 1946, swimwear manufacturers did not let the country go begging for style. In fact, wartime shortages drove designers to scour military technology and provisions for inspiration and materials. For a time, a drab palette of "camouflage" colors was all the rage on the beach. As restrictions reduced the quantity and styles of fabric, companies learned to do more with less. Sources of silk, still an important ingredient of swimsuits, dried up, and wool, that "old reliable" of the swimwear industry, retreated from the sands, leaving linen, cotton, sharkskin, and rayon.

Lastex, the rubber-based foundation of form-defining textiles, was in short supply, forcing swimsuit makers to develop new construction techniques that would deliver the fit and cling of elasticized fabrics. In 1943, the "year rubber went to war," Cole's Margit Fellegi reached deep into her bag of tricks and pulled out the fabulous "Swoonsuit." Made from parachute silk that Cole was fabricating for the military, Fellegi's suit featured lacing up the sides of both one- and two-piece models that delivered the same snug fit of the rubberized textiles.

At the end of the war, the garment industry did a rapid about-face, abandoning natural textiles in favor of new artificial fibers that had been perfected for military purposes. Synthetic yarn production burgeoned in the United States, and an ever-increasing number of man-made fibers streamed out of laboratories. Among the most popular for swimsuits were Celanese rayon, satin Lastex, and Nylastic, a special blend of nylon and laton which was exceptionally light-weight, quick-drying, and as "flexible as skin." Suits made of Lastex were often ornamented with hand-painted designs ranging from bucking broncos and flying fish to tropical flowers and pale pink cherubs.

By the end of the decade, swimsuit design was clearly aimed at flattering feminine silhouettes. By far the most potent impetus for the curvaceous ideal came in 1947, when Christian Dior's "New Look" captivated fashion on both sides of the Atlantic. Women who had entered the work force in traditionally non-feminine occupations, manning conveyor belts in truck plants or welding plates on Liberty ships, were aching for old-fashioned femininity. Then too, the horrors of the war had spread a vague discomfort with the mechanization of modern life. Nostalgia was in the air and fashion became self-consciously historicizing. Parisian haute couture was strongly influenced by the eighteenth century of Louis XV and especially by the fanciful costumery rendered in the paintings of Antoine Watteau. Vast swells of tulle billowing from graceful waists, rounded rosy shoulders above cunningly crafted bodices, and witty hats poised on artfully composed coiffures were only starting points for the ultrafeminine look that dominated the postwar years. As one American of the period put it, "One *expected* to be corseted."

The dimensions of the ideal bosom grew by leaps and bounds, as did the fascination with finding means of supporting and shaping this prodigious asset of American womanhood.

◄
By the end of the forties, the tubular tomboy ideal of the thirties had sprouted ripe womanly curves. Most suits could be worn with or without straps, depending on the wearer's fancy. Fabrics ranged from satin Lastex, some with hand-painted designs, to Nylastic, a special blend of the recently introduced nylon and laton which was exceptionally lightweight, quick-drying, and as "flexible as skin."

Professional undergarment designers and lay tinkerers alike zealously applied themselves to solving this problem. They came up with everything from wire boning and intricate seaming to clip-on brassieres and adhesive bra cups, devices that threatened to transform the female bosom into a Dixie-cup dispensary.

Hollywood and the fashion industry collaborated in promoting the bust decade. Movie studios churned out musical extravaganzas, many featuring aquatic ballets that paraded hundreds of bosomy beauties in sequined, skirted swimsuits. The most popular—and influential—in this cast of mermaids was Esther Williams, whose generous curves were set off to perfection in a feverish rash of "apple-pie-on-water" escapist films made by MGM. Decked out in gorgeous swimsuits, the statuesque swimmer was at her best in pools decorated in Hollywood baroque where she performed aquatic ballets to Busby Berkeley routines.

Fashion consultants were recommending multifaceted "bathing wardrobes" tailored to specific beach activities. For swimming, there were formfitting elasticized suits, in either one- or two-piece models available in colorful, hand-painted fabrics. Bustle-backed dressmaker suits in cotton fabrics were promoted for tanning. Some came with matching jackets to protect against overexposure. A new category of "dressy" swimsuits emerged, complete with built-in waist control and full-length zipper to produce the fashionable new hourglass shape.

Fostering a sense of family unity, swimwear manufacturers offered matching mother-and-daughter suits. The idea of identical costumes for the young mother and her little girl was typically American and met with wild success. A 1942 version, made of white velour with red dots, shone like the coat of a seal when wet. Cut modestly in the skirt, the adolescent and adult versions featured shaped bras that were in small, medium, and large sizes.

His-and-hers "Sweetheart" suits in matching Hawaiian or Polynesian prints were available throughout the forties for couples intent on advertising their love in public. Sunstruck bathers also took greater precautions when tanning. All sorts of beach dresses, shorts, ballerina skirts, and bolero jackets became the vogue as cover-ups. A new generation of suntan lotions was developed, and fashion bulletins stressed the importance of moderation and a

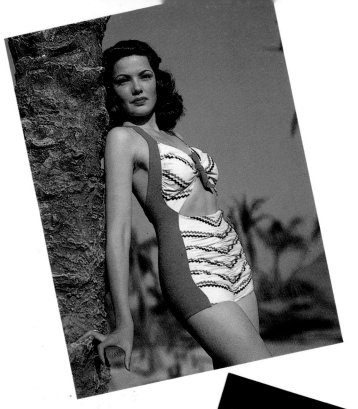

Top to bottom:
Incarnating the erotic ideal of the decade, Gene Tierney, Betty Grable, and Jane Wyman strike typical pinup poses.

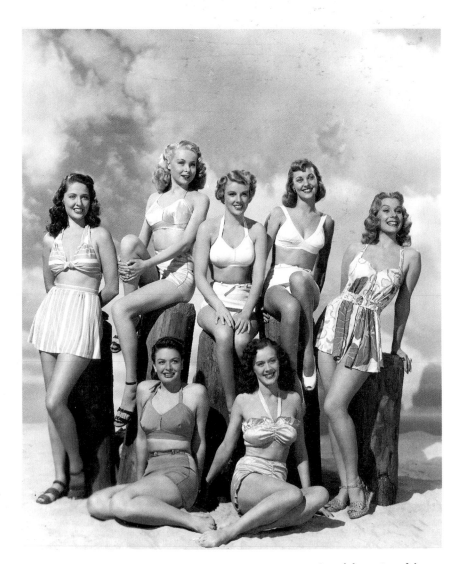

An adult version of the
Easter Parade.

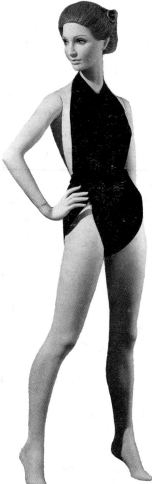

For one of her most
celebrated designs, the
"Diaper Suit," Claire
McCardell took a length of
checked cotton, the top of
which was bias cut, and
hung it from the neck in
front, passing it between
the legs and around the
hips to tie at the waist in
front. The back was com-
pletely bare above
the waist.

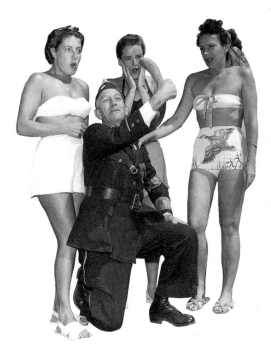

Horror-stricken, three 1949 bathing beauties contemplate the engorged thumb of an American Legionnaire at the American Legion Convention in Long Beach, California.

Twenty neckties were pressed into service as material for this natty two-piece of 1948.

In the 1940s, adventurous Beverly Hills hostesses set up "wet" bars and chamber orchestras knee-deep in their private pools.

Wasp-waisted and bosomy, a group of models stand at attention in a scene from Sam Katzman's 1948 film "Manhattan Angel."

▶ Young hopefuls try out for Billy Rose's Aquacade at the 1940 San Francisco World's Fair. Polka dots and flowers are among favorite patterns to appear on the year's short skating skirt styles.

careful tanning schedule. A typical editorial on beauty care during the summer of 1940 stressed that "it's not by accident that her architecture is frozen music and her skin like honey. She has exercised, and eaten with care. Her limbs are smooth and coated with oil to admit the sun's gentlest rays only...."

Advertising moguls in the swimwear industry turned to a new generation of graphic designers and illustrators. Jantzen launched its "intimate apparel" line in 1940 with an aggressive girdle campaign. Shortly afterward, the company commissioned *Esquire* illustrator Alberto Varga to create a new image for the Jantzen girl (the artist's last name was really Vargas, but the company dropped the "s" because it was too "gassy"). Things got spicy in the 1941 *Esquire* calendar that Jantzen mailed to 3,123 "preferred swimsuit accounts." Added to the calendar cover by Jantzen in bold typeface was an advertising blurb that read: "Meet the 1941 Jantzen Girl by Varga...She's young...she's thrilling...and ideal to every American man. You'll be seeing her this summer...in Jantzen's stunning swimsuit."

The coming of *Playboy* magazine twelve years later was apparent in the calendar's pictures alone, but the quips put the final icing on the cheesecake. Miss January's annotation read, "I've been in more triangles than the one I'm wearing." Others like, "I can't stay late, my wife isn't as dumb as your husband," or, "May, so delightful, and what a month for men, Daddys who have lost their *spring* discover it again," were sending shock (and shlock) waves through the minds of Jantzen's customers.

These successful campaigns encouraged Jantzen to continue its search for marketable flesh. With the rise of the movie industry in the 1920s, America's most saleable skin was, as it still is today, in Southern California. Jantzen hired James Garner in 1947. Plucked from among throngs of virile adolescents in sunny California, America's favorite TV detective was barely eighteen years old when Jantzen found him at, of all places, Hollywood High School and offered him $15 an hour. Garner made such waves modeling their line of "savage swim trunks" that he was chosen "Mr. Jantzen."

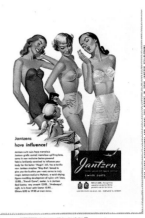

With its strapless, underwired "Stay-Bra" and tummy-control panel, the 1949 two-piece suit echoed undergarment designs of the day.

Special Fashion & Youth Promotion

While swimwear advertising projected a mood of wild abandon, bathing attire suggested strict control and even subjugation of the body.

Men's swimsuits from the mid-forties replicated the narrow hips and smooth abdomen of women's styles, resembling girdles in the tight discipline they imposed on the lower torso. Men with a more guarded attitude toward life could always opt for the "boxer-type" short.

To meet the appetite for novel "Made in the U.S.A." styles, manufacturers turned to fresh design talents, among them the world famous illustrator George Petty. His 1940 "Petty Girl" suit was rendered in the "new, superb-fitting SEA-RIPPLE with live ALL-WAY ELASTICITY."

In 1940, Italian designer Umberto Brunelleschi painted a magazine cover featuring a bare-breasted siren which was visionary in its foreshadowing of the topless suit by Rudi Gernreich.

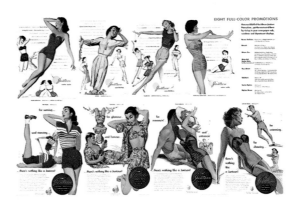

That same season, Jantzen's style books for wholesalers and retailers also featured a fair-skinned, fair-haired young beauty known at that time as Norma Jean Baker. Modeling the risqué "Double Dare" bathing suit (so-called because it afforded a glimpse of the upper thigh through two circular portholes), Baker (later known as Marilyn Monroe) seemed radiant as she stuck a two-pronged skewer through a six-inch wiener. Unlike the modeling photographs of Douglas Fairbanks, Jr., Dick Powell, Loretta Young, and others obtained through the Warner Brothers/First National trade arrangement with Jantzen in the mid-thirties, the pictures of Monroe and Garner were independent of film industry linkups. Hollywood stars soon became a standard fixture for swimsuit promotions. Established screen celebrities such as Rita Hayworth posed for swimwear spreads in family magazines, and matinee idols lent their names to popular swimsuit styles.

By far the most explosive fashion event of the forties was the introduction, in 1946, of the "bikini" or, as it was orginally christened, the "Atome." Nothing in the recent past had prepared the public for this quantum leap in exposure. In this miniscule attire, the navel, back, and upper thigh were bared in one fell swoop. The bikini was "the most meager swimsuit a woman could wear without being arrested."

Befitting an artifact of such disturbing cultural significance, the bikini claimed an origin nearly mythical in its antiquity. It appeared on Minoan wall paintings dating from 1600 B.C. and in Roman mosaics from the fourth century A.D. Six years after its "invention," the proto bikini was discovered by an Italian archeologist excavating a luxurious Roman villa on the island of Sicily. In the villa's capacious family gymnasium, Gino V. Gentili was confronted with a mosaic depicting eight female gymnasts sporting a diaperlike pantie and a strapless bandeau.

Jacques Heim and Louis Reard were the two Frenchmen who separately but nearly simultaneously launched the modern bikini. Heim, a couturier, designed the suit to be sold in his beach shop in Cannes. He called the suit the Atome in honor of its size, and the sky was the limit as far as advertising went. One sun-baked morning early in the summer of 1946, Cannes' bathers raised their tanned faces to the heavens to find a message scrawled by skywriting planes against the Mediterranean sky: "Atome—the world's smallest bathing suit."

Less than three weeks later, sun worshippers on the French Riviera were roused from their torpor by another message delivered from the heavens. This time the smoke loops spelled out "Bikini—smaller than the smallest bathing suit in the world." The man behind this aerial grafitti was Reard, a mechanical engineer who had brought the Atome a step closer to the subatomic. No one knows why Reard decided to call his suit the bikini, but the name stuck. It was, after all, the perfect tag for a fashion bombshell.

That summer, the first postwar atomic bomb was set off, and the announcement of the test had caused panic among Parisians. Many people speculated the blast would be some kind of superbomb that might go out of control and start a chain reaction that would blow the world to smithereens. The apocalyptic cloud that hung over this event fueled a flurry of "end-of-the-world" parties. When word leaked that the test was near a remote reef called Bikini in the South Pacific, these celebrations quickly evolved into "bikini parties."

The bikini suit was worn for the first time by French model Micheline Bernardini for a poolside fashion show at the Piscine Molitor in Paris on July 5, 1946. A number of American correspondents covered the show for the *Herald Tribune*, which ran nine bylined stories. The lead piece by Tex O'Reilly, bureau chief, treated the risqué garment with typical Texan insouciance: "There was a row of girls paradin' around in scanties and the judges were workin' overtime," he wrote. "Every one of 'em, I mean the girls, were as pretty as a spotted pup under a red wagon, but then all of a sudden, a blonde named Micheline Bernardini ambles out in what any dern fool could see was the smallest bathing suit in the world, including West Texas. Why folks, that suit was so small that...."

The swimwear industry received a steamy injection of Hollywood glamour when costume designer Margit Fellegi began to create plunging necklines, bare midriffs, and golden lamé jerseys for Cole of California. Fellegi's "Midriff Suit" of 1940 stirred up considerable excitement with its tie bra, cutout middle, and laton taffeta fabric.

In 1947, Jantzen's style books for wholesalers featured a fair-skinned, fair-haired young beauty, known at that time as Norma Jean Baker, modeling the risqué "Double Dare" bathing suit—so called because it afforded a glimpse of the upper thigh through two circular portholes.

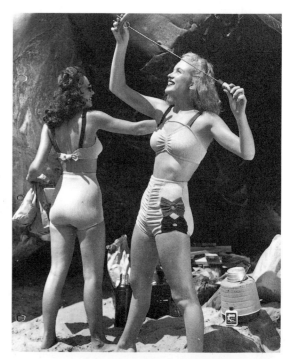

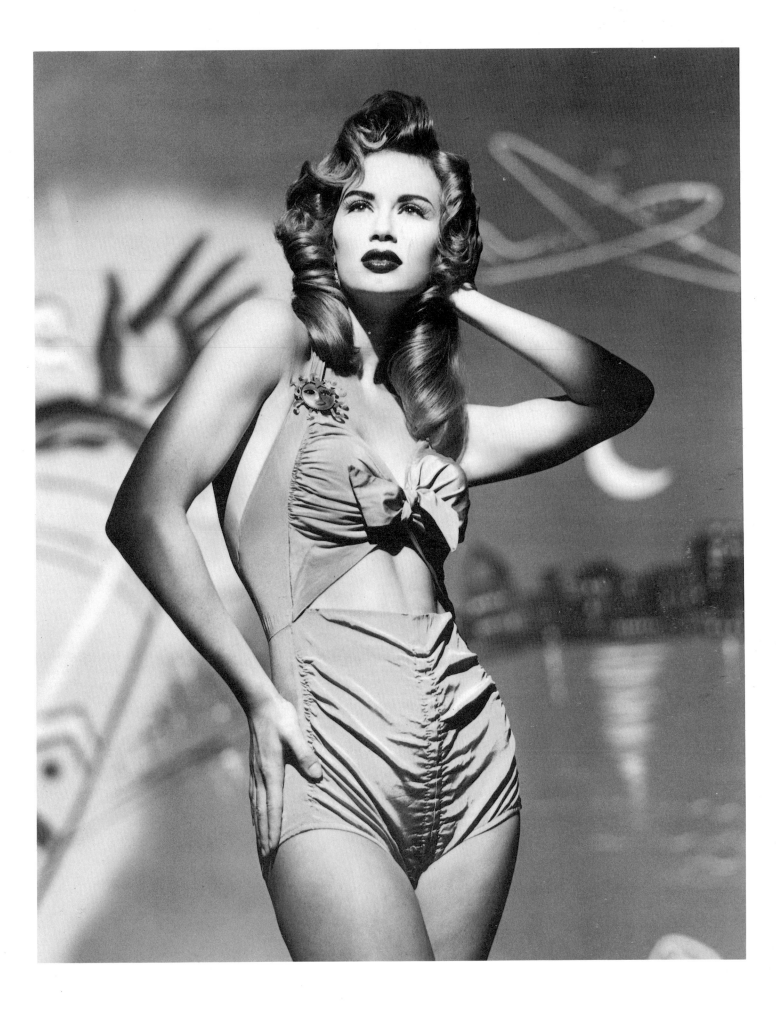

The quintessential tease, this sketchy garment was a provocation to fashion as much as to convention, for the bikini compressed the latest "look" into less than a square foot of fabric. All the subtle inflections of fashion could be expressed in the details of textile, fastenings, ornament, and the shaping of the bosom. As subsequent history would show, the bikini was more than a skimpy garment. It was a state of mind.

In the years to come, the garment that "revealed everything about a girl except her mother's maiden name" would inspire countless variations using only three patches of cloth. Two smidgens of lace across the nipples and another across the crotch were sufficient to suggest romantic dress. A silver breastplate and codpiece conveyed a gladiatorial chic. One high-tech designer affixed propellers to each breast and equipped each with its own solar collector. Another concocted a suit entirely of red hair, which was certainly less discomforting than a version fashioned out of porcupine quills. So small that it could easily fit into a matchbox, the inflammatory garment would undergo even more drastic shrinkage in subsequent decades until it would be little more than a giant set of quotation marks.

Americans were horrified by the spectacle of so much bared female flesh and by the novel exposure of the navel. "American women would be scandalized and would never wear such a crazy thing," manufacturers from coast to coast told the suit's inventors, intimating that naughtiness was a distinctly French trait. And, for a little over a decade, they were right. Banished from public beaches and scorned at private clubs, bikinis were reserved only for private sun bathing. Hollywood's Esther Williams recoiled from the skimpy two-piece. "Why, they come off in the water," the swimming beauty remarked. "If you can't swim in them, what good are they?"

In an era that favored the one-piece swimsuit as the All-American beach costume, the bikini spelled trouble. Not only decency, practicality, and chic seemed to ride on the choice between the one-piece and the bikini. Patriotism itself seemed to be at stake.

Bert Goodrich and Alan Stephan, Messrs. America 1939 and 1946 respectively, congratulate each other in matching leopard-spotted posing trunks. This skimpy style would not appear on American beaches until the 1960s.

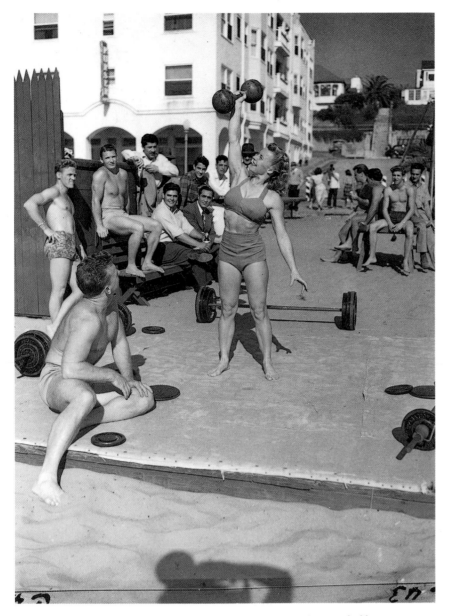

Surrounded by an appreciative audience, a female muscle builder struts her stuff on Muscle Beach in 1946. She is wearing that year's newest style, the bikini, which was described as a "two-piece bathing suit that reveals everything about a girl except her mother's maiden name."

"After meekly following where Paris led in the matter of longer skirts and padded hips for dresses," a reporter for *Life* magazine wrote in June 1947, "American designers are now taking a firm stand of their own on the matter of bathing suits." The bikini inspired a decisive backlash in the trend toward the covered-up look. "For now and next summer," wrote Amy Porter for the *Collier's* of 1946, "the smart-fashion money is on a return to the cover-up technique."

Perhaps because it gave something of a "bad name" to French design, the bikini also helped reinforce the climate favoring the growth of an autonomous American sportswear tradition with its own galaxy of star designers. It now became possible for a small but gifted group of Americans to meet the challenge of creating stylish and practical clothing responsive to distinctly American needs and tastes.

Claire McCardell, Tina Leser, Bonnie Cashin, Vera Maxwell, Joset Walker, Dorothy Cox, Clare Potter, and Sydney Wragge were just some of the talented pioneers in the fledgling American sportswear industry. Yet their contributions to swimwear fashion, while often brilliant and visionary, had little immediate impact on mass-market styling. Rather, they challenged reigning conventions, offering an alternative approach to clothing the body that, while as American as mainstream design, articulated a more thoughtful, and even "liberated" view of femininity.

A steady infusion of Hollywood costume designers into the swimwear industry quickly established Southern California, and especially Cole of California, as the premier purveyor of theatrical swimsuits. The swimwear industry received an injection of Hollywood glamour when costume designer Fellegi created alluringly plunging necklines, bare midriffs, and gold lamé jerseys for Cole of California. The East Coast, by contrast, acquired a reputation for discreetly ladylike costumes, daintily ruffled and elegantly understated.

The swimwear industry, dominated in the 1930s by a handful of major firms, suddenly blossomed with small and medium-sized companies. Since fashion had shifted from woolen knits to synthetic materials and natural blends, manufacturers were no longer tied to large investments in knitting machinery, and the new technology of fibers introduced a healthy flexibility into the swimwear industry itself, bringing with it the possibility for considerable stylistic diversification and the creation of specialized markets.

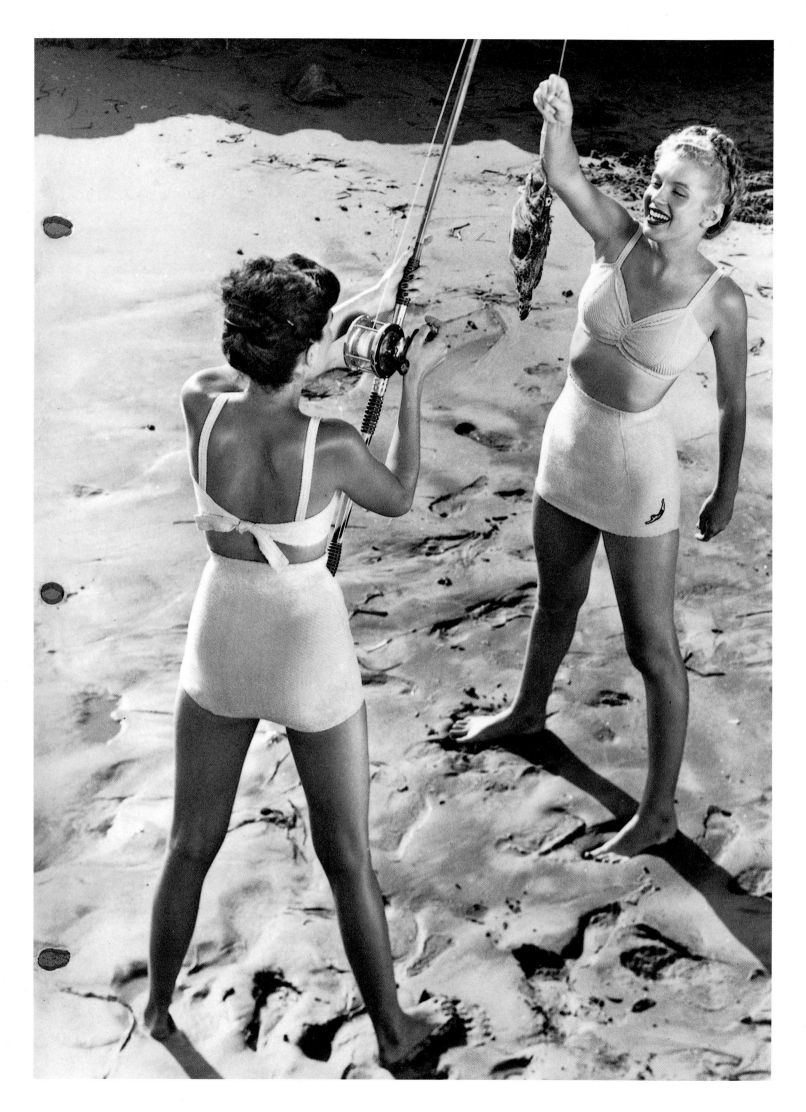

The shining star of American design was Claire McCardell, who has often been called the originator of "The American Look." An upper-middle-class Marylander, she studied fashion design in New York and Paris, and designed the kind of clothes she herself liked—inexpensive but intelligent and practical.

Her timeless, beautifully draped garments were often acclaimed as examples of modernism in fashion design. The Museum of Modern Art exhibited her work in the mid-forties, prompting *Look* magazine to speculate that this was "probably the first one-man show of dress designs exhibited just like any other works of art."

At a time when the "giants" among swimsuit manufacturers were embracing synthetic fabrics and turning out swimsuits with the look and cling of foundation garments, Claire McCardell was using natural materials and draping them over the female form to create a bold new fashion statement. Her designs were intended for women who liked to wear clothes that let them do what they had to do without constraint. This was a legacy that McCardell would pass on to Rudi Gernreich, her leading disciple on the West Coast, and to Calvin Klein in the East.

The "miracle" Lastex-based yarns that were the stock-in-trade of mass-market swimsuits were totally unacceptable to McCardell. "Fabric is to me all-important, both in swimming and under the umbrella. I prefer unshiny materials: knits, smooth wool, dull-surfaced cottons." She also disapproved of fluorescent colors and the novelty metallic knits, finding that "gold and lamé look better under the moon." Her favorite colors, usually in wool jersey, were black, gray, and sand. Wartime restrictions did not pose any problems for the designer who gravitated toward what were then considered "pool" textiles such as cotton, mattress ticking, seersucker, and even denim. Power fabrics and bosom supporters met with McCardell's disdain. "Don't wear bathing suits that look like foundation garments," she counseled, emphasizing the fact that a flattering fit depended less on firm fabric than on figure and style.

Swimsuits designed by McCardell were usually cut just like her favorite dresses and featured her signature "spaghetti" or shoestring ties—thin bias cords that could be wrapped around the waist, neck, or shoulders—along with sturdy gilt hooks and eyes and bold belts. In 1946, hard on the heels of the bikini, she designed a much acclaimed cover-up bathing suit that showed a quasi-Grecian inspiration in the soft draping of fabric caught below the bust and at the waist by shoestring ties.

Unfortunately, McCardell's brand of originality was hard to sell to a public hypnotized by the mannered and contoured silhouettes of the forties. Designs emphasizing natural lines and fabrics would not become truly popular in the United States for another decade. First, Americans would have to survive the fifties, a time of conservative ideas and fashion excess.

In 1949, Charles L. Langs, a Cadillac grill chrome-plater from Detroit, devised the first adhesive brassiere composed of two Dixie cup–like cones trimmed with ruffles. Strapless, wireless, and backless, the cups were lined with an adhesive ring that was glued to the fabric to provide shape and was good for only a single dip in the water. The bather had to renew the glue after each wearing by applying "rejuvenator" from a bottle. These intriguing articles of clothing, guaranteed to stick tight even through a dive from a ten-foot board, were called "Poses" (pronounced pose-ease). Langs, who had planned to flood the market with 200,000 pairs per day, found instead that his adhesive bra turned out to be a barely perceptible blip in the evolutionary line of the swimsuit.

Wearing the "Temptation," a no-frills solid-body two-piece, the young Marilyn Monroe has the look of a playful predator as she admires the dessicated remains of a fish still affixed to a hook.

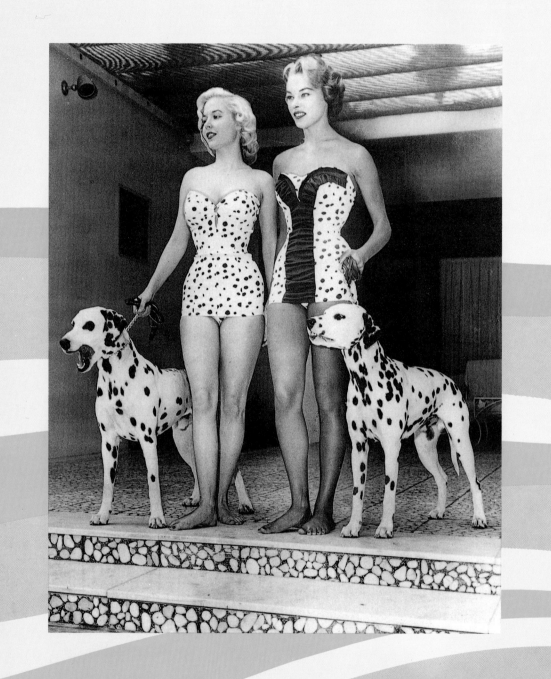

Reconstruction and Deconstruction

After World War II, swimwear manufacturers began to craft garments for an American buoyed by postwar optimism and soothed by the serenity of the Eisenhower years; for a country hypnotized by the marital bliss of Ozzie and Harriet, by sleek-finned automobiles, and by Marilyn Monroe who was taking the nation on a one-way journey to fantasy land. Increasingly, designers began to style suits for women whose bodies were being changed by motherhood. With their bold protuberances, architectonic styling, and glittering fabrics, swimsuits were uniquely tailored—both in spirit and substance—for an era characterized by leisure, affluence, and modernity. And by a consuming romance with the automobile and all its stylistic excesses.

In fact, like automobiles of the era, the signature of 1950s swimsuit silhouette counterposed jutting angles against bulbous shapes and curves. Pointed breasts—or "high beams" as they were jocularly known—surmounted wafer-thin torsos that flared gracefully from wasp waists to slim hips. The "Merry Widow" corset and radical developments in foundation garments had a powerful impact on the look of the new suit. Engineered with rubber elastic fibers and fortified with boning, underwiring, and doubled panels, these structures represented what one commentator called the "Sherman tank line of corsetry."

Jayne Mansfield, the decade's archetypical va va voom girl, explained in 1952 that for a woman to look right in a swimsuit she needs "a flat tummy, a firm bosom and a nice derriere. Then you're in business." Responding to the needs of a woman who lacked these minimal requisites—or at least thought she did—the sportswear industry invented the "constructed suit," a milestone in the history of swimwear design. Never before had so much engineering skill gone into fabricating such a frivolous artifact. The sculpted suit developed an awesome capacity to control and glorify the female body. Built as cunningly as corsets, many suits were

The black-and-white spotted "Dalmation" suit of 1954 drew its inspiration from the canine world.

boned at the sides to produce a smooth, long torso. Bras were wired, lined with a layer of foam rubber, or molded with pellon, a fabric used to stiffen petticoats, to shape the fashionably high, pointed bosom.

New materials and fabrication techniques were critical for advancing the cause of the structured suit. As quickly as the petrochemical industry produced new types of plastics, foams, and rubber compounds, they found their way into the support structures of swimsuit brassieres. Before cosmetic surgery had perfected breast augmentation procedures, padding was the only solution for small-busted women. In the late 1940s, constructed swimwear began to feature sewn cups that were shaped entirely by elaborate cutting and stitching techniques. The shapes which could be produced by this method, however, did not correspond to the geometrically pure ideal of the fifties. The new bosom demanded a considerably more mannered and artificial look than the pneumatic, rounded bust popularized by the previous decade's pinup girl. Moreover, the sewn bra cup was made with seams, which had a tendency to show through the stretch fabrics.

The fashion of the day dictated a bosom cantilevered over a pinched waist in a manner reminiscent of the canted roof of a Googie coffee shop or drive-in restaurant. While any soft material could be used as padding under street clothes, swimsuits demanded more innovation. The foundation industry rose to the challenge with devices that sculpted the bosom while augmenting it. Brassieres came equipped with everything from ventilated foam rubber pads to nippled rubber cones—or "falsies"—as well as inflatable prosthetics that could be blown up to the wearer's specifications.

The reintroduction of corsetry and controlled construction in swimsuit design was as much a result of cultural intangibles as it was of practical considerations. Though it might not have seemed so superficially, the "neo-Victorian" swimsuit of the 1950s was intended to clothe bodies in a way that would transform average women through the magic of what one manufacturer called "shapemakery." The mass-market swimsuit was specifically created to bolster the figures and self-esteem of women who, according to the strict criteria of contemporary fashion, were deemed "losers." *Holiday* magazine's Tony Robin put it gently, "Most women are neither athletes nor models, so some figure-control is required in their beach wear."

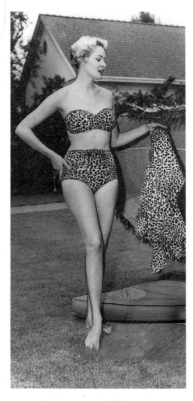

In 1954, women could mimic an entire bestiary of savage fauna. Fellegi designed a collection of shirred, fur-imprinted cotton suits in zebra, leopard, and tiger prints, while Brigance came out with a toothsome crocodile style.

Burt Lancaster and Deborah Kerr in the memorable "torrid" scene from the 1953 Columbia film "From Here to Eternity."

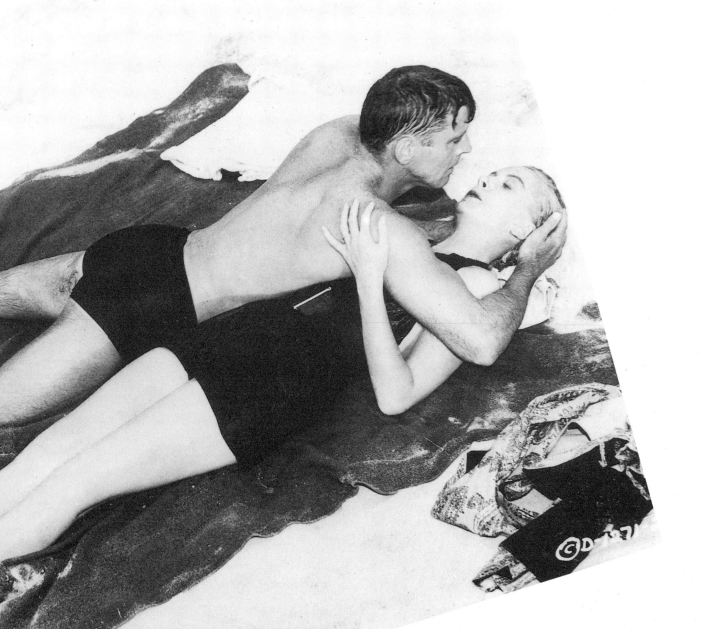

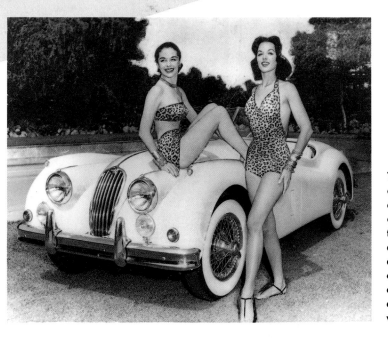

The "Female Animal" line of suits projected woman as ferocious feline with expensive tastes, though the advertising hype advised a less grasping attitude. Consoling impecunious swimmers, it counselled, "If you can't drive a Jaguar, wear one."

By showcasing suits such as the $1,000 "Salute to Spring," a flesh-colored mesh garment studded with rhinestones, manufacturers encouraged the American woman to be as style conscious on the beach as in the ballroom. Cole fueled the fad for these theatrical garments with a special line of "glamour suits" that helped bring attention to its mass-market collections. Early in the decade, Fellegi designed a jeweled line worth hundreds of thousands of dollars to show in cities across the country. Surrounded by Brink's guards and clouds of publicity, the suits were especially popular among affluent Texas matrons who had them special-ordered at upwards of $250 per garment, to wear to pool parties.

In part, the glamour look was the result of a "trickle-down" theory of design. Cole of California, which consistently produced the most stunning mass-market suits in this mode, made a point of studying what was being worn by the rich and famous at winter resorts. His scouts would then translate their observations into designs that brought the "rich" look to women of modest means. Fred Cole, who had been called a "sotty C.B. DeMille," pushed his line of snazzy suits with a series of flamboyant promotions. He lived in a $250,000 house with an Olympic-size pool overlooking Sunset Strip. Both house and pool were normally filled with flocks of tittering, splashing girls. Recalled one *Saturday Evening Post* correspondent, "Poseidon only knows how many magazine layouts and TV shows were set against a background of Cole cuties."

As competition for the designer swimwear market reached a fevered pitch, other American manufacturers sought to collaborate with famous French designers to add glamour to their products. The Yves St. Laurent influence was noticeable in the "trapeze" silhouette of 1958. Originally intended for street clothing, the look was also known as the A-line and was brought out in Jantzen's textured knit, designed—"with a Paris flavor"—by Fernand Lafitte. The fact that prominent French designers should have consented to work with American manufacturers was taken as a testament to the growing maturity of this country's swimwear industry which, by now, could claim global preeminence in this arena of sportswear. As one correspondent for *Holiday* magazine put it in June 1956: "The American bathing suit is now the world's classic suit, exported everywhere, imitated everywhere around the globe."

Since swimsuits of the era depended heavily on innovations in the foundation industry and while any soft material could be pressed into service as padding under street clothing, swimsuits were appreciably less forgiving. Bust pads fashioned from nylon horsehair, a coarse nylon mesh material that became available at the turn of the decade, bestowed the requisite conical shape to the breast but unfortunately had no "memory" under the stress of powerful swimwear fabrics, which tended to crush them. Moreover, if the discrepancy between the pads and the wearer's endowments were too great, these cups collapsed under the least pressure. For manufacturers and bathers, the future of the "new look" in the swimsuit depended on finding a better bust pad.

In 1951, Herbert Nigetson, founder of Metric Products, Inc., discovered a method for wedding plastic to textiles, producing a seamless, molded cup which combined a plastic copolymer shell bonded, on one side, to a polyurethane foam, and on the exterior, to a soft stretch nylon fabric. The "Curvelle," as this bra cup would eventually be known, marked a major advance for swimwear. It was fast drying, impervious to swimming pool chemicals, and comfortable to wear. Metric's contour-formed rubber cups could be molded into any shape and had the outstanding ability to "remember" their contours.

Though not as flamboyant, the male bathing costume kept pace with developments in the female suit. An antidote to the dreary dullness of the gray, three-piece business suit, the man's swimsuit exploded with colorful patterns and fanciful detailing. "Cabana sets"—matching boxer trunks and roomy shirts in vibrant prints—enjoyed tremendous popularity. The once staid boxer trunk became a screen on which a man projected everything from his taste in art and hobbies to his secret obsessions.

In fabric and detailing, men's suits mirrored women's trends so accurately that America's beaches could easily have been filled with matching couples. Neither sex had a monopoly on stripes, Glen plaids, dusky batiks, Hawaiian prints, atomic swirls, or submarine landscapes. And the same animal prints that stalked women's suits appeared on men's boxer short and cabana sets, with pony prints and zebra stripes the leading patterns. Among the most endearing was the "Lounge Lizard Cabana Set," a boxer short in cotton broadcloth with matching overshirt in a geometrical lizard print.

▶

A modest woman with conservative Mormon values, designer Rose Marie Reid capitalized on the trend toward one-piece suits that afforded more coverage. For the most part, she preferred the sheath sillhouette, making it the foundation of her line. Though she recognized the fashion appeal of tanned skin, Reid never compromised her penchant for modest high style.

The glamour suit became important during the quiet but affluent Eisenhower years. Manufacturers promoted the concept that the American woman was as figure- and style-conscious on the beach as in the ballroom, and fashion shows around the country featured suits such as the $1,000 "Salute to Spring," made of flesh-colored mesh and rhinestones.

An unusual mosaic swimsuit was assembled from small colored squares of lightweight plastic. It was waterproof and alleged to be "swimmable."

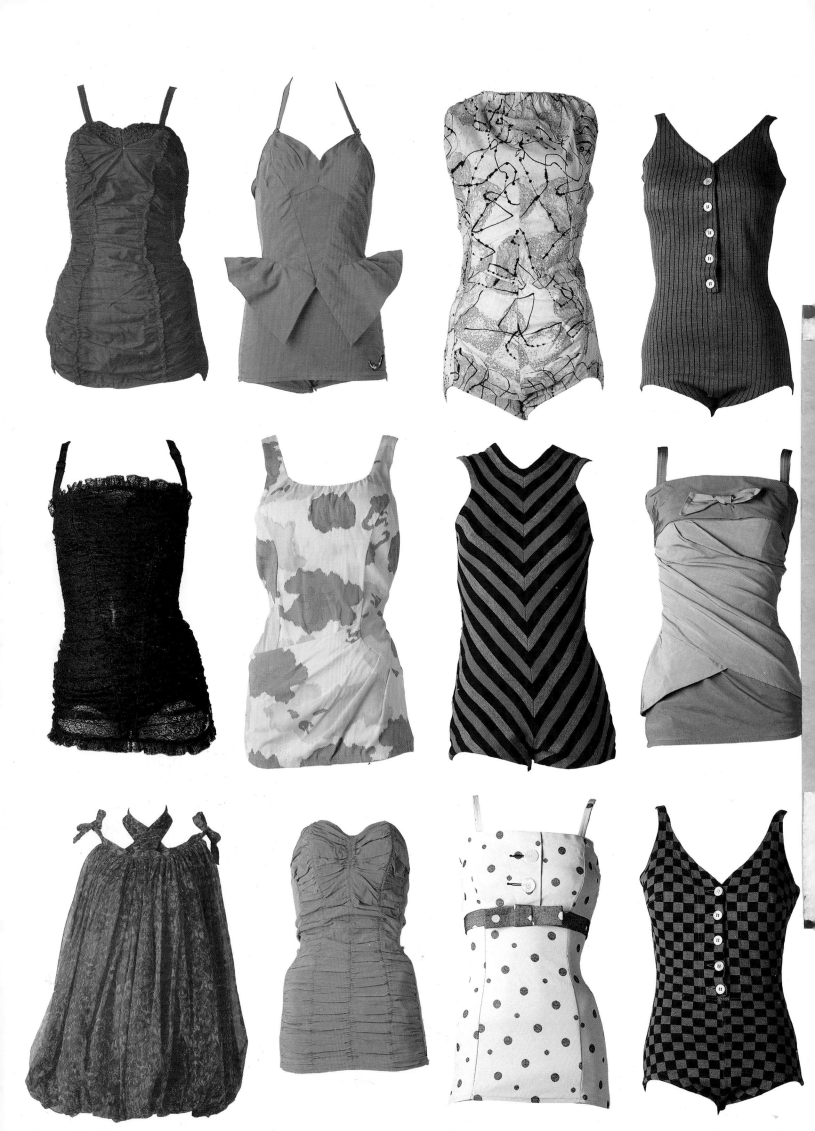

If there was a single name in swimwear that was synonymous with the movement toward coverage and shaping, it was Rose Marie Reid. Believing that no woman deserved the dreadful fate of an ill-fitting bathing costume, this Los Angeles manufacturer pioneered suits that reflected the basic themes of fifties swimwear. Its goal was simple: to design swimsuits that would help women win the battle of the bulge. By combining the advantages of a fine foundation garment with the fashion allure of an evening gown, Rose Marie Reid hoped to sell to a market that had traditionally been restricted to women with passable figures. It was a gamble that paid off. By 1951, the firm had not only emerged as the acknowledged trendsetter in creating swimwear that flattered a variety of female shapes but had also captured a significant slice of the market, competing favorably with such large manufacturers as Cole, Catalina, and Jantzen.

A passionate swimmer and seamstress from Vancouver, British Columbia, Reid simply recognized the fact that all women do not have perfect figures. She was interested in designing not only for shapely young damsels who could wear anything from a sack to a rubber band, but for the woman in her forties or fifties. As early as 1937, she had begun designing and manufacturing swimsuits that looked strikingly different from those that were available at the time. The "constructed" swimsuit was born. Her suits featured built-in bras, a "stay-down leg" made possible by a crotch of novel design, and "tummy-control" panels—all devices she patented. To make use of these features, she persuaded knitting mills to make water-resistant elastic material of rubber and acetate that retained the lines of her designs.

In her first year of business in Canada, the designer grossed $10,000 and netted $2,500. Most of her sales were in western Canada, but soon her reputation reached Jack and Nina Kessler, an American husband-and-wife team of great business acumen.

The Kesslers suggested that Reid move to Los Angeles and in 1946 began distributing her garments in the United States. Installing himself as president of the company, Kessler put up $50,000 and supplied managerial and financial skills. Reid furnished designing talent, patents, and manufacturing experience. Their first line of suits came off the assembly line just as buyers and fashion editors from all over the country were assembling in Los Angeles for a "market week."

The reaction, particularly among fashion writers and representatives of the country's finest clothing stores, was immediate and overwhelming. The Reid suits were a sensation. In magenta, orange, or vibrant pink, they were tailored to give the impression of snugly tracing the contours of the wearer's form, though always preserving a chic, ladylike decorum. With their tiny cap sleeves, covered buttons, and masterful drapery, these swimsuits articulated the understated elegance that would soon become associated with the names of Grace Kelly and Audrey Hepburn.

Between 1950 and 1956, Reid built her line around the novel notion of imagineering—which roughly translated into the strategy of matching the *right* suit to the right occasion and to the right body type. Situational imagineering involved, as her marketing campaign put it, a three-suit option: "One for Sun…one for Swim…and one for Psychology." As for the bather's shape, Reid systematized the female form into six geometric figures that included the heavy busted, the heavy hipped, the pudgy or mature, the petite, the tall, and finally, the perfect figure.

◄

By the mid-fifties, swimming suits were being constructed as cunningly as corsets. Bras were boned and lined with a layer of foam rubber molded with pellon, a fabric used to stiffen petticoats, to shape the fashionably high, rounded bosom. Many suits were also boned at the sides to produce a smooth, long torso.

The three basic figure types are pictured here with considerable editorial commentary.

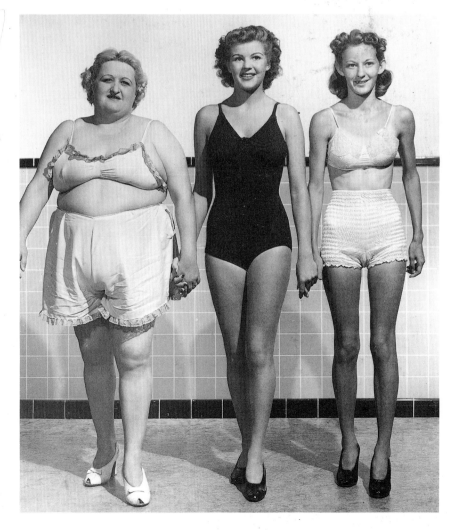

The perfect figure obviously needed no corrective measures, but for others, Reid designed suits that camouflaged the wearer's irregularities. The suit for the top-heavy figure had a bodice-bra of plastic boning and several rows of hooks and eyes in back that adjusted to the bust and gave "a natural divided bustline look." The heavy-hipped bather could "get to the seat of her trouble" by wearing a slimming dressmaker with stripes curving inward and upward "to lead the eye away from the hipline and to give the illusion of slimness." The cylindrical customer was told to avoid "like poison two-piece suits that reveal your 'spare tire,'" and was steered to sheath or dressmaker suits with built-in bras, tummy-control panels, and slim-paneled skirts. A side drape was developed for the female with a little bulge to her stomach. And for the woman "whose curves are not as calculated as she'd like them to be," Reid proposed molding, ruffle-top bras, and front shirring.

The 1950s have been described as the decade when vacations became the sole religion shared by the workers of all industrial nations. Summer holidays and weekends were cherished, planned long in advance, and venerated as a respite from the grind of nine-to-five workdays and commutes. Water seemed the most festive of the elements, drawing millions with its promise of restoration and renewal. Increased leisure time, the availability of private swimming pools, and the vogue for winter cruises spread the demand for swimsuits. American women wanted variety in swimwear and began buying several styles each season. The swimsuit acquired a new status and was increasingly seen as a garment that reflected a state of being "dressed" rather than undressed.

The purveyors of American swimwear found themselves feeding an appetite for hourglass curves, luxurious fabrics, and unambiguous sexual symbolism. "During a war, a man hates nothing more than to see a girl in pants," explained Fred Cole, who by the mid-1950s had manufactured some thirteen million swimsuits. "Today, we are in a disturbed period, and again femininity is very important." When it came to the swimsuit, femininity expressed itself primarily through the choice and treatment of fabrics. "Women are going to look more like women on the beaches this summer," announced a fashion commentator at the dawn of the decade referring

to a sampling of "feminizing" looks which ran from the black lace of the boudoir to the crinoline petticoat of the sock-hop. Other styles embraced the bloomer of the toddler's romper suit, the sophisticate's sheath, and the debutante's flounces. Swimsuits offered American women an unprecedented range of "looks," from homey to sophisticated.

If the 1920s had turned the Victorian bathing dress into a suit for swimming and the 1930s had transformed the swimsuit into a garment for sunning, the 1950s turned the swimsuit into a costume for opulent display. As Fred Cole put it in 1956, "At any smart resort, it's the promenade, not the water" that held center stage. Despite the fact that all major swimwear manufacturers religiously submitted textiles to a barrage of "scientific" tests, swimsuits were not styled with water as the prime design generator.

Advertising stressed a suit's capacity to make the wearer look stunning. The swimsuit

During the quiet Eisenhower years, Dalmatian-spotted suits, which frequently sold as mother-daughter combinations, offered a humorous, domesticated version of the female animal.

A saucy, prison-striped two-piece enhanced the "jail bait" image of Jacqueline Park, selected Miss Hot Rod 1950.

Miss Home Show 1951 models a one-piece blue-print-patterned swimsuit with matching crown.

Eyes were popping at a 1953 California lingerie show.

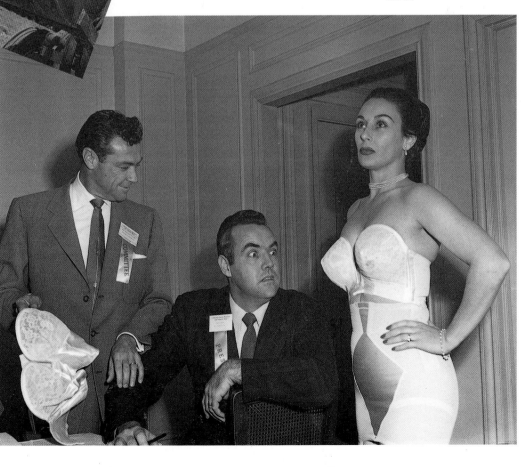

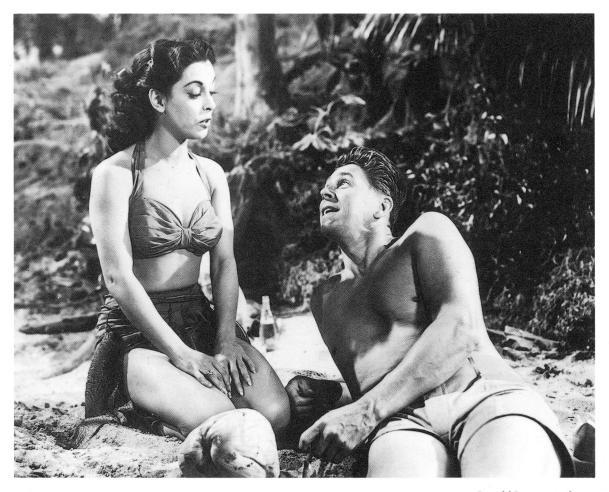

Ronald Reagan in the 1953 Columbia release "Tropic Zone."

Suits with an international flair were on parade at the Ad Orama Fashion Show in 1956. The Egyptian motif made a strong representation, as did the harem look, straight out of "One Thousand and One Arabian Nights."

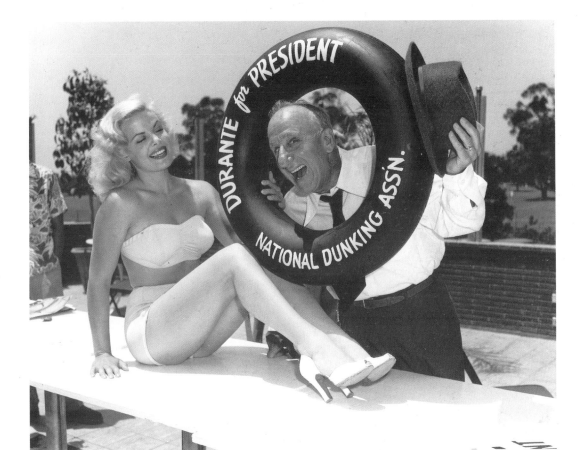

Accustomed to sticking his king-sized nose into everything, Jimmy Durante tossed his giant proboscis into the ring of a giant doughnut to announce his candidacy in the 1950 presidential election of the National Dunking Association.

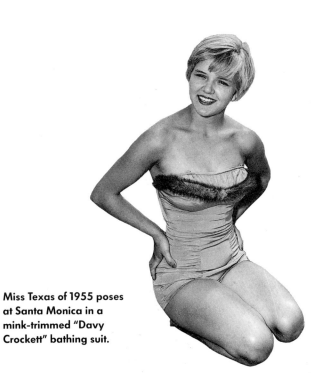

Miss Texas of 1955 poses at Santa Monica in a mink-trimmed "Davy Crockett" bathing suit.

of the 1950s was as theatrical and ornamental in its time as the promenade costume of the Victorians. A throwback to an earlier era, this corseted garment was not structured to facilitate movement through water. Encumbered with elaborate foundation devices as well as frills, flounces, and drapery that lost all appeal when wet, the bathing costume once again became a casing for displaying the body. As much as anything, these suits were "calculated to change a shy wallflower into the belle of the beach." They were designed less for the attainment of physical fitness than for the ceremonial pursuit of poolside pleasures and social maneuvering. Not since the Victorian era had the design of bathing costumes so thoroughly ignored the aquatic function in order to serve a social and decorative one.

After a brief flirtation with two-piece suits at the start of the decade, Americans firmly embraced the one-piece design. For many women reaching adulthood during those years, the divided suit looked too much like a bra-and-pantie combination. Since sweeping across the Continent shortly after its inception in 1946, the bikini was rejected by the American public. It was considered somehow risqué—if not vulgar.

Like the flashy chrome-trimmed automobiles of the 1950s, the most striking swimsuits of the decade reflected a taste for opulence, for the exotic, and the fantastical—whether in the realm of nature, culture, or the machine. Into less than a yard of fabric designers compressed a cultural narrative whose forms, fabrics, and fragments extended over vast reaches of time and space. Such prestigious designers as Claire McCardell, Frances Sider, and Carolyn Schnurer, as well as major swimwear manufacturers, translated every conceivable style of costume—historical, primitive, ethnic, futuristic, fanciful, and contemporary—into the miniscule terrain of the swimsuit.

In many important respects, the quintessential 1950s swimsuit was a first cousin to the short party dress as well as other more formal garments. Slim sheaths, bouffant petticoats, tunics, and elegant Empire waistlines were translated into thigh-length swimsuits done up in fabrics borrowed from formal wear. Textiles, though waterproofed, were attuned to days passed in indolent conversation by the seashore, on the foredeck of a motor cruiser, or at the side of a moonlit pool.

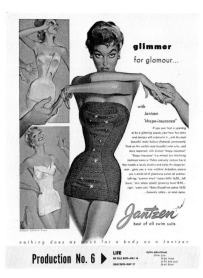

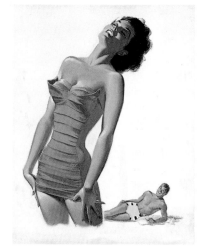

Red and pink—in shades ranging from creamy pastel to strident fuchsia— swept the beaches in the late fifties. Lipsticks and nail polishes were furnished in equally nuanced tones to harmonize with suits made of opulent velvets or pert calicos.

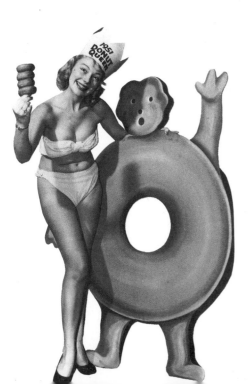

Bursting out of her terry- cloth bikini, the 1951 Donut Queen treated her fans to a display of visual puns.

In 1954, shorter shorts were the vogue. Many zipped on both sides for better fit. Shirring migrated from women's suits to the front and back of men's trunks. A new style called the "Piccolino" (Italian for "small") was imported by MacGregor from the Italian Riviera. Tight and cut to just graze the navel, these swimtrunks were fashioned of Celaperm and cotton Lastex fabrics. The sleeveless jersey shirt, not seen in public since the early 1930s, made a comeback as a special sport shirt for boating or golfing. It was modeled to great advantage by Rock Hudson, described in *Look* as "the coming male movie star in 1955."

Some of the most exotic and imaginative swimsuits for women never hit the fashion columns or consumer market. These were extemporaneous concoctions, whipped up to commemorate an occasion, advertise a product, or simply create a sensation. Miss Home Show was photographed in a one-piece blueprint design suit with a matching crown. Miss Texas of 1955 posed at Santa Monica in a mink-trimmed "Davy Crockett" suit. Later that year, an unusual mosaic swimsuit was assembled using small colored squares of lightweight plastic; it was both waterproof and alleged to be "swimmable." In 1954, a fully buoyant swimsuit appeared on the market. Crafted to mimic normal one-piece suits, these flotational devices had a front panel that concealed a spongy material that kept its wearer on the water's surface.

Makeup became as theatrically elaborate for the beach as it was for the street. With so much emphasis on ornamenting the face, it was not unexpected that sunglasses should claim far greater design inventiveness than ever before. This item of beach attire attained unprecedented heights of mannerism with shapes that mimicked butterfly wings, cocktail glasses, feline faces, musical notes, and the futuristic fins of Detroit's dream cars.

By mid-decade, the beachgoing American female was constructed from head to foot. But change was on the way. As early as 1955, *Look* magazine had sensed that America was headed toward a compromise with propriety. Just as Parisian fashion designers—Jacques Heim among them—were banishing the bikini from their lines, Americans were beginning to display an enthusiasm for the skin-baring two-piece suit they had rejected since its debut in 1946. The approach to change was gradual and genteel, smacking more of evolution than revolution.

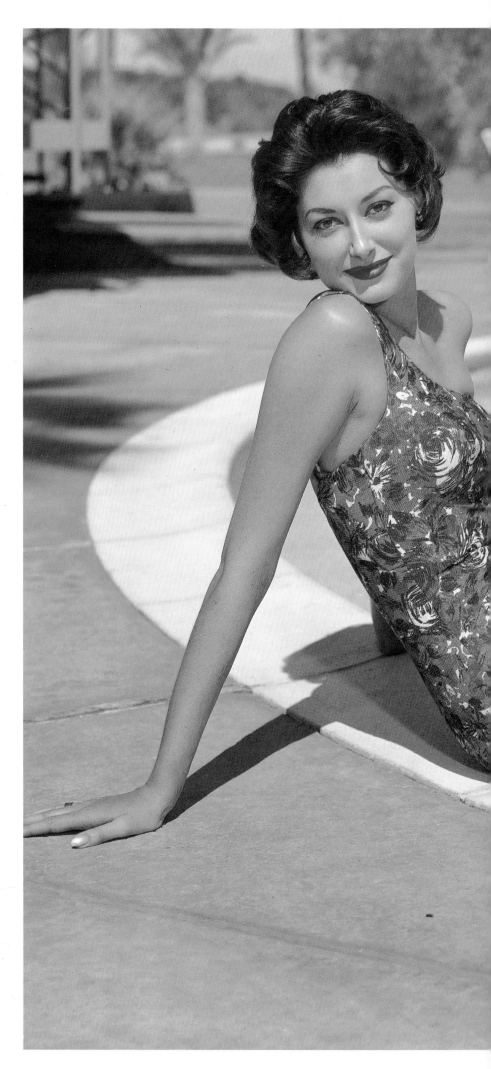

In 1950, Rose Marie Reid introduced a suit made of a uniquely photo-permeable fabric that permitted the sun to penetrate through the weave. Made in a gold-flowered print, the suit allegedly allowed total body tanning.

In February 1959, a *New York Times* headline announced that the "Bikini Is in the Swim of Things Again: Sudden Popularity Here Is a Mystery." Columnist Phyllis Lee Levin offered several reasons for the sudden surge of interest in the bikini. A sharp increase in private swimming pools, which were said to encourage private sunbathing, was cited as one important incentive to disrobe. Since the bikini's introduction, the number of privately owned residential swimming pools had jumped from 2,500 to 87,000. Travel, too, may have played its part. Since the mid-1940s, the number of passports swelled from 23,435 to 676,898.

Respectable department stores and boutiques along New York's Fifth Avenue may not have gone so far as to display the bikini in their windows, but they did stock it, in generous numbers, and to their great disbelief, sold it. *Harper's Bazaar* and *Esquire* gave the two-piece suit their approval when they published Richard Avedon's color photographs of Suzy Parker, a model and movie actress, "with nothing between her and the Caribbean elements except her Bikini."

By 1960 the constructed suit was on its way out. Diane Vreeland, then fashion editor of *Harper's Bazaar*, cast her vote for the uncovered look and the new cultural wave it signified. "Bikini says to me the best things in life are free," she rhapsodized. "The world of the Bikini is the normal world, a world completely consumed by the elements. It makes me think of boats, of a lonely South African beach, of the pride Mediterranean folk have in their bodies. We city people forget that the elements take up more space than people, thank God."

Cartoon characters and film stars such as Esther Williams were among the most popular subjects of paper doll kits.

By 1953, 75 million people – half the population of America – were visiting Atlantic beaches every summer. Reflecting this trend in the country's recreational and social life, the bathing suit acquired a new status, promoted from the state of undress to the state of dress. For a mix of functional and formal reasons, accessories took on increasing importance in the beach wardrobe. Sunglasses in fantastical shapes protected the eyes from harmful glare. Beach bags, rubber caps, sun hats, and a staggering variety of footgear –coordinated or contrasting with the basic suit – insured stylistic continuity.

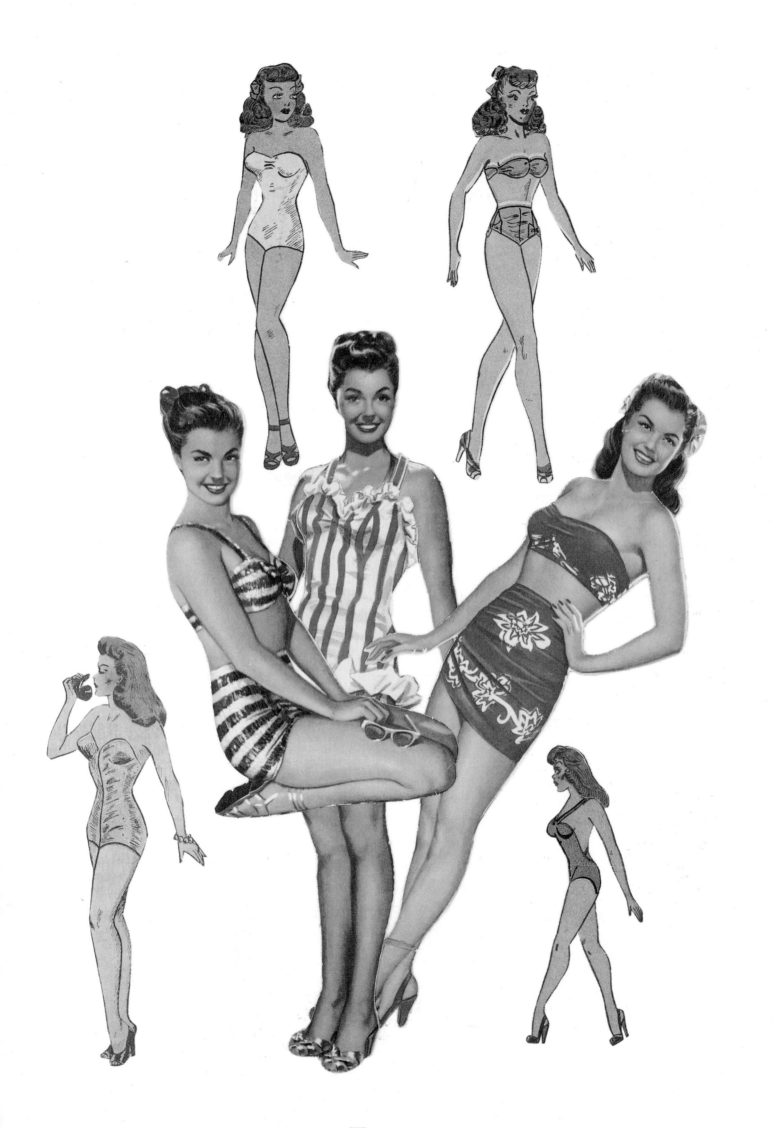

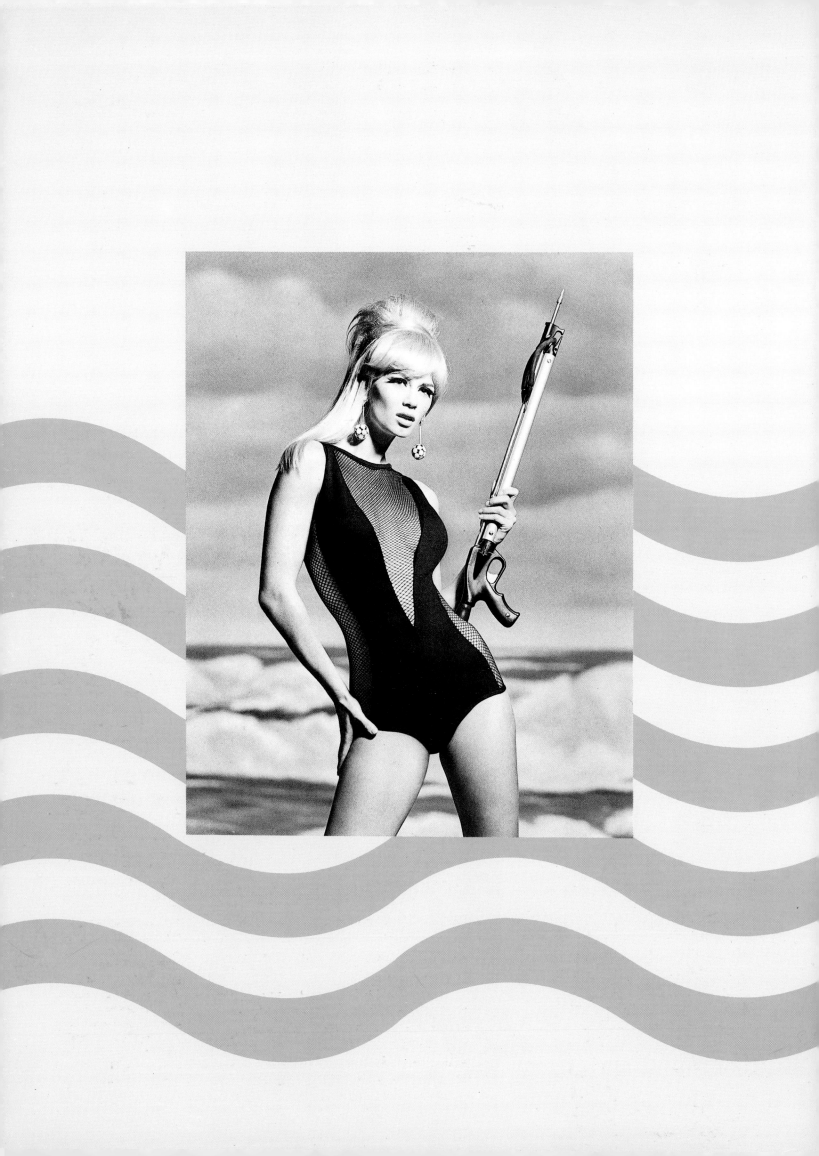

The Incredible
Shrinking Suit

The bathing suit that best epitomized the peek-a-boo fever of the mid-1960s was the "Scandal Suit" from Cole of California.

If the 1950s saw the triumph of the suit over the human form, the 1960s did quite the opposite. The body was finally brought out in the open.

By the early 1960s, post-war "baby boomers" were reaching maturity. Flushed with the consciousness of their purchasing power, they were prepared to impose their tastes and values on a society they considered outmoded.

A powerful, irresistible sense of renewal was in the air. Rebellion, protest, and idealism were on everyone's minds. Against mounting tensions of the cold war, the conflict in Vietnam, and student demonstrations, American adolescents fell in love with the mop-haired Beatles, the demonic Rolling Stones, Jimmy Hendrix, and gravelly-voiced Janis Joplin. The counterculture was born, and before it was all over, 300,000 flower children celebrated by dancing in ecstasy on a muddy farm in Woodstock, New York.

The political left seemed to measure radicalism by the number of square inches of skin exposed. To bare flesh was to be politically subversive and culturally enlightened. Thousands of young radicals and free spirits flaunted miles of skin as a way of taunting authority and traditional values. It was chic to wear jeans with holes, to strip off cosmetics, to burn bras, and "let it all hang out." Structure, after all, was just another name for stricture. And, according to the 1960s ethos, nude was natural, and natural was good.

Naturally, swimwear design underwent a major revolution. Spandex—a synthetic polyurethane fiber—became generally available. Composed of segmented plastic foam, spandex fibers could be covered with silk, cotton, wool, sharkskin, or faille to provide a stretchable, lightweight yarn. Lycra, Dupont's commercial name for spandex, possessed great tension, spring, and excellent figure control—in addition to being light, soft, supple, and cool—making it ideal for a swimwear look that stressed shape, vibrant color, and a clingy silhouette.

In June 1965, *Vogue* promoted the new synthetic fabric as something very close to a second skin: "When it's dried in the sun it's a sinuous velvety black, and when it's soaked with water it glistens like a seal on the rocks." Because they resisted oils and oxidation, spandex fibers

"Beach Party" (1963) introduced Annette Funicello ("Dee-Dee") and Frankie Avalon ("Frankie"), the Fred Astaire and Ginger Rogers of sixties libidinal youth. Between 1962 and 1966, the golden years of the adolescent beach movie, Annette and Frankie snuggled and volleyballed their way through such mawkish comedies as "Bikini Beach," "How to Stuff a Wild Bikini," and "Muscle Beach Party," in which "...10,000 biceps go around 5,000 bikinis..." Thronged by dozens of wriggly, top-heavy beach bunnies, Elvis Presley crooned his way from "Blue Hawaii" and "Paradise—Hawaiian Style" to "Girl Happy" and "Fun in Acapulco."

were quickly recognized as superior to both rubber thread and stretch yarns, making Lastex obsolete overnight. Vastly more powerful than Lastex-based fibers, Lycra allowed for shaping and molding without the intricate tailoring, boning, and stiff padding that characterized swimsuits of the 1950s. The result was a softer, rounder bosom, a gentle relaxation of contours, and a greater reliance on the stylishness of the natural body.

The first ripples of what would soon be dubbed the "Nude Wave" began to creep onto American shores in 1960. Over the course of the decade, the bare midriff emerged from under wraps that retreated lower and lower beneath the navel. The bosom burst out of diminished tops, peeked from plunging décolletages, swelled from the sides of shrunken "bib" tops, and, for one delirious season, exploded in all its unadorned glory for the topless look. Backs came and went, sometimes as far as dorsal cleavage. It was as if nature, confined and disciplined by two decades of structured swimwear, burst out into the open in all her munificence.

From Los Angeles to Long Island, women began to peel down in suits whose chief feature was brevity. "American fashion is now dominated by teen-agers," explained one Westhampton, Long Island matron to a *Time* magazine reporter. "They have the figures and the courage to wear these swimsuits, and adults— happily or not—are following their lead." More than ever before, the beach became a place where the average American female underwent what critic Ellen Willis called a "trial by exposure, a separation of the women (bulging and blemished) from the girls (trim and smooth)."

As the summer of 1960 neared, a keen anticipation about the degree of undress at the beach began to agitate the popular imagination. Fashion commentators and culture watchers murmured about the "Big Strip," and once again, prophecies of imminent nudity began to make the journalistic rounds. Still, after years of seeing beaches monopolized by the one-piece suit, Americans were startled by what they saw on the sands that summer: miles and miles of midriff, much of it bared to reveal the navel. To the accompaniment of screaming headlines, the bikini had finally arrived to stake its claim on the beaches of America.

That it had taken this scanty two-piece so long to gain popular acceptance is one of the enigmas of the history of the American swimsuit. During the fifteen years following its introduction, the bikini had never quite managed to wriggle out of its uniquely American role as a perennial second-class citizen. Immensely popular with editors of "girlie" magazines and red-hot pinup girls with names like Chili Williams, the bikini faced a stiff fight for universal acceptance. In 1958, *Newsweek* had reported that bikinis "had a record of bans and secret sales second only to *Lady Chatterly's Lover.*" While not explicitly banned from public beaches prior to 1959, the bikini was, nevertheless, strongly discouraged.

The summer of 1960 would change all that. On July 4, the day that American women traditionally parade the latest in swimsuit fashions, the *New York Times* stood breathlessly by, waiting to register the latest degree of nudity. "The Fate of the Daring Bikini May be Decided Today," announced the headlines. As the summer ripened, the two-piece hit the beaches with tidal wave force, bearing on its crest the finally triumphant bikini.

This did not mean, however, that the vast numbers of bikinis sold actually appeared in public. Many women bought them "to sleep in"—as they told sales clerks—or just to lounge around a family swimming pool. If not in public, at least in the privacy of their own homes, American matrons slipped into brief bikinis that were a glory of color, polka dots, and beguiling patterns. As one woman of the day put it, "middle-aged women lay intoxicated by the shimmering heat of the noonday sun, dreaming their own ungovernable bodies had arranged themselves into the enticing curves of a Brigitte Bardot."

The suit's mounting popularity proved that the art of forecasting styles for the beach was as treacherous as predicting the weather. Between 1960 and 1964, at least one fashion prophet was sure to announce each season that "bikinis are finally out," only to have the nation's beachgoers prove the enormity of his mistake.

And while the French bikini may have been every man's secret wish—as long as it appeared on someone else's wife or daughter— American designers favored a slightly less revealing costume. In July 1963, a *Newsweek* correspondent announced that "the bikini, long the scarlet woman of the $200 million-a year U.S. swimwear industry, is unmistakably moving toward respectability."

In this country the bikini covered slightly more skin than its French counterpart. A uniquely American innovation was the "convertible" or "modified" bikini that permitted precise control of dermal exposure. Dubbed the

Immortalized in song, the polka-dotted bikini became a fixture in American popular folklore.

With joyous unconcern for modesty, Jayne Mansfield models the bikini which, until the early sixties, was discouraged on public beaches and snubbed at even the most tolerant private clubs.

"bikini with a conscience," this two-piece was equipped with drawstrings or bows on the sides of the trunks and in the middle of the bra that allowed the wearer to adjust the coverage to match taste and circumstances. The convertible suit was a favorite with teenage daughters of mothers bent upon foisting 1950s standards of modesty on their offspring. One coquettish teenager explained the situation to a *Saturday Evening Post* correspondent in 1963. "Mother doesn't want me to show my navel in public, so I wear the trunks this way when I leave home," she said, displaying trunks which hid most of her midsection. "...And this way when I get to the beach," she added, folding down the top of the trunks a fetching four or five inches.

Going from brief to briefer, the bikini was the swimsuit sensation of the decade, casting its spell well beyond the wet and sandy world of summer fashion. In fact, it captured the Hollywood imagination in a way that no other item of attire before or since could rival. As early as 1960, it inspired Brian Hyland's "Itsy Bitsy Teenie Weenie Yellow Polkadot Bikini." Later that year, MGM released "Where the Boys Are," an innocuous fantasy film about college students on the beaches of Fort Lauderdale, Florida. Hardly a critical success, the film was a smash hit with the nation's teenagers.

Described as "sunny, sexy, and totally amusing," the beach party movie developed around an elementary formula of young love, raucous rock 'n' roll, and squadrons of bikini-clad starlets. Although they did little to advance the art of cinematography, the more than 100 beach movies produced during the decade played an important cultural role. Hollywood's rocking beach reels helped establish the world of youth as a separate culture and enshrined the bikini as its official summer uniform.

In the summer of 1963, some swimwear watchers predicted that five years hence the "covered-up" look would again become commonplace on American beaches, while another contingent predicted a swing toward nudity and even the proliferation of topless suits. "Will it be topless bathing suits in five years?" *Newsweek* asked. Within less than a year, there was evidence to support both sides. In coming seasons, two-piecers would cover up heavily, with necklines inching up to the shoulders and bottoms chastely hugging the upper thigh. At the other end of the spectrum, the nude look would soon explode in a fury of fanfare as the first American topless suit made its debut.

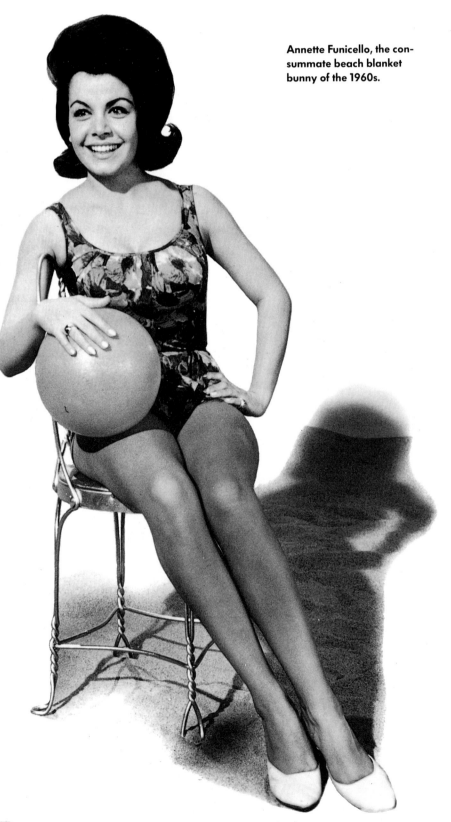

Annette Funicello, the consummate beach blanket bunny of the 1960s.

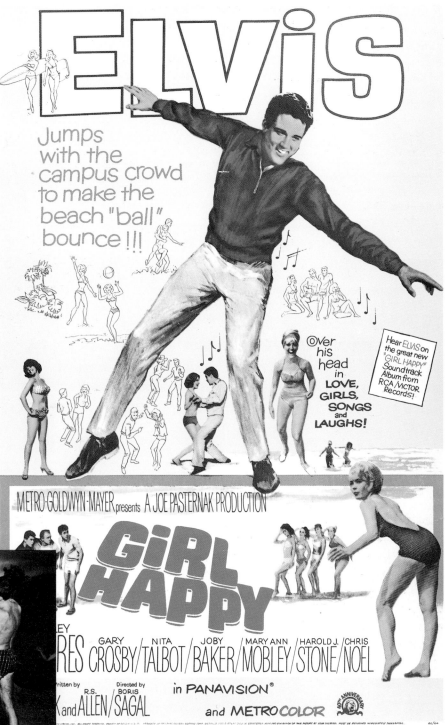

Swimwear designers of
the 1960s embarked on a
delirious adventure in the
skin trade. The arduous
battle for maximum expo-
sure, waged square inch
by delicious square inch,
was on the point of bring-
ing victory to the pro-
ponents of less is more,
whose ranks were sud-
denly swollen by vast
numbers of firm-fleshed
adolescents.

If sunglasses were the signature beach accessory of the 1950s, the swimcap was the triumph of the 1960s. A constant accompaniment to the swimmer's costume since Victorian times, the swimcap reached its apotheosis during this decade. Brightly colored, appliqued with flowers, ribbons, or contrasting bands of fabric, or coaxed into fantastical shapes, the bathing cap was often designed by milliners.

Nineteen sixty-four was the dividing line between eras. The Free Speech movement rocked Berkeley. The Civil Rights movement was well on its way in the South. President Johnson launched his War on Poverty while, on the international front, the Gulf of Tonkin incident escalated U.S. involvement in Vietnam. And, to the mixed reviews of fashion critics, statesmen, and church dignitaries, Rudi Gernreich unveiled his "topless" suit for women.

In June of that year, in the strict privacy of a bedroom in his Manhattan hotel suite, Gernreich presented the swimsuit that took the ultimate plunge. His audacious creation was an austere black knit extending from midriff to the upper thigh, bare above the waist except for a pair of skinny suspenders that met above the navel and climbed up the chest, just grazing the inner curve of the breasts. There was something paradoxical about the shock value of this suit that went beyond the obvious affront to modesty. The straps were so utterly useless for swimming or tanning that they called attention to the *missing* fabric in a way that was downright prurient. On one level, the topless costume was utterly asexual. Defending himself against the label "the Bolivar of the bosom," the designer protested that "sex is in the person, not in what she puts on."

In some respects, his topless suit transcended lewdness because its shape and cut were so out of step with contemporary ideas of erogenous zones. The topless suit was a paradox in the history of fashion design. Unlike the miniskirts and see-through blouses of the 1960s that signalled the dawn of a new, sexually permissive era, the topless suit seemed oddly out of place. On the one hand, it smacked too much of a remote future, yet on the other, its silhouette seemed obstinately anchored in the past.

Since the 1940s, American girls had played with paper dolls whose basic attire was the swimsuit. When the Barbie Doll was introduced in 1952, the miniature bathing suit appeared as a seasonal counterpart to the adult costume. Each year, Barbie was packaged in a brand new beach ensemble that replicated fashionable swimwear down to the minutest details such as thongs, sunglasses, beach bags, and tanning gear. Millions of little girls were learning about what it took to look chic on the beach as they tugged tiny maillots and polka-dotted one-shoulder suits on their stiff-legged Barbies and fastened low-slung golden belts around their improbably narrow hips. The anatomically incorrect Ken may not have taught them about the realities of life, but he did train the future shoppers of America how to take care of their men on the beach.

According to *Life* reporter Shana Alexander, the suit was a nightmare to design. Gernreich "realized that just a bikini bottom would be the *end* of design." Each of his initial sketches for the topless suit looked like male boxer shorts. In desperation, he added straps "for pure decor." When knitters and cutters finally worked out the proportions, the prototype turned out to have a decidedly "retro" feel. It looked more like a suit of the future that had been projected decades earlier than anything one would have expected from the imagination of the 1960s. In fact, the designer's final version was virtually a carbon copy of a topless suit sketched nearly a quarter century earlier by Umberto Brunelleschi, the eminent Tuscan fashion stylist, illustrator, and stage designer. A magazine cover painted by Brunelleschi in 1940 depicted a white-fleshed bather in a shiny red suit that left the breasts exposed on either side of ribbon straps.

Instead of delivering a sensuous jolt, the avant-garde suit—so eagerly anticipated and so persistently foretold in the history of the swimsuit—was treated by most critics as either a freak or a gag. Alexander dubbed it "fashion's best joke on itself in years," while *Newsweek* recorded an explosion of topless jokes across the country that centered on the concepts of "naked truth" and "my bare lady."

The bare-breasted look triggered an international buzz about morality, legality, and aesthetics. Some of the harshest criticism came from the world of fashion itself. Norman Norell, the high priest of American couture, had nothing kind to say of the experiment. "There is no news in the no-top bathing suit," he remarked astringently to *Women's Wear Daily* editor John Fairchild. "If you are designing a bathing suit for the future, I would do a little fig leaf, or a tiny bottom of a bikini, or wear Nothing." The French were deeply affronted by the implication that they had been superceded at their own game and protested with banner headlines asserting that "The Americans Have Invented Nothing...The Bare-breasted look already here 32 years ago."

In Allentown, Pennsylvania, a contingent of women threw up picket lines around Hess's Department Store which had ordered a shipment of the "offensive suit." Manhattan's Lord & Taylor changed its mind while waiting for its order to arrive. "They will be sealed up immediately," the store's president, Melvin Dawley, announced, "and shipped to the poor," who, presumably, were exempted from feeling the prevailing winds of fashion or taste. *Life* magazine carried a portfolio of photographs showing the horrified reaction of shoppers from Hong Kong to London. "No wonder there are so many nervous breakdowns," commented a Parisian matron, who pitied American women because they were exposed to "such violent fashion trends."

Aside from the handful of publicized bathers who showed up topless in public, no one knows how many women actually wore the suit within the confines of their private pools and curtained bedrooms. One commentator speculated that the suits were sold mostly as gag gifts for brides. Gernreich's daring brainchild might have furthered the cause of the sexual revolution but in a decidedly understated way. The ratio of suits purchased to the number of suits worn in public was miniscule.

Gernreich was far from alone in carrying on his subtraction campaign. A mere six months after he introduced his topless swimsuit, the American public was being jet-propelled into an unprecedented age of dermal exposure. The classic maillot began to resemble a piece of Swiss cheese, inspired by André Courrège's "space-age" theme in fashion that punched out circular holes at odd points of the anatomy. Flesh-colored bras were slipped on under transparent blouses.

Joan Collins relaxes at home in shorts and swim-suit top.

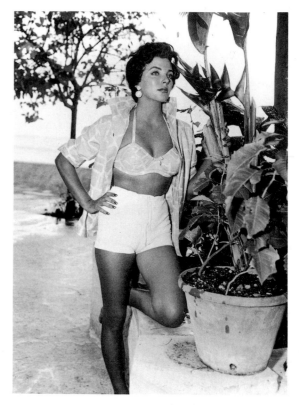

Denounced by the Vatican press as the by-product of the "industrial-erotic adventure" which "negates moral sense," the topless swimsuit pioneered by Austrian-born Rudi Gernreich in 1964 was snapped up by women throughout the world. Gernreich reportedly had no intention of tapping an actual market when he showed his topless swimsuit to the press. But when orders started pouring in, he rushed the suit into production. Although most stores refused to advertise the scandalous garment, they bowed to customer demand and did a brisk business in sales. Within a week of putting the suit on their racks, New York's major department stores had sold over 150 pieces. San Francisco women turned deaf ears to clergymen's warnings that "nakedness and paganism go hand in hand" and snapped up the wool knit in black, brown, blue, red and orange at $24 a pop. By the end of the season, Gernreich had sold some 3,000 suits.

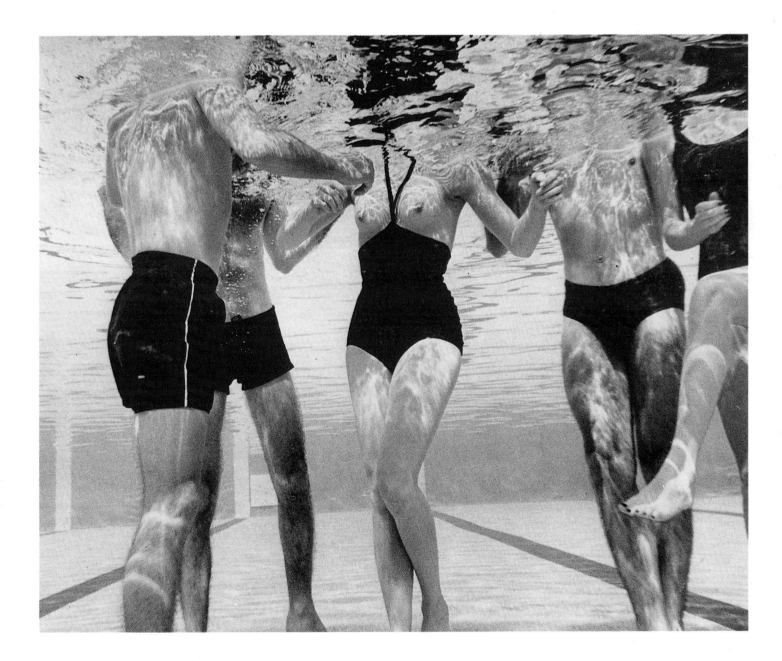

Circles, triangles, and squares were carved out of the sides, backs, and fronts of maillots to produce marvels of sartorial decoupage. Designers and trendsetters encouraged timid bathers to embrace maximal exposure by reciting to them the bill of rights of beachwear: "If you bulge, so what? Isn't your husband used to it? Who doesn't have a right to God's sun, God's beach, God's water? Do you buy a bathing suit to enjoy the beach or to impress the neighbors?"

A jubilant mood was once again in the air during the mid-1960s, as fashion commentators speculated gleefully about the end of the swimsuit. One Los Angeles department store staged a window display inspired by the topless suit. In full view of passersby on Wilshire Boulevard, a hanger labeled "Yesterday" held an old-fashioned, one-piece Annette Kellerman suit; another hanger labeled "Today" supported the Gernreich topless, and a third captioned "Tomorrow" supported nothing at all.

But when tomorrow finally did come in the form of the 1965 swimwear season, the suit was back on the hanger, but barely so. Instead of ushering in total nudity, the topless suit of 1964 had spawned a suit with more coverage that, oddly enough, was more erotic. The new entry featured a veil of black mesh creating an illusion of bareness that, according to some, was far superior to the real thing. From billboards and television screens to record album covers and magazines, America was assaulted by an aggressively sexy look in swimwear—the Scandal Suit Collection by Cole of California—and a wickedly explicit ad campaign to back it up.

Cole's trio of breathtaking suits was designed around the theme of "new but not nude." The "Scandals" were clinging black leotards from which huge hunks of side, front, or midsection had been sliced away and replaced by wide-mesh elastic net. Engineered by Margit Fellegi, the peekaboo suits were perfect for the woman caught in the transition from the protocol of sexual discretion to the ethos of free love. Cut extremely conservatively by mid-sixties standards, the Scandal suits put everything under wraps, at least theoretically. In practice, however, the vast expanses of see-through netting turned their wearers into sizzling sex goddesses.

With twenty-six design "firsts" to her credit during her twenty-eight years at Cole of California, Fellegi had longed to develop a suit that, as she put it, would become "tastefully scandalous." The previous season's experiment in toplessness, and especially the public's fascination with the bare look, convinced her that bathers were ready to accept a more daring silhouette.

For years she had shied away from radical cutouts, protesting, in her lilting Hungarian accent, "But darling, I can't sew holes. I'm not going to do it." But after months of working with New York's Acme Lace Company, Fellegi eventually succeeded in developing a rubber-core, nylon-wrapped mesh that gave the figure control of a girdle but was suggestively transparent, flattering, and allegedly allowed for an even suntan. "Now I can slice the body up any way I want to," Fellegi explained in *Life*, "and know that the solid pieces will hold together. If I want a very long leg line, I can start it at the armpit. I can make the lowest cut bra and you *can't* pop out. I can redesign the human body!"

Cole introduced the collection to its salesmen in September 1964 at the Saint Francis Hotel in San Francisco. To the strains of "Alley Cat" by the Guitar Ramblers, a phalanx of leggy models slinked out onto the runway clutching to their chests unfurled newspapers emblazoned with the headline, "EXTRA SCANDAL." As they reached the end of the ramp, they dropped their newspapers to reveal the flesh-baring black mesh suits. A stunned silence settled on the crowd. As Barbara Kelly, then Cole's vice-president for advertising and publicity, recalled, the salesmen were utterly immobilized by the spectacle that smacked more of the Folies Bergère than a trade show. Then a storm of protests exploded. First to panic were salesmen from the Midwest, convinced that the suit would never sell in the heartland. But it was too late to pull the suit from the market. An advertising campaign was already under way, and that was just as radically innovative as the suit it promoted.

Jane MacGowan's photograph introducing the Scandal suit featured a golden-haired beauty sitting brazenly on a brass bed at the ocean's edge. With lowered eyes and through half-open lips she purred, "Isn't it time somebody created an absolutely wild scandal for nice girls?" The combination of a bed, complete with suggestively rumpled linens, and a swimsuit model was a first in the history of swimwear promotion.

In the early sixties fashion continued to pay tribute to the full-blown womanly figure, but it did so with somewhat less bolstering and girdling. The covered-up look, with high halter necks, decorously decked midriffs, and in some very chic cases, smart little sleeves, received wide media coverage. High necklines were often accompanied by daringly bared backs, cut round or square or V-shaped. Along with floral and abstract prints in tones of pale champagne, mellowed persimmon, or bright magenta, animal prints appeared in wild profusion.

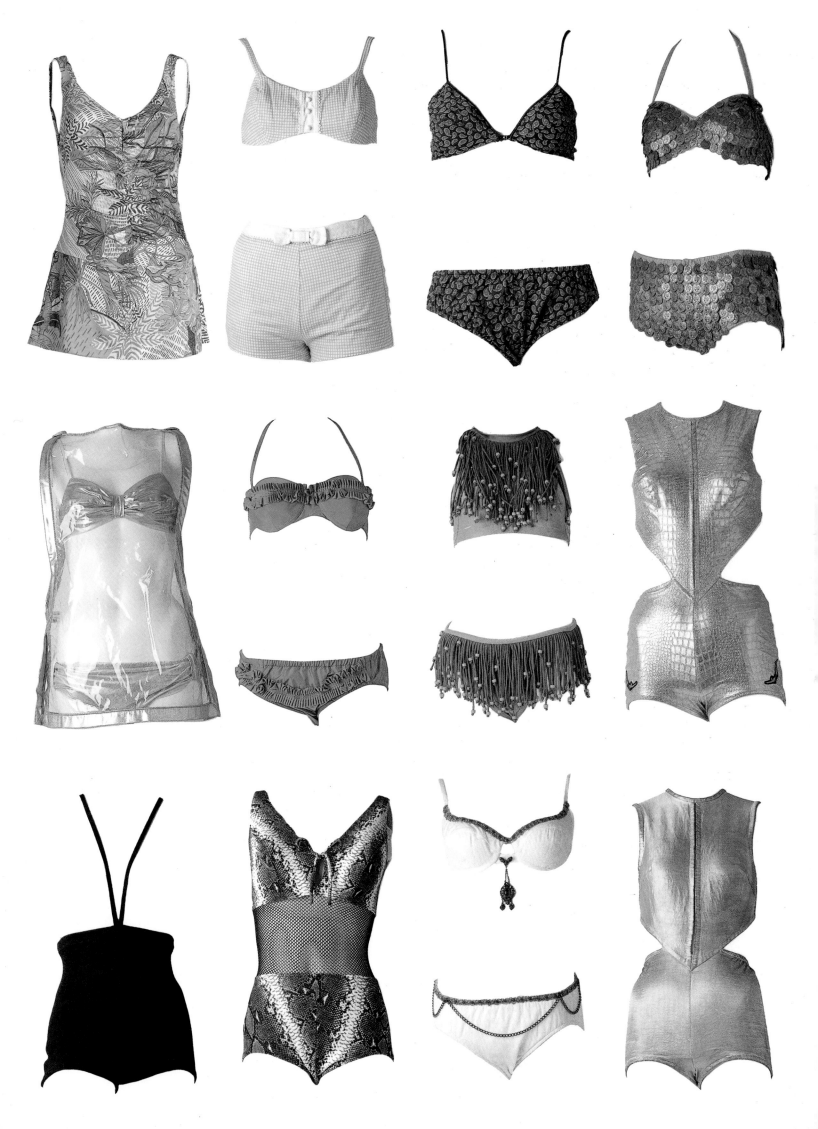

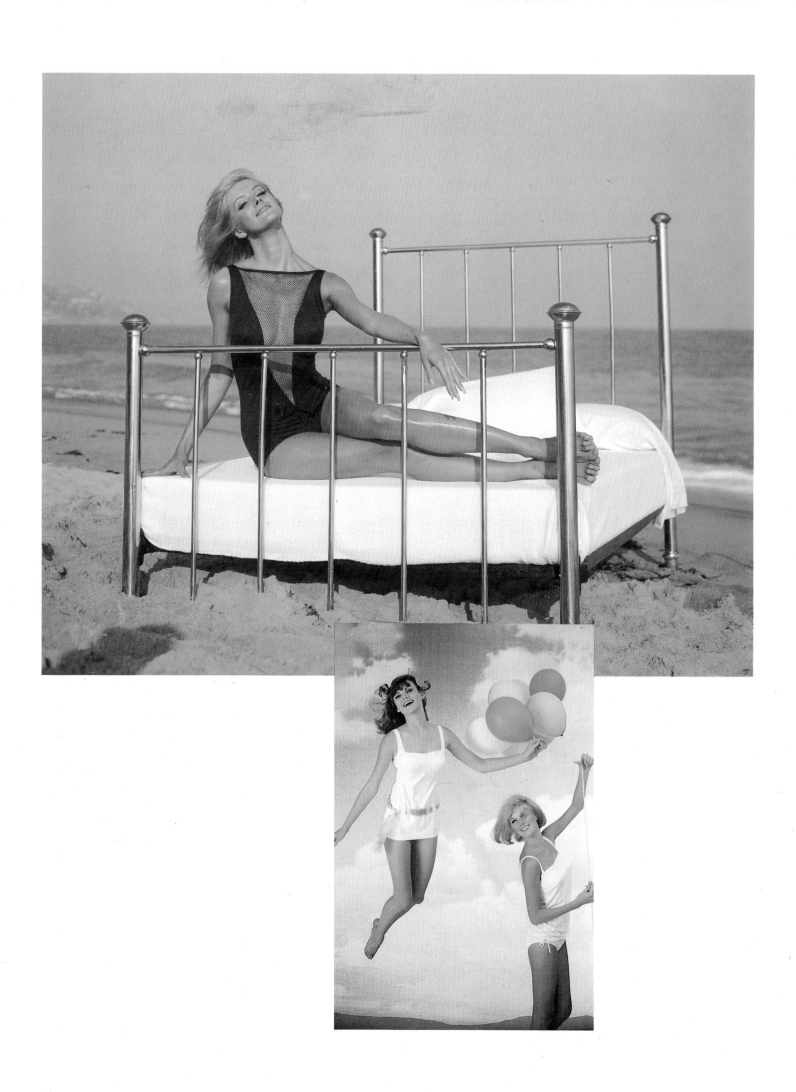

The bathing costume that best epitomizes the peek-a-boo fever of the mid-sixties was the "Scandal Suit" from Cole of California. The breathtaking V-shaped decolletage was rescued from indecent exposure by the flimsiest stretch of black fish-net. Photographed in a brass bed by Jane MacGowan, the "Scandal Suit" offered a scorchingly explicit come-on to a responsive public.

In quest of potent myths that would sell new styles and fabrics, swimwear manufacturers challenged fashion photographers to new heights of ingenuity. Photographer Jane MacGowan used the elaborate flight machinery engineered for the theater production of "Peter Pan" to suggest the ingenuous look of "Peter Pan" swimwear of 1966.

The girl on the brass bed was slathered on everything from billboards to the cover of a record album—"Scandalous Music for Nice Girls"—distributed by Cole for $1. Included among its twelve cuts were Patti Page's "Call Me Irresponsible" and Ray Conniff's "Never on Sunday." The television commercial for the suit was such a hit that it was listed in television guides. The impact of so much overt sexiness was astonishing even in a decade dedicated to taboo-bashing. To be sure, the suit, as well as the campaign, triggered the customary avalanche of objections. Some people found that the suit put too much of the body "out there in the raw." And Cole even received letters from concerned citizens convinced that the suit contributed to the delinquency of minors and to the general lowering of moral standards. One irate writer even accused the scandal suit of "aiding the cause of communism."

Not surprisingly, Cole's scanty fabrications of fishnet bred hundreds of variations. Jantzen conceded that "there's no question (the scandal suit) was a coup that will lead to more daring suits in the next couple of years" and promptly rushed in its own gauzy suit and netted models that included a bejeweled white bikini complemented by diaphanous harem pants. With the popularity of revealing swimsuits firmly entrenched, Catalina, Cole, Jantzen, and Rose Marie Reid—the Big Four of the trade—as well as smaller firms such as Elizabeth Stewart, Caltex, Peter Pan, and De Weese, designed suits with the same kind of audacity and showmanship that went into the costumes of strip queens and show girls.

Despite these daring innovations, manufacturers continued to offer a wide range of suits. Fashion magazines inventoried at least twelve distinct swimsuit models, from the classic maillot to the Empire, the asymmetrical, and the bikini. Loose-fitting blouson tops were a staple, and the covered-up look continued to provide a steady counterpoint to the rise and fall of tops and the shrinkage of bottoms. Halter necks, decorously decked midriffs, and in some very chic cases, even smart little sleeves received wide media coverage.

Jackie Kennedy's influence endured throughout the decade, injecting a steady dose of understated elegance even into costumes for the beach. Oleg Cassini, her favorite designer during the White House years, launched a line of swimsuits under the label "Peter Pan."

And beginning with 1964, a number of high-fashion designers began to get into the swim. Bill Blass, Oscar de la Renta, Geoffrey Beene, Donald Brooks, and Jacques Tiffeau brought out attention-getting suits dedicated to the notion of bringing high style to the waterfront.

Swimsuit photography invaded sports magazines, revealing the dramatic impact of those scanty garments on the 1960s. During the dark days of winter in 1964, a week after the Super Bowl and shortly before the start of the NCAA basketball season, a sizzling issue of *Sports Illustrated* hit the newsstands. On a lark, managing editor André Laguerrre had decided to do "a place in the sun story" that would feature beautiful girls in lovely, exotic locations.

The spread also set the tone for an ideal body type that would gain increasing importance. "We started the healthy, California look," explained senior editor Jule Campbell, who oversaw the next twenty-three years of *Sports Illustrated* swimwear issues. Campbell scouted out broad-shouldered, muscled young women whose bodies had definition as well as curves. The quintessential *Sports Illustrated* girl—who also exemplified the "California look"—was model Cheryl Tiegs, whose full bosom and trim bottom thrice graced the magazine's cover.

By 1968, however, a perceptible boredom was beginning to set in around the bikini. While just a year earlier, bikinis accounted for some forty-five percent of bathing suit sales, in that year they captured only about twenty percent of the market. Tom Brigance, who created vast numbers of swimsuits in the course of his illustrious career, complained that there was very little a designer could do with a bikini. "It's like plucking an eyebrow," he was quoted as saying in an interview with *Time* magazine. To whip up enthusiasm, manufacturers began resorting to a variety of materials with shock value to boost lagging sales: loosely crocheted fishnets that had originated in St-Tropez; floral lace, metallic textiles, and "leatherette" all surfaced late in the decade.

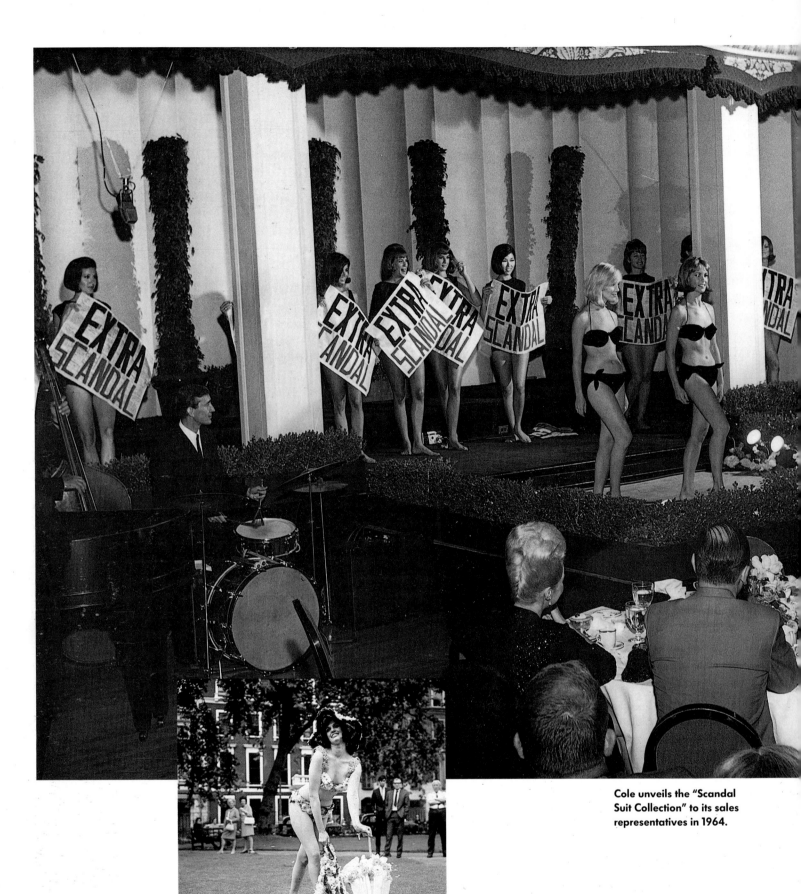

Cole unveils the "Scandal
Suit Collection" to its sales
representatives in 1964.

With its minimal allocation
of fabric, the bikini stimu-
lated designers to wild
experimentation which
often totally ignored func-
tion, as in this flower-
festooned suit.

By the end of the decade, swimwear designers moved toward a redefinition of the swimsuits. In the years that followed, mere bareness would soon be replaced with strategically designed scantiness using, as its departure point, that all-time American favorite, the one-piece swimsuit—or, at least, what passed for a one-piece suit if seen from the front or the back. Viewed from the sides, it looked like nothing at all—or nothing interrupted by brief episodes of fabric, a metallic clasp, or an anecdotal spaghetti strap or two. The sides of the body, from armpit to haunch, were about to emerge to claim their place in the sun.

Of course, the sideshow initially met with resistance. One confirmed girl-watcher was quoted by *Time* magazine as saying that "Side cutouts are wrong: no one is interested in the sides of a woman, for which, as far as I know, there is very little use." The next two decades would prove just how wrong a man could be.

The provocation of this sculptural metal suit derives from its allusion to the medieval chastity belt.

8

In the eighties, the body was in fashion, and nowhere more so than on the beach. Whereas in earlier decades the suit had done most of the work of imparting a fashionable shape to the body, now the body had to fend for itself. The suit was nothing more than an artful framing mechanism for an exquisitely toned and sculpted physique.

Just when Rudi Gernreich's Monokini made it seem the swimsuit was on the verge of becoming a memory, the rules changed. Suddenly, it was no longer a matter of "how much" exposure but of "what," "where," and "how." The challenge, nearly uninterrupted through the 1960s, had been to see how much—or more precisely, how little—one could get away with wearing on the beach. By the mid-1970s, however, the thrill of nudity was gone. As Gernreich explained in 1975, "Now nudity has come, but some coverage is still required."

A new physical ideal, the machine-tuned body, began to emerge from exercise studios, aerobic classes, and body-building salons. Women who came to maturity during the period seemed less preoccupied with snaring mates on the beach than with riveting public attention on their meticulously sculpted bodies. They had come to the conclusion that, as far as their anatomies were concerned, uncultivated nature was not always the best ally. The sixties catechism that had preached the equality of natural forms grew less convincing as time weighed heavily on firm bosoms and trim thighs. Suddenly, discipline and artistry were no longer bad words when it came to preparing the body for public display. What nature could not deliver, the high-tech culture of exercise machines could.

In contrast to the fifties, when the body borrowed its shape from the bathing costume encasing it, the swimsuit was now a second skin that dramatized, but did not alter, what lay beneath it. Its purpose was still to cover the essentials. More important, it was now meant to frame the physical perfections and to permit the freedom of movement required by exercise routines. In the way that swimming, suntanning, and the promenade had functioned as design generators for the swimsuits of their respective eras, workout programs have now become the chief inspiration for swimwear.

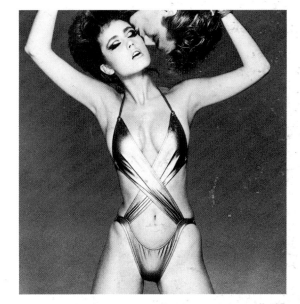

Despite tremendous expenditures of time, effort, and money required to successfully tighten up the flanks, millions of women enthusiastically agreed to put on a public sideshow by wearing side-baring swimsuits. For those who could wear it, the thigh-high swimsuit of the 1970s became an instant badge of superiority, telegramming the victory of machine over flesh. It was an era during which the body was transformed into a "machine for living." And more than any other garment, the swimsuit was responsible for advertising modern man's ability—or obsessive need—to reshape the body by subjecting it to a squeaking, clanging maze of steel cables, rubber handles, weights, and hydraulic impediments.

The fascination with retro fashions extended to advertising campaigns which tapped into nostalgia-packed imagery, as in Catalina's revival of the pinup girl.

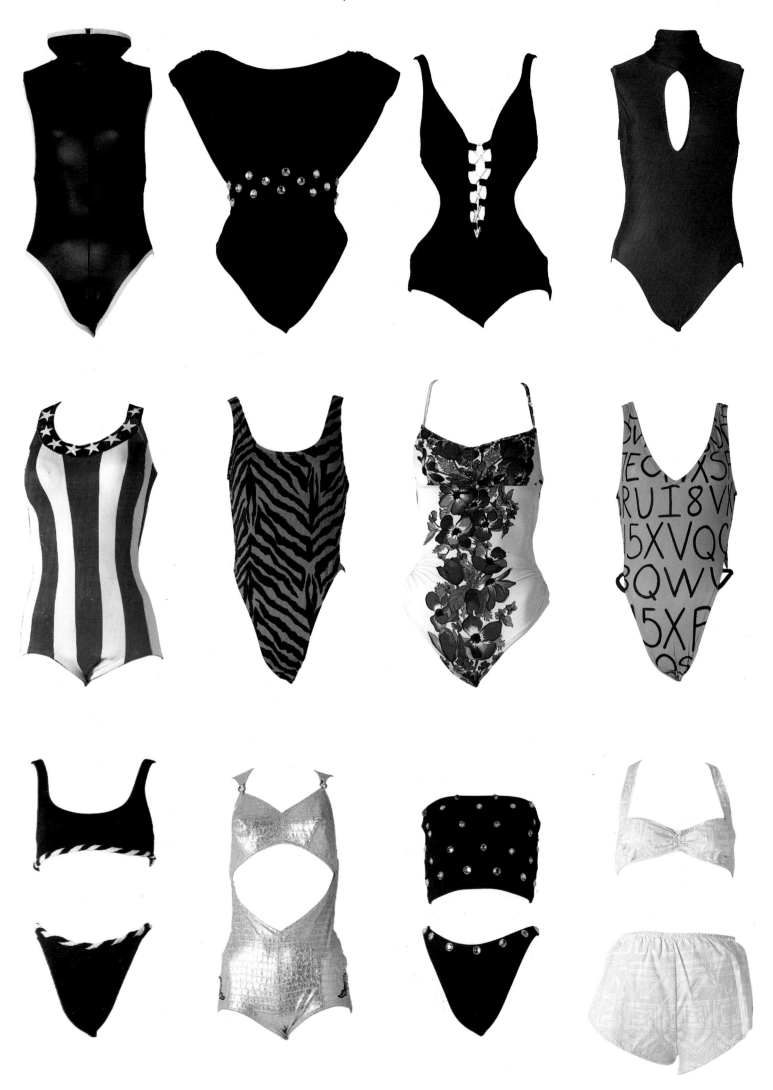

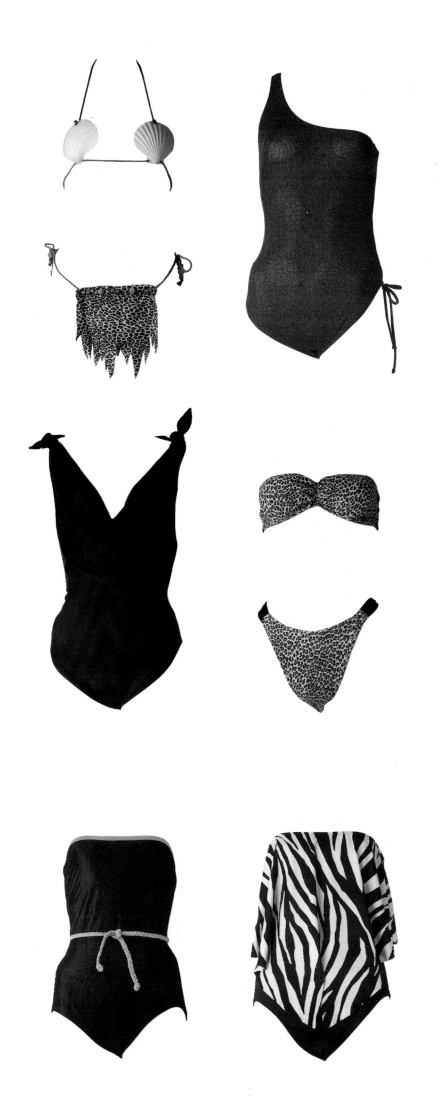

The swimsuit had come a long way since the days when bathing became an acceptable leisure pastime. Numerous layers of garments had come and gone, yards of fabric had shrunk, postage-stamp-size patches of material had wandered across the female body. But one theme had stubbornly remained constant: in one guise or another, the machine had played a crucial role in determining the size, structure, and shape of female bathing attire.

In the early 1800s, bathers had enclosed themselves in mobile wooden shacks that were tugged by horses into the open seas. In its Victorian heyday, the bathing costume relied on the mechanical rigidity of corsetry to give it a fashionable shape. In the following decades, devices adapted from foundation garments migrated from anatomic zone to anatomic zone, emphasizing or concealing whatever protuberances were dictated by prevailing tastes. During the 1950s, the suit itself became a machine for shaping, boning, girdling, and molding the body into the requisite fashionable form. Over the past fifteen years, however, the machine—although still integral to swimsuit design—was finally detached from the garment itself. Instead of being an intrinsic part of the garment's structure, it became a piece of equipment that was used to mold and chisel human musculature into a shape that was worthy of exposure and to which the swimsuit would adapt.

It is no accident, perhaps, that the anatomic regions put on display during the last twenty years have been those that age least gracefully. Buttocks, upper thighs, the high reaches of the hip, the zone beneath the waist, and even the armpit became erotic focal points. Few women over the age of twenty could boast flawless physiques in these areas, but vigorous exercise, combined with careful dieting, could banish sag, flab, and cellulite.

Swimsuits of the 1970s and 1980s boasted a potpourri of shapes and styles that drew their inspiration from historical precedents ranging from the maillot to the bikini.

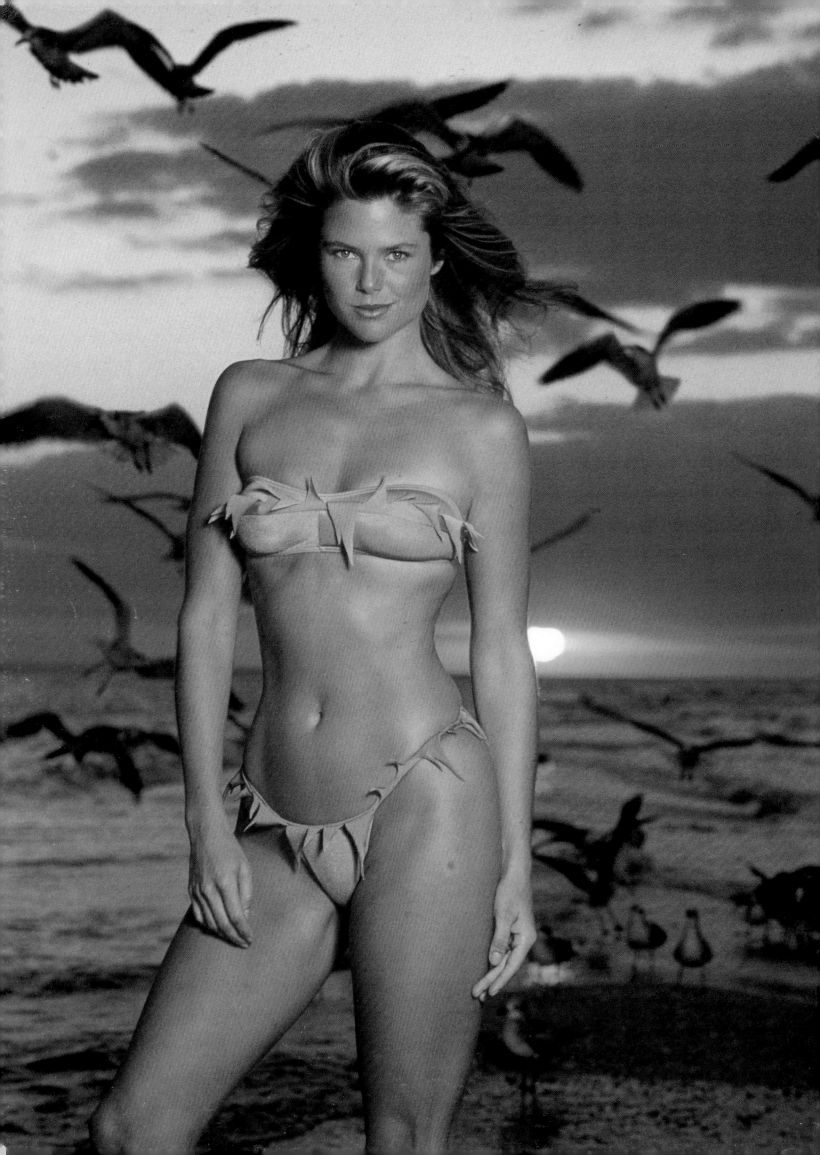

The signal that erogenous zones had shifted from the bosom and midriff to the upper legs was sounded as early as 1974 when American buttocks went on display in the Tanga, or String, a minimal bikini originating on the beaches of Rio de Janeiro. Consisting of two miserly triangles of cloth joined by a cord over either hip, the suit became one of the most important Brazilian imports since coffee. By July 1974, Manhattan's Bloomingdale's had sold out its entire order of 150 suits in two weeks. A Madison Avenue boutique exhausted its stock of 160 Strings in two days. And that was only the beginning.

Fashion consultants warned that not everyone should risk wearing the suit. "It's something I'd hate to see on every woman in the world," cautioned Beverly Hills designer Jim Riva. American manufacturers rushed the style into production, introducing a number of variations with an eye toward enhancing comfort and, coincidentally, bolstering modesty. Cole of California engineered a wider version of the String. According to company executive Jack Healy, the unrefined Rio model "kept creeping toward the center, and the wearer had to tug at it all the time."

A two-piece modification of the Tanga, modeled in *Sports Illustrated* in 1981.

The return of the classical
bikini is heralded in the
Sports Illustrated swimsuit
issue of February 5, 1979.

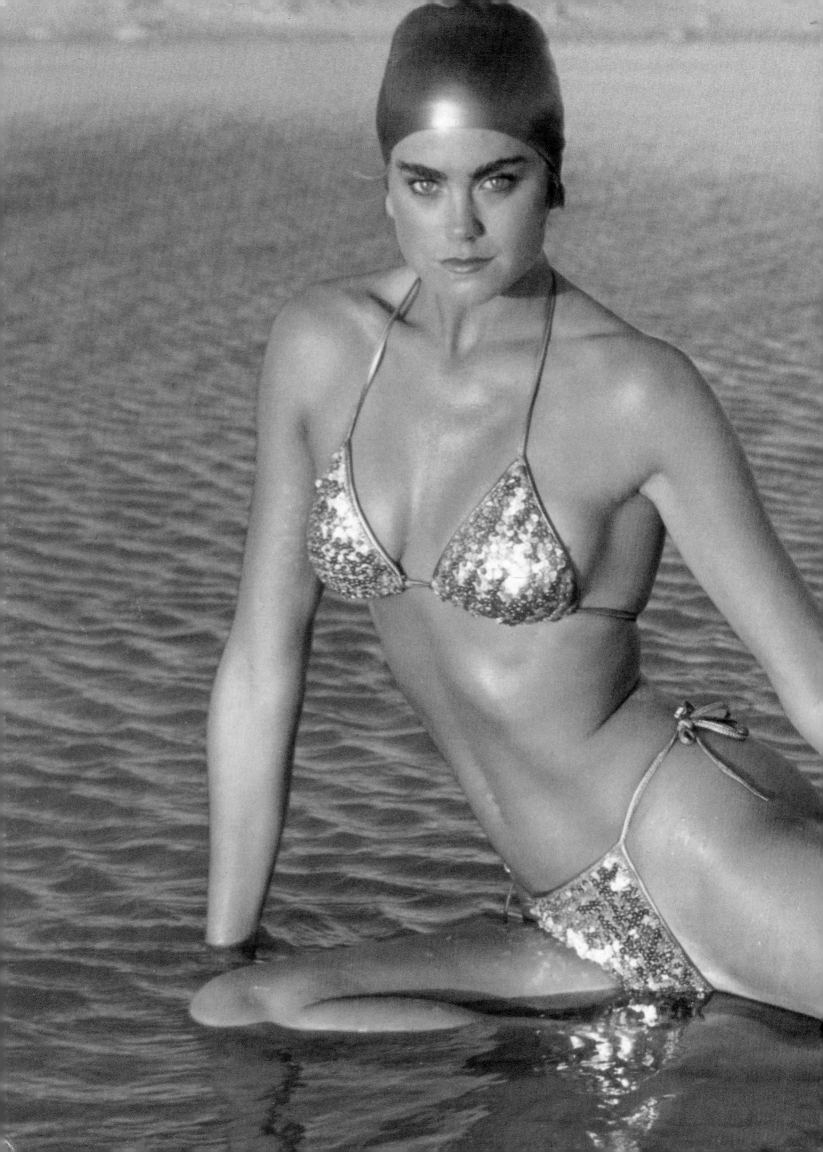

Meanwhile, Rudi Gernreich created his own version that he called the "Thong." Gernreich's virtually bottomless bathing suit was described as "little more than a Banlon breastplate held on by skinny straps around the neck and between the buttocks." Not the least provocative of its features was the fact that the Thong refused to discriminate between male and female anatomy. Gernreich's design was entirely unisex, which meant that, as in the case of the topless suit, breasts lost their status as sexual symbols. The crotch alone remained under wraps, and that only as a grudging concession to public morality.

Pared to a minimum, the basic "tank" suit was subjected to some extraordinary engineering. Norma Kamali's strappy version with a separate tube brassiere offered the option of going topless.

◄
Previous pages: The bathing cap makes a reappearance in *Sports Illustrated*'s 1984 swimsuit issue.

The String and Gernreich's "Bottomless" suit resembled "posing" suits adopted by competitive bodybuilders. Their daring exposure of the posterior may have seemed radical when it appeared, but it turned out to be an accurate forecast of the shape of things to come. The thigh-and-buttock-revealing features of the Thong quickly passed into mainstream American design where they completely revolutionized the look of the one-piece suit.

Ironically, by taking the two-piece to its minimalist extreme, the Thong had pushed the bikini to its vanishing point, marking a resurgence in the popularity of the one-piece swimsuit. "People are more body-conscious these days," explained Peggy Gay, a beachwear buyer for Saks Fifth Avenue during the summer of 1977, "and there is a certain sleek sexiness in a onepiece that doesn't exist in a two-piece."

Inspired by the costumes of Japanese sumo wrestlers, the Thong was available in three models: a tank suit, a two-piece, and a topless bikini. All three versions left the legs bare, fore and aft, nearly to the waist.

The triumphant return of the one-piece was the result of two nearly simultaneous advances. The first involved the development of light, flexible fabrics for racing suits. The other was a matter of purely formal innovation. In 1976, two New York designers, Norma Kamali and Halston, each produced a one-piece wrap suit cut high on the leg. In baring the thigh nearly to the waist, these young American designers called attention to a new erogenous zone that would be linked explicitly with the one-piece suit of the seventies and eighties.

The new maillots not only bared more skin but were also lighter than ever before, with some models weighing in at a mere two ounces. Fabrics blended of Lycra and nylon accounted for much of the weight loss, as did the absence of structuring devices. The trend toward the superlight one-piece had been taking shape since the end of the 1960s, but it was not until the 1973 World Aquatic Games in Yugoslavia that American swimsuit designers began to pay serious notice. That year the women's swimming team from East Germany so thoroughly defeated their American counterparts that puzzled experts began to cast about for explanations. The more they looked, the plainer the answer became. It was not, they concluded, a matter of superior training but merely of superior swimsuits.

It was discovered that the East Germans were wearing skintight, nearly transparent maillots which, because they clung to the body like a second skin, shaved seconds from a swimmer's time. Speedo, which had been turning out competition suits since the 1960 Rome Olympics, immediately responded with a Lycra suit that stretched tightly over the body. By the end of the 1970s, the "skinsuit" had spread far beyond the sides of training pools to leotards and exercisewear.

While fashionable bathing costumes of the seventies had celebrated an austere, clingy look with razor-sharp cutaways, the eighties championed a return to glamorous Hollywood-inspired costumes. This, after all, was the decade of postmodernism and nostalgia. Reflecting these trends, one-piece swimsuits featured shirring, plunging décolletés and low-cut backs, usually in dramatic black lustrous fabrics, and frequently dripping with diamantes, pearls, and spangles. Animal skin prints, Carmen Miranda tropical motifs, and sultry ethnic colors invaded suits that, once again, showed elements of the fine tailoring and construction characteristic of swimsuits designed in the 1940s and 1950s.

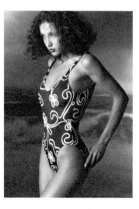

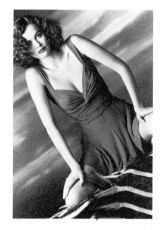

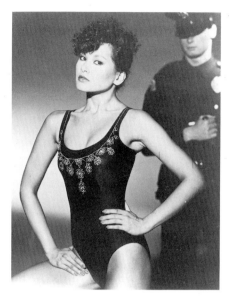

As yuppies revived the neglected art of conspicuous consumption, Cole of California gave a new meaning to the term "investment dressing." Costing $12,000, the world's most expensive swimsuit boasted a generous scattering of diamonds and pearls on a sleek jet-black maillot.

Taking its cue from the postmodernist impulse that informed almost every sphere of design and the plastic arts, the swimsuit of the 1980s became a melting pot of encyclopedic references. Animal skin prints, tropical prints, and sultry ethnic influences vied with high-tech patterns, searing neon colors, and graffiti scrawls.

Shiny Lurex material is used in Cole of California swimsuits.

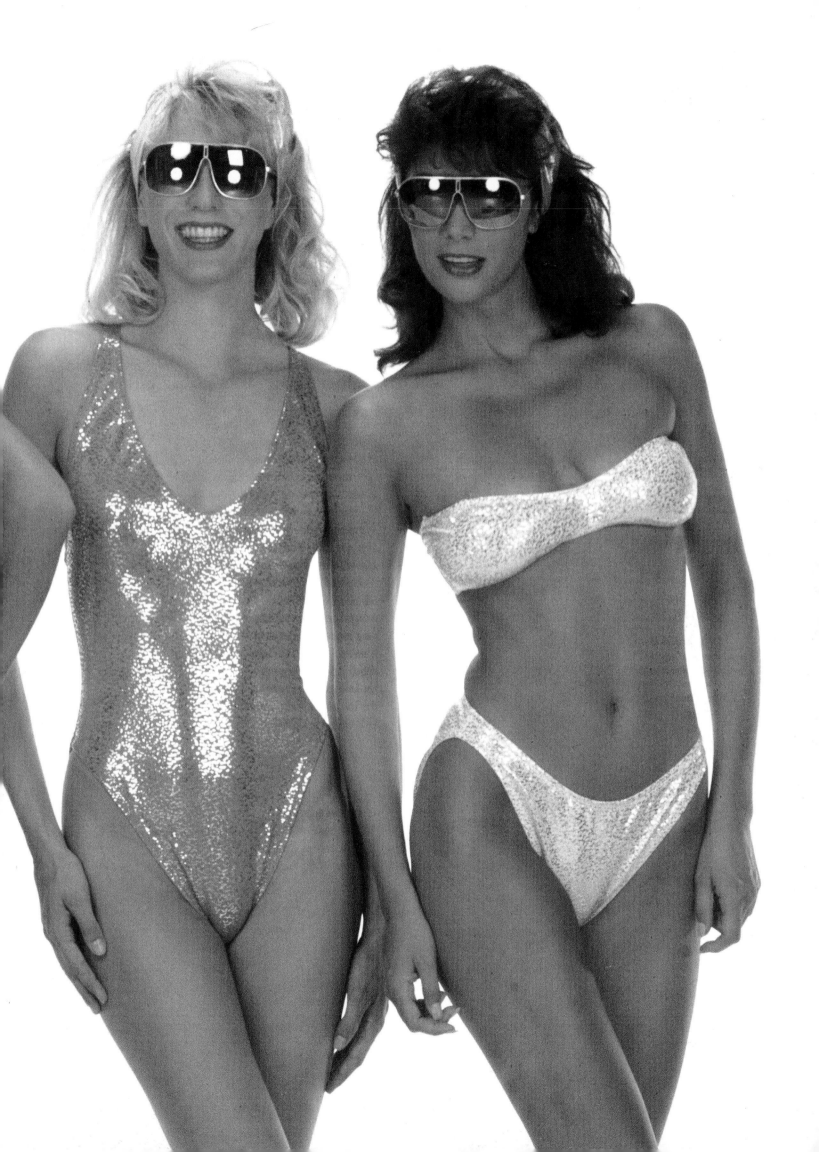

Swimsuits of the era were developing along two divergent tracks. Some designers—among them Speedo and Jantzen—chose to side primarily with a design aesthetic that was linked to modern functionalism, while others—notably Kamali and Anne Cole—introduced suits that reflected postmodern leanings. In its 1986 swimsuit issue, *Life* magazine introduced Anne Cole's neo-60s look, which was based on nostalgia fabrics such as leather look-alike vinyl and metallics. Moving with even greater conviction, Cole's 1987 collection featured a powerful strain of 1930s look-alikes: covered-up, clinging maillots with great back exposure and interesting strap treatments worn by models in tight rubber caps. When asked for her motivation in reviving swimwear of that period, Cole commented, "I was born in the thirties and I shall live in the thirties. It was a romantic, devil-may-care era, a time when the economy plummeted, but great things were being created in fashion. It was the magical age of the tank suit with its flat-chested, knit look before we all got bosom happy."

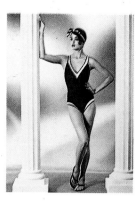

Swimsuits by Cole of California tapped a rich vein of time-honored styles such as the clinging maillot. By the 1986 season, swimsuits had truly entered the postmodern age.

In 1987, *Time* magazine predicted that, "as surely as hemlines rise and fall, the two-piece suit will inch its way back into fashion again." In fact, the pendulum seemed to be swinging once again from the maillot back to the bikini, as it has done without fail since those two basic forms of the modern swimsuit had emerged in the thirties.

But this decade also brought the Olympic Games to Los Angeles, the heart of the Southern California swimwear industry. The impact of racer-style maillots for recreational suits became nearly universal as lean, high-cut, cross-back shapes appeared in virtually every swimwear line. The "tank" suit now became established as the single most important silhouette, and a spate of new shapes appeared: cutouts, turtlenecks, scooped-out backs and fronts, as well as innovative crossover monokinis that featured two bands stretched diagonally across the breasts, detouring around to the back, and then reappearing at the waist to slip down to the crotch.

Men's swimwear, long confined to the basic boxer and the brief, underwent considerable diversification and drew on a rich repertoire of cultural allusions.

Among mass-market swimwear designers, Norma Kamali and Anne Cole of Cole of California lead the "retro" trend, relying heavily on resurrecting—and subtlely refiguring—successful styles from previous periods. Kamali dipped into the 1940s to champion, once again, the covered-up two-piece. Her 1985 collection copied such detailing as gathers across the brassiere, and shirred, skirtlike bottoms with front flaps over the crotch. Her open-midriff velvet suit bore a strong resemblance to Margit Fellegi's 1939 Swoon Suit.

Even Norma Kamali reported that her young customers had complained because they could not find bikinis in a market flooded with maillots. It seemed that the bikini was—and most likely always would be—claimed by the young as a garment to which they have a natural right. It is their badge of transition into adulthood. And it will be up to a new generation of designers to modify the bikini's profile, work out a new set of proportions, and invent a style that will crystallize contemporary trends and attitudes.

Just how far the pendulum will again swing in favor of the scanty two-piece is a matter for pure speculation. What we do know, however, is that for more than a century, America's best designers have been making waves with their swimsuits. It is hard to imagine designers anywhere else who have been able to accomplish more in the world of swimwear fashion while working with so little. And even harder, still, to ponder is the swimsuit of the future which, if history has its way again, will present the challenge of having to do so much more with even less.

One eighties stylistic faction showed an unabashedly historicist—or postmodern—suit that boasted sculptural construction, elaborate drapings, and fabrics popular in earlier decades. Such media personalities as Cyndi Lauper and Madonna brought undergarments out into the open and created a receptive climate for swimsuits featuring boned and wired bustiers and girdle-like sarong bottoms. These structuring devices, however, were no longer meant to be functional, but were used as historical footnotes, stylistic jokes, or, as Anne Cole noted, "fashion decor."

The prototype for a street-legal, bottomless-top swimsuit of the future, designed by Cadillac Ranch creator Doug Michaels, represents as radical a departure in swimsuit architecture as the bikini and topless suits that preceded it.

Index

Bibliography

All American: A Sportswear Tradition. New York: Fashion Institute of Technology, 1985.

Baedeker, Karl. *The United States, with an Excursion into Mexico: A Handbook for Travelers, 1893.* New York: Da Capo Press, 1971.

————. *The United States, with Excursions to Mexico, Cuba, Porto Rico and Alaska: A Handbook for Travelers.* Leipzig: Karl Baedeker, 1909.

Banner, Lois W. *American Beauty.* Chicago: The University of Chicago Press, 1983.

Bell, Quentin. *On Human Finery.* New York: Schocken Books, 1976.

Bony, D'Anne, ed. *Les Annees 40 D'Anne Bony.* Paris: Editions du Regard, 1985.

————. *Les Annees 50 D'Anne Bony.* Paris: Editions du Regard, 1982.

————. *Les Annees 60 D'Anne Bony.* Paris: Editions du Regard, 1983.

Brownmiller, Susan. *Femininity.* New York: Linden Press/Simon & Schuster, 1984.

Bush, Donald J. *The Streamlined Decade.* New York: George Braziller, 1975.

Carter, Ernestine. *Magic Names of Fashion.* Englewood Cliffs, N.J.: Prentice-Hall, Inc., 1980.

Corbman, Bernard P. *Textiles: Fiber to Fabric.* New York: McGraw-Hill Book Company, 1983.

Cunnington, Phillis, and Alan Mansfield. *English Costume for Sports and Outdoor Recreation.* London: Adam & Charles Black, 1969.

Deford, Frank. *There She Is: The Life and Times of Miss America.* New York: The Viking Press, 1971.

Dulles, Foster Rhea. *America Learns to Play.* New York: D. Appleton-Century Company, 1940.

Eichler, Lillian. *Book of Etiquette.* Oyster Bay, N.Y.: Nelson Doubleday, Inc., 1922.

Fairchild, John. *The Fashionable Savages.* Garden City, N.Y.: Doubleday & Company, Inc., 1965.

Fraser, Kennedy. *The Fashionable Mind.* New York: Alfred A. Knopf, 1981.

Glynn, Prudence. *Skin to Skin: Eroticism in Dress.* New York: Oxford University Press, 1982.

Haupt, Enid A. *The Seventeen Book of Etiquette and Entertaining.* New York: David McKay Co., Inc., 1963.

Hillier, Bevis. *The World of Art Deco.* New York: E.P. Dutton, 1971.

Hole, Christina. *English Sports and Pastimes.* London: B.T. Batsford Ltd., 1949.

Hollander, Anne. *Seeing Through Clothes.* New York: Avon Books, 1980.

Horn, Richard. *Fifties Style Then and Now.* New York: Beech Tree Books, 1985.

Kasson, John F. *Amusing the Millions: Coney Island at the Turn of the Century.* New York: Hill and Wang, 1978.

Kidwell, Claudia. *Suiting Everyone: The Democratization of Clothing in America.* Washington, D.C.: Smithsonian Institution Press, 1974.

————. *Women's Bathing and Swimming Costume in the United States.* Washington, D.C.: Smithsonian Institution Press, 1968.

Langner, Lawrence. *The Importance of Wearing Clothes.* New York: Hastings House, 1959.

Laver, James. *Costume and Fashion.* New York: Thames and Hudson, 1985.

————. *Modesty in Dress.* Boston: Houghton Mifflin Co., 1969.

Lee, Sarah Tomerlin, ed. *American Fashion: The Life and Lines of Adrian, Mainbocher, McCardell, Norell, Trigere.* New York: Quadrangle/New York Times Book Co., 1975.

Lurie, Alison. *The Language of Clothes.* London: Heinemann, 1981.

McCardell, Claire. *What Shall I Wear?* New York: Simon & Schuster, 1956.

Major, John M., ed. *Sir Thomas Elyot's The Book Named the Governor.* New York: Teachers College Press, 1969.

Marchand, Roland. *Advertising the American Dream.* Berkeley: University of California Press, 1985.

Martin, Judith. *Miss Manners' Guide to Excruciatingly Correct Behavior.* New York: Atheneum, 1982.

May, Larry. *Screening Out the Past: The Birth of Mass Culture and the Motion Picture Industry.* Chicago: The University of Chicago Press, 1983.

Melinkoff, Ellen. *What We Wore: An Offbeat Social History of Women's Clothing, 1950-1980.* New York: Quill, 1984.

Milbank, Caroline. *Couture: The Great Designers.* New York: Stewart, Taber & Chang, 1985.

Morton, Grace Margaret. *The Arts of Costume and Personal Appearance.* New York: John Wiley & Sons, Inc., 1943.

Parish, James Robert, and Ronald L. Bowers. *The MGM Stock Company: The Golden Era.* New Rochelle, N.Y.: Arlington House, 1973.

Payne, Blanche. *History of Costume from the Ancient Egyptians to the Twentieth Century.* New York: Harper and Row, 1965.

Pilat, Oliver, and Jo Ransom. *Sodom by the Sea.* Garden City, N.Y.: Doubleday, Doran & Company, Inc., 1941.

Probert, Christina. *Swimwear in Vogue Since 1910.* New York: Abbeville Press, 1981.

Rosencranz, Mary Lou. *Clothing Concepts: A Social-Psychological Approach.* New York: The Macmillan Company, 1972.

Rudofsky, Bernard. *The Unfashionable Human Body.* New York: Van Nostrand Reinhold Company, 1971.

Russell, Douglas A. *Costume History and Style.* Englewood Cliffs, N.J.: Prentice-Hall, Inc., 1983.

Serrano, Dare. *Lovely Ladies: The Art of Being a Woman.* Garden City, N.Y.: Doubleday, Doran & Co., 1929.

Snow, Richard. *Coney Island: A Postcard Journey to the City of Fire.* New York: Brightwaters Press, 1984.

Stacy, Jan, and Ryder Syvertsen. *Rockin' Reels: An Illustrated History of Rock & Roll Movies.* Chicago: Contemporary Books, Inc., 1984.

Steele, Valerie. *Fashion and Eroticism.* New York: Oxford University Press, 1985.

Strutt, Joseph. *The Sports and Pastimes of the People of England.* London: Chatto & Windus, 1876.

Vanderbilt, Amy. *Amy Vanderbilt's New Complete Book of Etiquette.* Garden City, N.Y.: Doubleday & Co., 1963.

Watkins, Josephine Ellis, ed. *Fairchild's Who's Who in Fashion.* New York: Fairchild Publications, Inc., 1975.

Wilcox, R. Turner. *Five Centuries of American Costume.* New York: Charles Scribner's Sons, 1963.

Illustration Credits

Front cover: Cole of California Archive; photo by Matthew Ralston.

Back cover: Speedo, Inc.

Front flap:
upper left: Jantzen Archive; photo by Gideon Bosker (G.B.)
middle left: postcard, circa 1904, collection of author
lower left: Jantzen Archive
upper right: Jantzen Archive
lower right: Arlene Holmes Paper Doll Collection

Back flap:
upper right: photo by Tim Street-Porter
middle left: photo by G.B.
middle right: photo by G.B.
lower right: Great Shakes Collection; photo by G.B.

Page 3:
postcard, circa 1935, collection of the author

Page 4:
watercolor by Frank Clark, 1929, Jantzen Archive

Page 7:
Jantzen Archive

Page 10:
cartoon by Lynda J. Barry

Page 11:
Bettmann Archive

Page 12:
University of California, Los Angeles, Library

Page 13:
top: Cole of California Archive
middle: postcard, circa 1930, collection of the author
bottom: University of Southern California Archives of the Performing Arts

Page 14:
top: Cole of California Archive
bottom: UPI/Bettmann Archive

Page 15:
top: Cole of California Archive
middle left: Dick Whittington Photo
bottom left: mermaid shaker, collection of the author
top and bottom right: Jantzen Archive

Pages 16 and 17:
University of Texas

Page 16:
top left: photo by G.B.
second from left: University of Southern California Archives of the Performing Arts
second from right: Kobal Collection
top right: *Life,* circa 1939

Page 17:
top left: postcard, circa 1920, collection of the author
top center: *Delineator,* circa 1900
top right: Dick Whittington Photo

Page 18:
top: *Sports Illustrated;* photo by Bryan Lanker
bottom left: Bettmann Archive
bottom right: Time-Life Pictures Archive
top right: Cole of California Archive

Page 19:
Cole of California Archive

Page 20:
Bettmann Archive

Page 21:
bottom left: *Godey's Lady's Book,* circa 1900
middle right: Bettmann Portable Archives

Page 22:
Godey's Lady's Book

Page 23:
top: Bettmann Archive
bottom: *Godey's Lady's Book*

Page 24:
top left: *Godey's Lady's Book*
top to bottom right: Metropolitan Museum of Art

Page 25:
Jantzen Archive

Pages 26 and 27:
top: California Historical Society
bottom: *Outing,* circa 1900

Page 28:
Outing, circa 1900

Page 29:
top right: Bettmann Archive center: Bettmann Archive

Page 30:
Collier's, 1898

Page 31-32:
all, Bettmann Archive

Page 33:
top left: Jantzen Archive
bottom left: postcard, circa 1905, collection of the author
middle right: Bettmann Archive

Page 34:
postcard, circa 1925, collection of the author

Page 35:
The Los Angeles County Museum of Art Costume and Textile Collection, Jantzen Archive, and Cole of California Archive.

Page 36:
middle left: Metropolitan Museum of Art
middle right: Culver Pictures

Page 37:
upper left: Bettmann Archive
top to bottom right: Culver Pictures

Page 38:
bottom right: Culver Pictures

Page 39:
top right: Bettmann Archive
bottom center: Bettmann Archive

Page 40:
top to bottom left: *Ladies Home Journal*
bottom right: Culver Pictures

Page 41:
Ladies Home Journal, 1913

Page 42:
Culver Pictures

Page 43:
top right: watercolor by Frank Clark, Jantzen Archive
bottom right: Jantzen Archive

Pages 44 and 45:
top left: Bettmann Archive
top center: Jantzen Archive
top right: Jantzen Archive
bottom left: University of California, Los Angeles, Library
bottom right: Bettmann Archive

Page 46:
Los Angeles County Museum of Art Costume and Textile
 Collection, Jantzen Archive, and Cole of California
 Archive

Page 47:
postcard, circa 1920, collection of the author

Pages 48-51:
all, Jantzen Archive

Page 53:
top: Bettmann Archive
middle: University of Southern California Archives of the
 Performing Arts
bottom: Dick Whittington Photo

Pages 54-57:
all, Jantzen Archive

Pages 58 and 59:
top: postcard, circa 1930, collection of the author
top right: Great Shakes Collection; photo by G.B.
bottom center and right: Jantzen Archive

Page 60:
swimsuits from Jantzen Archive, Cole of California
 Archive, and the Los Angeles County Museum of Art;
 photos by G.B.

Page 61:
Jantzen Archive

Page 62:
top: Jantzen Archive
bottom: Los Angeles Public Library

Page 63:
postcard, circa 1930, collection of the author

Pages 64 and 65:
all from Jantzen Archive except page 64, Kleinert's
 advertisement, from the collection of the author

Pages 66 and 67:
Coney Island, by Paul Cadmus, Los Angeles County
 Museum of Art

Page 68:
Jantzen Archive

Page 69:
left: Coca-Cola Archive
lower right: Bettmann Archive

Pages 70-74:
all, Jantzen Archive

Page 75:
left: Bettman Archive
right: University of California, Los Angeles, Library

Page 76:
Dick Whittington Photo

Page 77:
top left: BVD Collection
lower left: Bettmann Archive
right: Bettmann Archive

Pages 78 and 79:
postcards, circa 1930-1940, collection of the author

Page 80:
Kobal Collection

Page 81:
Jantzen Archive

Page 82:
swimsuits from the Los Angeles County Museum of Art
 Costume and Textile Collection, Jantzen Archive, and
 Cole of California Archive; photos by G.B.

Page 83:
Jantzen Archive

Page 84:
Kobal Collection

Page 85:
top: Kobal Collection
middle right: Metropolitan Museum of Art
bottom: Jantzen Archive

Page 86:
top left: University of California, Los Angeles, Library
center: Kobal Collection

Page 87:
top left: International News Photo: University of
 California, Los Angeles, Library
top right: Dick Whittington Photo
middle right: Columbia Pictures
bottom right: University of California, Los Angeles, Library

Page 88:
Jantzen Archive

Page 89:
top left: Umberto Brunelleschi, 1940
top right: Jantzen Archive
bottom: Jantzen Archive

Page 90:
Jantzen Archive

Page 91:
Cole of California Archive

Page 92:
top: University of California, Los Angeles, Library
bottom: postcard, circa 1940, collection of the author

Page 93:
top: University of California, Los Angeles, Library
bottom: postcard, circa 1940, collection of the author

Page 94:
Jantzen Archive

Page 95:
Time-Life Pictures Archive

Page 96:
University of Southern California Archives of the
 Performing Arts

Page 97:
top left: photo by Tim Street-Porter
right: photo by G.B.

Page 98:
University of Southern California Archives of the
 Performing Arts

Page 99:
top: Columbia Pictures
bottom: University of Southern California Archives of the
 Performing Arts

Page 101:
top right: Cole of California Archive
middle left: Rose Marie Reid Archive
bottom left: Dick Whittington Photo
bottom right: UPI/Bettmann Archive

Page 102:
swimsuits from the Los Angeles County Museum of Art
 Costume and Textile Collection, Jantzen Archive, and
 Cole of California Archive; photos by G.B.

Page 103:
Dick Whittington Photo

Page 104:
University of Southern California Archives of the
 Performing Arts

Page 105:
top: University of California, Los Angeles, Library
middle: University of California, Los Angeles, Library
bottom right: University of Southern California Archives
 of the Performing Arts
bottom left: Dick Whittington Photo

Page 106:
top: photo by Tim Street-Porter
middle: Academy of Motion Picture Arts and Sciences
bottom: University of Southern California Archives of the
 Performing Arts

Page 107:
top: photo by Tim Street-Porter
middle: UPI/Bettmann Archive
bottom: University of Southern California Archives of the
 Performing Arts

Page 108:
Jantzen Archive

Page 109:
top: Jantzen Archive
bottom: UPI/Bettmann Newsphoto

Pages 110 and 111:
Rose Marie Reid Collection

Page 112:
photos by Tim Street-Porter

Page 113:
Arlene Holmes Paper Doll Collection

Page 114:
Cole of California Archive

Page 115:
Barbie Doll Museum; photo by G.B.

Page 117:
middle left: Paul Popper Ltd.
bottom right: Rex Features

Page 118:
Academy of Motion Picture Arts and Sciences

Page 119:
Dick Whittington Photo

Pages 120 and 121:
Barbie Doll Museum; photos by G.B.

Page 120:
swimcaps from Jantzen Archive

Page 122:
Academy of Motion Picture Arts and Sciences

Page 123:
all, Time-Life Pictures Archive

Page 125:
The Los Angeles County Museum of Art Costume and
 Textile Collection, Jantzen Archive, and Cole of
 California Archive

Page 126:
top: Cole of California; photo by Jane MacGowan
bottom: photo by Jane MacGowan

Page 128:
top: Cole of California Archive lower left: Popperfoto, Ltd.

Page 129:
Popperfoto, Ltd.

Page 130:
Cole of California Archive

Page 131:
lower left: Catalina Collection
middle right: Norma Kamali Collection

Pages 132 and 133:
Los Angeles County Museum of Art Costume and Textile
 Collection, Jantzen Archive, Cole of California Archive,
 and Catalina Archive

Page 134:
Sports Illustrated; photo by John G. Zimmerman

Page 135:
top left: Jantzen Archive
bottom right: Norma Kamali Collection

Pages 136 and 137:
Sports Illustrated; photo by Walter Iooss, Jr.

Pages 138 and 139:
Sports Illustrated; photo by Paolo Curio

Pages 140 and 141:
all, Norma Kamali Collection

Page 142:
top left: Cole of California Archive
top right: Norma Kamali Collection
bottom left: source unknown

Page 143:
top center: Norma Kamali Collection
top right: Cole of California Archive
middle left: Norma Kamali Collection
bottom center: Cole of California Archive

Pages 144 and 145:
Cole of California Archive

Pages 146 and 147:
all, Cole of California Archive

Pages 148 and 149:
Jantzen Archive

Pages 150 and 151:
Norma Kamali Collection

Page 152:
Illustration by Jim Allegro.

Book and Cover Design	**Woods+Woods** **Graphic Communications** **San Francisco**
Editing	**Charles Robbins**
Typography	**EuroType** **Berthold Typefaces:** **Bodoni Old Face Regular** **Bodoni Antiqua Bold Condensed** **Futura Demi-Bold**